SPRINGFIELD, OHIO:
A SUMMARY OF
TWO CENTURIES

SPRINGFIELD, OHIO:
A SUMMARY OF
TWO CENTURIES

TOM DUNHAM

authorHOUSE®

AuthorHouse™
1663 Liberty Drive
Bloomington, IN 47403
www.authorhouse.com
Phone: 1-800-839-8640

Published by AuthorHouse 08/22/2012

ISBN: 978-1-4772-6190-3 (sc)
ISBN: 978-1-4772-6193-4 (e)

Library of Congress Control Number: 2012915184

CONTENTS

The First 50 Years

Unlike Columbus, Ohio's capitol city, which was founded for political purposes or Zion in northeast Ohio, founded for religious reasons, Springfield, Ohio was surveyed with a keen eye for industrial development. However, the first group of settlers in the area had no interest in such development. These settlers, which included John Humphreys and Simon Kenton, had arrived in west-central Ohio from Kentucky in 1799. The eight or so families built a fort at the confluence of the Mad River and Laconda Creek, later to be called Buck Creek. (Today the confluence is about where state route 40 crosses route 68). This area of fertile soil, tall grasses, interspersed with forest, and replete with well-watered streams was viewed by the settlers as prime farm sites. Kenton's wife, impressed with the many streams of clear water suggested, as the story goes, that the area be called Springfield, thereby giving the designer of the original plat a name for the future town and city.

The founder, by virtue of his plat, was James Demint, who had also arrived in the area from Kentucky in 1799. He carried with him a government certificate granting him land along Buck Creek east of the Mad River. Unlike the others, Demint showed no interest in farming, preferring to build a log house west of the settlers' fort on the north side of the creek just west of the later Limestone Street. From his house, Demint could look across the creek and see a quick running stream flowing north and emptying into the larger Buck Creek about where Center Street is today.

This was an age when water power drove industry, and for the encouragement of industrial development on his land, Demint could hardly have selected a better site for a town plat that the one designed in 1801. South of the Buck and east of the stream (soon known as Mill Run) Demint had his surveyor, John Daugherty, lay out a plat of 96 lots with three east-west streets and three north-south streets.

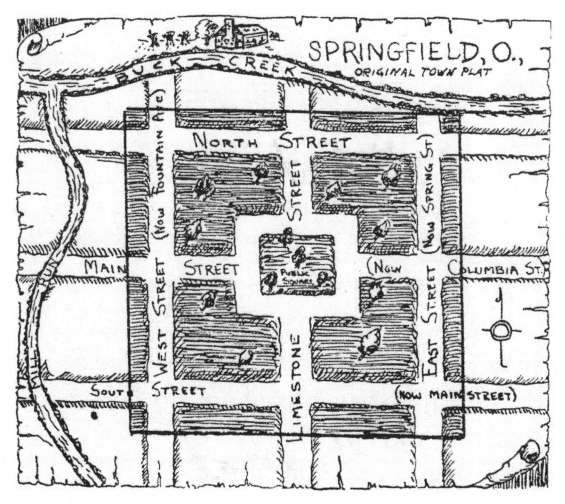

Demint's 1801 plat. This drawing shows the location of Buck Creek and Mill Run in relation to the later downtown.

This plat framed on both the north and west by water power sources would prove to be a magnet for early manufacturers. Not surprisingly, the first enterprise was established by Demint himself, this being a grist mill on Mill Run near the creek. From the wheat he ground for area farmers, Demint purchased some from which he made whiskey, selling much of it to local Indians. The production of whiskey has therefore the distinction of being Springfield's first industry

Entrepreneurs following Demint were not long in coming. Among the first was Cooper Ludlow in 1805 and Robert Rennick in 1806. Ludlow's previous work was as a tanner, and he selected a Mill Run site near Buck Creek in order to establish his trade. Later Ludlow opened a tavern on Main Street near Factory Street (later Wittenberg Avenue). Rennick also found

Mill Run suitable for his trade of milling flour, and near the creek built his mill, which he operated for about fifteen years, afterwhich Henry Bechtle acquired possession and ran it until 1835. A decade of so after the settlement's founding, Mattox Fisher arrived in Springfield from Kentucky with funds enough to construct a cotton and later a flour mill in 1814. Like Ludlow and Rennick, Fisher favored the northern part of Mill Run for his mill where he assumed the site of Demint's old grist mill. Fisher operated the profitable mill until 1834 when it was destroyed by fire. Ira Page also came to Springfield in 1814 and soon after he and James Taylor established a woolen factory near Fisher's mill and for about fifteen years manufactured jeans and flannels for the growing community.

Griffith Foos became a well-known early entrepreneur who in 1801made a trip from Franklinton (now Columbus) in order to observe the area. Liking what he saw, Foos moved his family to the raw settlement, benefiting from Demint's offer of land at a bargain price. His land purchase included what later became the Main and Spring streets intersection, where he built a double log house, turning part of it into a tavern by the end of 1801. Foos operated the tavern until 1814 when he turned his attention to industry, and by 1817 he had opened an oil mill on Mill Run a few blocks southeast of the original plat. [1] (Foos' oil mill and those built later were water powered mills that produced linseed oil from locally grown flax seeds).

In the first fifteen years after the original plat, several other mills had opened on Springfield's waterways. Benjamin Prince in his 1922 history of Springfield wrote that in the few years after the 1801 plat ". . . as many as a dozen industries had their motive power on the swift flowing current." Springfield historian, Oscar Martin, viewed such development as Demint's intent. In his 1881 history of Springfield, Martin expressed Demint's progression for Springfield in the following glowing terms: ". . . the nucleus of the frontier settlement, growing into the thrifty hamlet, then the ambitious town, the restless enterprising, manufacturing city, where the throbbing engines of industry beat ceaselessly, and the hum of busy wheels grows stronger year by year." [2]

Transportation limitations

The geographical location of Demint's plat had obviously been a success in so far as it encouraged individual entrepreneurs to locate at its waterways. However rapid growth of these early industries was not forthcoming, the problem being poor transportation to outside markets. Unfortunately Demint could do nothing about the lack of commercial trade routes through or

near his plat whose streams beckoned industry. Demint died in 1817 without seeing significant transportation routes develope. Indeed for its first half century, Springfield's relatively isolation was its Achilles heel that hindered early growth. Isolation was of course never total. Residents from early years had traveled southwest to Dayton, south to Cincinnati, east to Columbus, and southeast to Chillicothe. By 1801, surveying had begun for a route to Dayton and Columbus. Early on the Chillicothe Pike to South Charleston was established. (This route would become the future East High Street through Springfield). But these routes were slow and cumbersome, never fully cleared of tree stumps and would remain poorly surfaced. Therefore, they could hardly be profitable trade routes. Consequently, commercial isolation characterized Springfield's economy, as raw material for its grist and flour mills came from local farms, and finished products were largely sold and consumed locally.

If area roads were not the answer for trade routes, neither were waterways. Ohio's fine system of canals that in the 1820s and 1830s spurred growth in areas between the Ohio River and Lake Erie had bypassed Springfield and indeed all of Clark County. Somewhat surprising the Buck Creek and Mad River outlet to Dayton and beyond never became profitable. In spite of Springfield's commercial isolation, the small town of 935 individuals, according to the Western Pioneer newspaper, was by 1828 supporting the following enterprises: three cabinet makers, two millwrights, two distillers, three brickyards, a paper mill, and a flour mill. In addition, there were fourteen general merchandising stores, four groceries, four lawyers, and five physicians. And this did not complete the list of those with an enterprising spirit.[3]

Although denied a canal, Springfield was not denied a section of the country's first interstate highway, the National Road. Chartered by the Congress to extend from Cumberland, Maryland to Vandelia, Illinois, work began in 1811, and by year's end, eleven miles was completed. The road builders, under the supervision of the War Department, reached Wheeling on the Ohio River in 1818. Columbus, a 120 miles from Wheeling did not see the road until 1830. In 1832, using Main Street (South Street on the 1801 plat) the federal road workers entered Springfield. This route gave the town a much improved street, for the federal standards were strict, mandating a surface of crushed stone, each piece being smaller than two and a quarter inches as measured by an iron ring that each passed through. The road was built thirty-three feet wide. Outside towns, another twenty feet to each side had to be cleared of stumps and the holes filled. In addition to a new surface, Springfield also benefited by a new bridge over Mill Run that crossed Main Street. As the new road cleared the town boundary, work ceased due to the failure of Congress to

fund future construction. Because the road was not continued until the late 1830s, Springfield became known as "the town at the end of the Pike." When the road was resumed, it would be state funded, and respective state funding would continue into Illinois..

The National Road increased Springfield's commercial traffic. During September and October 1836, over 1200 wagons passed over Main Street, which had become the stagecoach route. It was not uncommon for up to seventy-five coaches per day, many of them carrying mail to points east and west, to rumple through the town, where horses were changed. This resulted in barn construction on the west side of Spring Street between Main and Columbia streets. The stables held up to 400 horses, a boon to feed and other suppliers for the care of the horses. As stagecoaches did not commonly run at night, entrepreneurs established hotels for the travelers. One of the most popular was the Werder Hotel built in 1829 at the Spring and Main street intersection. A block away, the Buckeye House began operations in 1830, lasting for over two decades. The best known hotel, largely because it still exist, is the Pennsylvania Hotel, built in 1839 along the National Road, about where the federally funded portion of the road stopped.[4]

Yet the boost in commerce following the National Road through Springfield was modest. Although during the decade of the 1830s, the town's population had doubled, the number of individuals totaled just 2,062 by 1840.

Though of welcome commercial benefit, the National Road was not the answer to Springfield's limited access to wider markets. New local manufacturing inventions, as we will see, would arrive in the 1840s and 1850s, and in the absence of wider trade routes, they would not be able to boost the local economy. But through the late 1830s and early 1840s, the waterways that Demint saw as nursing industry would continue in this task. James Leffel would later leave a large footprint on Springfield industry, but in the early 1840s his gift as an inventor was already becoming evident. To supplement the water power of Buck Creek and Mill Run, Demint by the end of 1840 had designed a man-made waterway called the Mill Race. His design called for cut on the north side of Buck Creek about a mile and half east of the downtown. Then a channel was to be dug west paralleling the creek, where near Limestone Street, the water would be directed back into the creek, thereby forming a long slender island. The actual construction of the mill race was done by Samuel and James Barnett. Near the downtown, the race had a 24-foot drop, called Barnett's hydraulic, which provided the power for future mills. The Barnetts, showing confidence in the new waterway, invested $32,000 and built in 1841 a flour mill along the race that could produce

130 barrows of flour daily. Leffel, who had earlier built a foundry on Mill Run, abandoned it in order to construct a larger foundry along the new race. Here Leffel with help from William Blackeney began the successful manufacture of the Buckley stove, an invention of Leffel's that was a refinement of the traditional cooking stove. By 1848, three additional plants had begun business utilizing the power developed by the Barnetts. In 1847 the Smith and Boucher oil mill was in operation producing linseed oil from flax seeds.

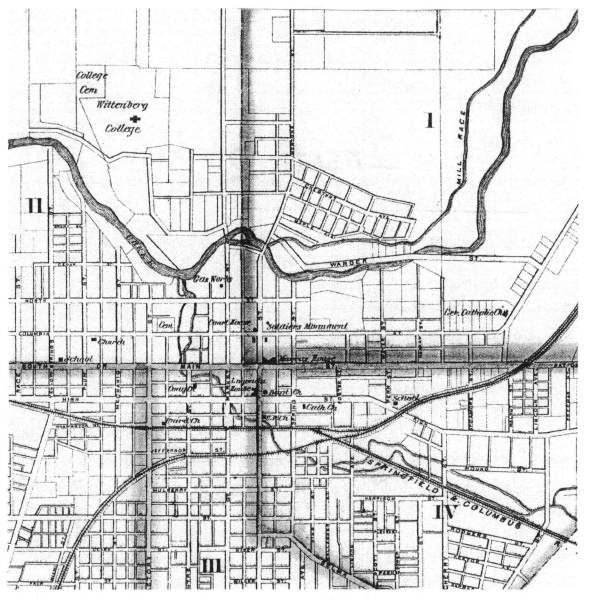

This detail from an 1870 map shows the location of the Mill Race. It flowed right to left on the map.

The water power of the area brought John Pitts from New York in 1842 in order to build a factory on the north side of Buck Creek near Limestone Street within the newly formed island.

The factory was about 120 feet long and four stories high. In addition, Pitts built two adjacent buildings for storage. The twenty men employed by Pitts manufactured the Pitts Thrushing Machine, which could thrush and clean grain in a single operation. Pitts remained in Springfield for nine years before relocating to his headquarters in Buffalo. However, as late as 1856, the factory at Buck Creek was managed by a Pitts agent and was producing about 200 machines per year.

Springfield's waterways were well supplied with woolen mills, and in 1848, according to Charles Rabbits oral history account, there were five with five miles of each other to serve the many sheep farmers in Clark, Fayette, and Madison counties. The Rabbits and Olds mill on Barnetts hydraulic was one of the largest in the area. The partners not only made cloth, but also traded raw wool for cloth. Olds left the business in 1855, but Rabbits remained until 1874. During the Civil War he was especially successful in selling cloth and wholesale clothes in Cincinnati destined for the Union Army. After the 1870s, however, woolen mills in the Springfield area became unprofitable due to the establishment of large factories in the East.[5]

Wider markets

Springfield's difficult accessibility to large outside markets came to an end with the arrival of railroads beginning in August 1846. The first train—carrying passengers—arrived from Cincinnati traveling from the west side along the Washington Street tracks and stopped at the recently erected passenger depot near Limestone Street. Freight trains soon followed, giving industrialists and merchants access to eastern markets via Cincinnati.

An alternative eastern route became available in 1848 when the Mad River and Lake Erie Railroad extended its tracks to Springfield from Sandusky at Lake Erie. Once Springfield shipments reached Sandusky, connections were available to Buffalo and then across New York state. Of these two lines in Springfield, historian Oscar Martin in his 1881 history wrote: "It was a beginning of a new state of things in all that related to travel and commerce. The amount of travel and freight that poured over this route as soon as it opened was astonishing."[6] More lines soon followed, and in 1881 a truck line was established through Springfield by the Indianapolis, Bloomington, and Western (I.B.W) system. As the Springfield lines were incorporated into the I.B.W. system, the city then had direct connections with the major eastern cities as well as to St.

Louis and Chicago. In 1890 the I.B.W. was absorbed into the Big Four System. (Initially the Big Four referred to Cincinnati, Cleveland, Chicago, and St Louis).

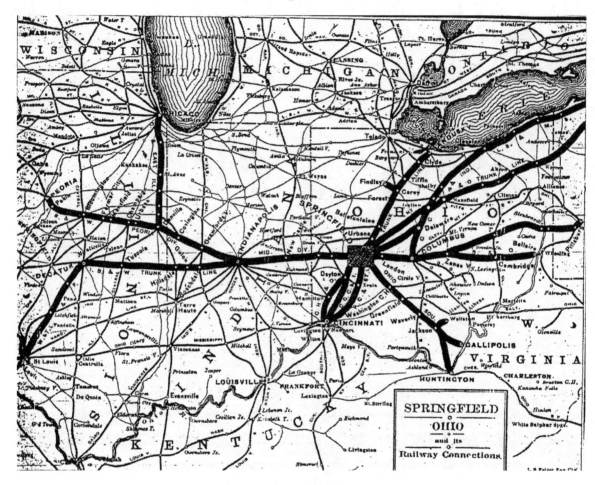

An 1880 overview of Springfield's network of rail lines.

Springfield at Mid-Century

The advent of railroads into Springfield brings us to the mid 19th century, a time when the federal censes showed Springfield's population had more than doubled from that of 1840 to 5,109. Accordingly the state legislature in March 1850 elevated Springfield from a "town" to a "city," provided the local voters approved, which they did two months later by a margin of 386 to 63. [7] In its first half century, Springfield had achieved two earlier governmental milestones. In 1818 a legislative act designated the early settlement as the county seat of the newly created Clark County, which in 1818 was created from Champaign, Madison, and Greene counties. A second change was the 1827 act of the legislature that incorporated Springfield as a "town." With this act, Springfield departed administratively from the township, also named Springfield. For its first

twenty-six years, the town had been governed by the township trustees, and its regulations were enforced by a justice of the peace and a constable elected by the entire township. Once a town, the legislature gave Springfield the authority to elect a Council of five members, from which a president was chosen who would be the ranking executive. Little is known of town government, for according to early historians, nearly all of the governmental records were lost.[8]

As a city, Springfield's record keeping would fare better. The 1850 legislative act included a charter, which of course negated the town government in favor of new governmental structure that mandated the election of a Mayor at two-year intervals, as well as six council members serving two years with the terms staggered. The charter specified that voters be white males and a resident of the city for six months. Significantly, the charter expanded the boundaries of the new city.

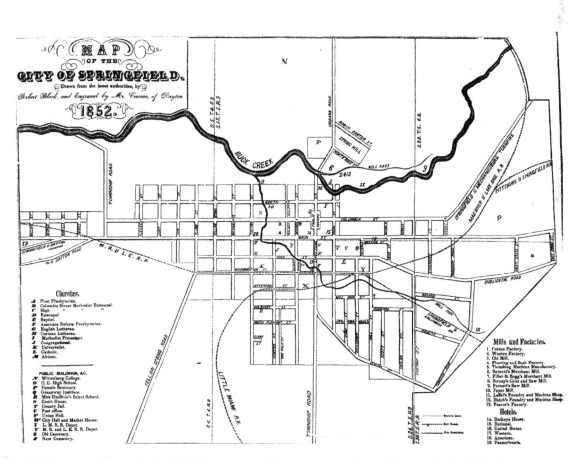

This 1852 map reflects Springfield's streets and its corporate boundary as defined by the state act of 1850. The line at the top or north is McCreight Avenue.

Helped by the National Road, the city's retail had continued to expand. By 1852 Springfield could boost seventeen mercantile stores, forty-three groceries, three drug stores, five hardware stores, four hat shops, three jewelers, three bakers among the enterprises. As Springfield became a city, banking made its appearance. The Mad River Valley Bank opened in January 1847 on the north side of Main Street between Market and Limestone streets. It would remain, though under a different structure, in downtown for over a century. About a half block away, the city's second bank, the Springfield Bank, opened in January 1851 near the intersection of Main and Limestone. It later became the First National Bank, and it too served downtown customers for over a century.

Since the early commercialism was confined to a small area, with many of the shops along Main Street, the new city would have a busy and viable appearance. Debarking train passengers at the south edge of the downtown added to the vitality of the shopping area. The father of the later industrialist, William Whiteley, recalled for an oral history project that upon residence in 1857, he found that Springfield had "grown to be quite a lively place." Furthermore, as demonstrated by the abundant retail, nearly all of which was locally and family owned, Springfield provided a fluid environment for employment. The experience of D.S. Morrow, another resident who told his story for an oral history project, provides an example of the mid-century opportunities for those with a modicum of ambition. Morrow came to Springfield in 1850, and got his start manufacturing cigars. When he and his partner had an ample supply, Morrow drove a two-horse wagon to surrounding towns selling cigars and tobacco. He did this for two years, then made a career change to producing linseed oil from locally grown flax seeds. He was still doing this some ten years later when the Civil War erupted, which created a large demand for his product followed by increasing profits.[9]

Of benefit to the city's downtown retail were the gas street lights that first appeared in 1849. Since 1825 Springfield streets had been lighted by oil lamps costing the town $25.00 each. In addition, an assessment of twelve cents was levied on the resident of each house for the oil and wick. When manufactured gas began to be produced by the Springfield Gas, Light, and Coke Company, gas lighting displaced the oil lamps, first lighting city offices, commercial stores, and downtown streets. Manufactured gas lighted the city until 1890 when cheaper natural gas was piped into Springfield.[10]

As of 1853, the city's real estate valuation was just under $700,000, of which $577,000 was levied on buildings. Nearly all of the built real estate at this time was located in the eastern part of Springfield, which encompassed the downtown. This part of the city was known through its first half century as "Sleepy Hollow, "as most people were white collar workers. The western part of the city, that is, west of Mill Run or today's Center Street, was known as "Old Virginia." Here many men where employed in physical labor, who had migrated from Virginia.

Churches

In modern times, Springfield in a religious context has been thought of as a Lutheran town. This opinion is no doubt due to the presence of the Lutheran established Wittenberg College. Enjoying a prominent, elevated physical setting complemented by tall buildings, the campus makes an imposing presence. As students and faculty grew spreading more buildings and facilities over the near northside, the college's influence grew in city affairs. At the same time, the number of Lutheran churches gradually increased. Thus, the Lutheran image was not without a physical basis. Ironically, however, it was not until forty years after Springfield's founding that a Lutheran church was built, and the Lutherans did not establish Wittenberg College until 1845. Other denominations did not wait so long.

Methodists & Presbyterians: The Methodist first began as a society in 1806, meeting in a private schoolhouse at Main and Market streets until 1814, when a small building was erected at North and Market, which served the congregation until 1833. In that year the Columbia Street Church was dedicated at Columbia and Market streets. Growth of the congregation necessitated a new church in 1851. Called the High Street Methodist Church, it was built on the north side of High just east of Spring Street. Although in a different building, the church remains at this location today.[11]

Following the Methodists by a few years, the First Presbyterians organized a small congregation in 1819, which met in private schoolhouses until 1828 when a small building was erected. By 1848, the congregation had completed a high spired church on the north side of Main Street at Fisher (the site of today's National Road Commons). Fifteen years later, the prosperous First Presbyterians built an imposing brick building at the same site. Lasting until 1928, the church featured a 175-foot peaked tower. Growth of the First Presbyterians led to the construction of

a Second Presbyterian Church in 1860 on the east side of Limestone Street between Main and High streets (More on the Presbyterians later).

Episcopalians & Bapists:Although without a building until 1844, the Episcopalians date their presence in Springfield from 1835. In November 1844, the first church building at the southwest corner of High and Limestone streets was consecrated by the Bishop (in the 20th century this was the early site of Wren's Department Store). The church served its parishioners at this building until 1874 when the new Christ Episcopal Church was completed on East High Street, nearly across the street from the earlier built Methodist Church. Christ church remains viable at the same location.

The Baptists appeared in Springfield the same year as did the Episcopalians—1835. Also in 1844, the Baptists began their church construction, diagonally across the High and Limestone intersection from the Episcopal church. Although the Baptists were able to hold services in the building prior to completion, it was not dedicated until February 1852. By 1882, the Baptists had abandoned the downtown site in favor of the upscale residential neighborhood of South Fountain, where at South Fountain Avenue and Miller Street, the congregation built a new church, which survived until 1977 when the building was replaced at the same site by a more modern structure.[12]

First Baptist Church at northeast corner of South Fountain and Miller. Built in early 1880s as the upscale Fountain Avenue housing area was developing. Demolished in mid 1970s for a new church building.

Lutherans: By the Spring of 1841, there were enough Lutherans in Springfield to organize a congregation. From the beginning, the congregation was called the English Lutheran Church in contrast to the German speaking churches in Pennsylvania. (When the Second Lutheran Church was built in the 1880s, English Lutheran then became the First Lutheran Church). Without a church building, the Lutherans like other early denominations met at various locations until 1844 when services ceased due to the resignation of the pastor. The following year Ezra Keller, a graduate of Gettysburg Seminary in Pennsylvania, who was serving as a missionary in Ohio and neighboring states, took the lead to re-organize the Springfield congregation. In March 1845,

the Board of Directors of Wittenberg College loaned the congregation money for the purchase of a building lot at the northeast corner of High and Factory streets. (Factory Street became Wittenberg Avenue in 1907).

Historically English Lutheran had a close relationship with Wittenberg College. Not only had the college provided the loan for the building lot, Ezra Keller served in the middle 1840s as both pastor of the church and president of the college. Moreover, as the college was without a building for its first six years, classes were held in the church basement.

By November 1845, the basement was completed, and then construction slowed. Martin in his 1881 history wrote that the church was built piecemeal and ". . . it was a long time before it was finished." In 1869 and 1870, the church was remodeled and expanded. The east and north walls were moved outward. The south wall, being the front of the church, was moved about twelve feet toward High Street, which explains why today the church lacks a front lawn. A finishing touch was the construction of a 160-foot bell tower and spire, which was destroyed by lighting in June 1873, and not rebuilt until 1883. The renovations had allowed for a seating capacity of 750.[13]

The German speaking Lutherans organized in 1845, holding services in the courthouse and private homes until the congregation completed a two-story brick building at the southwest corner of North and Factory streets, just three blocks north of English Lutheran. Known as St John's Lutheran, the initial building served a half century until the present Gothic church building was completed at the same site in April 1897.

Catholics: Relative to the Protestants, the Catholics were late arriving in Clark County, for prior to 1830 there were no Catholics in the county. In the late 1830s small numbers began to settle in Springfield, and in the 1840s, German and Irish Catholics swelled their number in the town, leading to masses being held by a visiting priest from Dayton. In 1848 ground on East High Street just east of Spring Street was purchased, and in 1850 a church was completed. It was dedicated in December of that year as St. Raphael the Archangle. Although this church was a moderately large, two-story building, 40 x 125 feet and seating 700, it would later be too small for the growing parish, and in 1898, the present St Raphael Church was completed.

Schools

There had been education of the youth since shortly after the founding of Springfield. However, the early schools were an ad hoc affair formed by interested citizens without the benefit of public funds. Rarely was there a formal school building in the early years. A notable exception was a private high school for boys built in 1835 on East High Street. It survived under various private auspices until 1869 when the building was leased to the public established Board of Education.

The female answer to the boys private high school was the Springfield Female Seminary. After several years of holding classes for girls in the basement of the First Presbyterian Church, funds were raised for the construction of the Female Seminary on the north side of Buck Creek just west of Limestone Street (the site of James Demint's log house). Classes began in the new building in 1852, and though stressed by financial problems, the school survived until 1871, when it was purchased by the Board of Education, and became Northern Elementary School.

Public Funded Schools: Formal public schools in Springfield date from the 1850 city charter that gave the new City Council control of common schools, including the authority to levy a tax for the erection and support of schools, and further to select citizens for a board of managers for the schools. In 1855, two elementary schools were completed, an East School on High Street east of Spring Street and West School on Main Street near Yellow Springs Street. Also in 1855, the appointed board of managers gave way to an elected Board of Education. By the end of the decade, the Board had constructed two more elementary schools and two secondary schools. These schools were for white children only, as Springfield continued with its practice of segregated schools. Inasmuch as public schools across the state were segregated, the Ohio legislature in 1848 mandated that local authorities construct schools for colored children. In the late 1850s, the city's first public colored school opened on Pleasant Street near Center Street.[14]

Lyceum: What we know today as adult education was in the 19th century called a lyceum or literary society. In 1830, several Springfield residents organized such a society, complete with a constitution and bylaws. At early meetings in the Presbyterian Church, authorities on various subjects were invited to lecture. Discussion and debates on various topics became the format of many lyceum meetings. The society functioned under its original mandate until 1849 when it was re-organized. By that time, the lyceum had its own reading room and library, and was

subscribing to several newspapers from many parts of the country. A prominent visiting lecturer in 1899 was the newspaper editor and owner, Horace Greeley.[15]

Wittenberg College: The college can trace its roots to the 1836 founding of an English language synod in Pennsylvania that provided a board of directors with $1,500 to establish a Lutheran college in the west for the education prospective ministers. The board by Spring 1844 opened a new institution in Wooster, Ohio, called the Theological and Literary Institution (no state charter was obtained). But Gettysburg Seminary graduate, Ezra Keller, who would become Wittenberg's first president, favored a location farther west, resulting in Xenia and Springfield making bids. Springfield's bid of $4,667 and a choice of two locations was accepted. An eight-acre plat east of town was offered by owner, Jeremiah Warder, but the board chose a seventeen-acre site north of Buck Creek, west of Limestone Street, owned then by the Woodside Cemetery Association. No time was wasted obtaining a state charter, formally naming the institution, Wittenberg College, a name already in use by the synod and by Keller.

Classes began in November 1845 with seven male students having enrolled. As we have seen, classes for the first six years were held at the English Lutheran Church. From the beginning, the college's educational aim went beyond preparing students for the ministry. The curriculum was classical in the mold of eastern colleges, supplemented soon by science courses, the general purpose being the preparation of graduates for leadership in the society and state.

By 1851, the college's first building, later called Myers Hall, was ready for use, and has been in use since that time. It was located at the top of a hill, facing south, looking toward downtown. Ezra Keller, however, did not live to see it completed. Appointed President in mid 1846, he died of typhoid fever in December 1848 at age thirty-six.

In September 1851, Wittenberg graduated its first class, the commencement being held at City Hall on Market Street. All nine graduates were white and male, and four became ministers. Although the college's outlook was anti-slavery, and its admissions policy did not formally deny the admission of women and blacks, Wittenberg nevertheless was not founded with the liberality of Oberlin College in northern Ohio, which from its opening in 1835 admitted both women and blacks. Wittenberg would remain an all white and male preserve for nearly three decades after its founding.[16]

Newspapers

At 1850 the reigning newspaper was the weekly Republic. Its lineage can be traced to Springfield's first newspaper, the Farmer founded in 1817, which became the Farmer Advocate in 1821, evolving into the Western Pioneer by 1825. This name persisted until 1836 when the name was shorted to Pioneer. In the 1840s, the Republic was born. Along the way there were at least two short-lived newspapers controlled by political parties. One of these political organs had during the 1840s progressed into a bona fide newspaper, first known as the Union Democrat. Under various owners, it survived until 1905 when then as the Daily Democrat, it consolidated with the Press Republic to form the Daily News.

In its first fifty years, Springfield had made steady progress in industry, commerce, transportation, and education, but city still had a rough, western edge. Springfield did not in 1850 have a water works that would guarantee safe water for its residents. This was still about thirty years away. Instead residents obtained water from unregulated, dug wells, some water being stored in unclean cisterns. Although there was little in the way of ordinances and regulations governing health sanitation, the cholera scare that swept through many American cities in 1832 resulting in hundreds of deaths drove Springfield authorities and citizens into taking preventive action. At a town meeting, committees were formed in four sections of town to lead the effort in cleaning all streets and alleys of filth and debris. This activity was effective, as the cholera was blocked to the extent that no Springfield resident died. In nearby New Carlisle on the western side of the county, thirty-three of its residents had died. But in May 1849, the cholera returned and this time Springfield was not so lucky. The epidemic lasted two weeks, resulting in seventy-five deaths and the closing of many businesses.

Industrial Growth

Following the snapshot of Springfield at mid 19th century, we can now approach what proved to be a giant step in city's industrial development. As Springfield's railroads were growing into an efficient network connected to national markets, the city was entering a far different manufacturing age than the one driven by the water power of Buck Creek and Mill Run that had provided the early 19th century town with its grist and many other mills. From about the mid 19th century, Springfield's industry evolved into the production of iron and steel products that would require new and larger factories driven by steam and coal and later in the century by electricity. The transition, however, from water to coal power did not immediately displace the early mills. Benjamin Prince wrote in his history that there were still seventeen flouring mills in and around Springfield in 1856,[1] but the downward trend was clear, for by 1868 only five such mills remained.

When Springfield became powered by steam, its most dominant product became agricultural implements, a not surprising development given Ohio and the country's copious acres of rich farmland, plowed by a growing army of farmers. The Springfield area in the 1860s and 1870s would have in total as many as fifteen to twenty farm machinery manufacturers, but like the 20th century automobile industry, there was a Big Three. First in time was Warder and Brokaw (later to become Warder, Bushnell, and Glessner). A few years later Whiteley, Fassler, and Kelly was formed, and in another decade the Champion Machine Company would round out the dominant three companies. Led by these manufacturers, Springfield beginning in the late 1860s became for the next two decades a leading national player in the agricultural implements industry.

Warder and Brokaw

On an organized basis, Springfield's beginning as a primer farm implement manufacturing center began in 1850 when the partnership of Benjamin H. Warder and John W. Brokaw was formed. Brokaw, an attorney, originally from Rochester, New York, left the firm after a decade for the Union Army. Warder, age 26 in 1850, would go on to become one of the city's wealthiest

and most respected industrialists, and would also be known as a philanthropist and patron of the arts. He was the son of Jeremiah Warder, who came to Springfield in 1830 to assume control of his father's large land holdings acquired by a Revolutionary War land patent. Shortly after his arrival, Jeremiah purchased the village of Laconda, about two miles east of downtown along Buck Creek. Laconda had gotten its start in 1806 when Simon Kenton had established a grist mill along the creek. Kenton left the area six years later to join the American forces in the War of 1812. By the time Warder made his purchase, other settlers had built a saw mill and a woolen factory, all of which became part of the Warder purchase. (The Laconda area would some half century later be annexed by Springfield, and could then be located where Laconda Street and Belmont Avenue intersected near Buck Creek).

In the mid 1840s, Benjamin was helping his father operate the mills, and when Jeremiah died in 1849, young Benjamin seeing a future in farm machinery took on Brokaw as a partner. The new firm began the manufacture of mowers, the New York reaper, the Marsh harvester, and other farm implements. By the mid 1850s, the partners were selling 200 to 300 products annually.[2] During the decade, the Warder firm became one of Springfield's early companies to make the transition from water to steam power. The transition was timely in that it coincided with the much needed rail transportation. As the Warder partnership was getting underway, both the Mad River Railroad and the Springfield and Pittsburgh line had tracks to Laconda with a spur line to the factory yards. The company, also known as the Laconda Agricultural Works would continue production with considerable expansion at its Laconda site until it became fifty-two years later one of the five companies that would merge to form International Harvester.

The success of the Warder partnership was clear by the 1880s. In that decade the firm expanded its works by the construction of a 5,100 square-foot office building, a 518 x 60 foot production building, a 4,500 square-foot boiler building, and by the construction of two warehouses, each 300 x 60 feet.[3]

Over its half-century life as an independent company, senior partners came and departed. After Warder and Brokaw teamed up, J.C. Childs joined the partnership—the company then known as Warder, Brokaw, and Childs. Brokaw, however, was killed in the Civil War, and in 1866, Childs made other investments and moved east. Ross Mitchell had become employed as the firm's bookkeeper, and in the year Childs left, Warder offered Mitchell a one-third interest in the company for $10,000, which he accepted when Warder agreed to finance $6,000 of the

price. The firm then became Warder, Mitchell, and Company. Asa Bushnell had joined Warder as a junior partner in 1866, and John Glessner had come aboard in 1868, also as a junior partner. When Mitchell left the company in 1881, both Bushnell and Glessner were given senior status, and the company forever became Warder, Bushnell, and Glessner. (Even though Warder died in 1894 his name was retained).

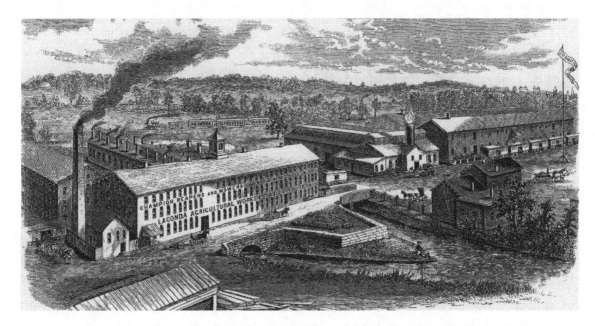

Laconda works of Warder, Bushnell, and Glessner in late 1870s.

Warder partners—Mitchell, Bushnell, and Glessner: We have touched on Benjamin Warder's success and his impact on Springfield. His financial success obviously meant that wealth would accrue to his senior partners. As Prince wrote: "Mr. Warder was a financial wizard, and all associated with him accumulated property"[4] and added that Mitchell, Bushnell, and Glessner "accumulated fortunes." When Mitchell resigned from the firm in 1881 after sixteen years, he continued at age 57 to invest his wealth in real estate. About a year after retiring, he constructed the five-story Mitchell Building at the northwest corner of High and Limestone streets. The building served as the home of many businesses for nearly a century, until it was demolished in the mid 1970s. After completing the 1882 building, Mitchell helped finance the Shuey Building at Jefferson and Center streets. He also held considerable properties in the affluent East High residential district. After residing for many years on Belmont Avenue near Laconda, Mitchell built a second home for him and his wife at 302 East High Street. The house is still extant. Of some $50,000 given by Springfield residents for the construction of Wittenberg's Recitation Hall in 1883, Mitchell was the largest donor, while also heading the fund drive. One of his last philanthropic endeavors was

his combined gift with John Thomas of $100,000 for the construction of the city's first hospital opening in 1894 along East Main Street.

Bushnell: Asa Bushnell's wealth was also accumulated as Warder partner and later company President. Born in New York in 1834, his residence in Springfield began in 1850, working for the wealthy druggist, Dr. John Ludlow, whose daughter he married. In 1857 Bushnell took a position with Warder, but shortly resigned to become a partner with Ludlow. By 1866 he had an opportunity to return to Warder as a junior partner. The company was incorporated in 1867, and after Mitchell retired and Warder became less active, Bushnell became company President in 1886. His business success with Warder gained him positions as President of the First National Bank, as well as President of the Springfield Gas Company. In this age it was common for prominent businessmen to hold such duel offices. The Ohio Republican Party had had its eye on Bushnell since the late 1880s, several times offering him its nomination for high office. Finally, he accepted the gubernatorial nomination in 1895. Bushnell served two terms as Ohio Governor, spanning the years from 1896 to 1900. (more on Busnell's residency later).

Glessner: John J. Glessner became that last full partner of Warder. Although most of his working career was spent with the Springfield company, he spent very little time in the city, having been assigned to Chicago in 1868, where he headed the firm's sales office. He was still in charge of the Chicago office in 1902 when Warder was absorbed into International Harvester. Glessner then became a Vice-President of International Harvester. In the mid 1880s, Glessner used part of his fortune to build a stone mansion on Chicago's Prairie Avenue, one of the city's most wealthy areas, just south of the downtown. At his death at age 93 in 1936, Glessner left his house and contents to the American Institute of Architects.[5]

Whiteley's Appearance

Warder, Bushnell, and Glessner's success had come on the shoulders of inventors whose farm machine patents had expired, allowing Warder and others to manufacture previously invented products. A more original Springfield manufacturer of farm machinery was William N. Whiteley, whose career began a few years after the Warder partnership began. A precocious inventor, Whiteley was in his early twenties when he patented the first of his many inventions, the field mower. This was followed in 1856 by his invention of the Combined Self Raking Reaper and Mower. Whiteley's early inventions were, however, well behind the first patented

reaper—this being Cyrus McCormick's 1831 reaper, of which his large commercial manufacture of it in the 1840s and beyond in Chicago became an American success story. Although Whiteley's initial success was at least a decade behind that of McCormick, he and his partners would build a farm machinery empire that for a brief period surpassed the McCormick Chicago works and established Springfield as the country's leading manufacturing center of agricultural implements. As a businessman, Whiteley excelled as an inventor, a promoter, and a driving force with boundless energy, but he would always lack appreciation for the accounting side of business. As researcher, James Frankart wrote, he was a poor financial man who "needed a strong guiding hand in matters of money and business."[6] His carelessness with financial matters would later bring him down, but for the next three decades Whiteley would be national force in the production of agricultural machinery.

Whiteley's first partner was James Fessler, who like Whiteley was mechanically gifted, but had little capital to bring to the business. Yet in 1856 they had established themselves in a shop on South Limestone Street near the railroad tracks, and in the first year the partners built twenty reapers of their own design and sold all of them. (By way of comparison, McCormick in 1849 completed his first business year at his factory along the Chicago River. Employing 123 workers, McCormick manufactured over 500 reapers, selling nearly all of them. He then built a new plant in 1851 that the local press called the largest of its kind—three stories, 40 x 190 feet, powered by a thirty horsepower steam engine).[7]

The poorly financed partnership of Whiteley and Fassler became financially secured by Oliver S. Kelly, a Clark County native, who in his early thirties returned to Springfield in 1857 after a successful few years building houses in California. Kelly contributed $5,000 to the new partnership of Whiteley, Fassler, and Kelly. At about the same time, Whiteley's brother Amos signed on as manager of finances. The partners worked well together, and between 1859 and 1863 moved to the northeast corner of Market and Washington streets, facing the railroad tracks where a new shop was constructed. The three-story brick building with thirty-one bays facing Market Street initially extended north about half way to High Street. On the east side of the building, foundry areas were built. Between 1870 and 1875, the partners extended the building to High Street. At the corner of High and Market, a four-story office was constructed and attached to the earlier section.

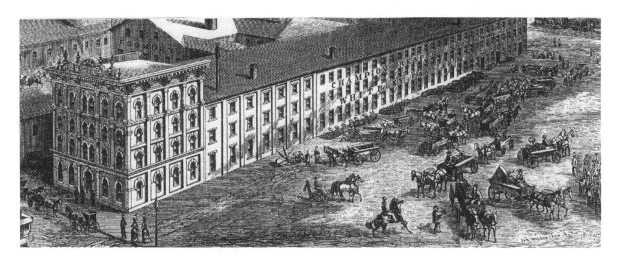

The works of Whiteley, Fassler, and Kelly. The four-story section faces High Street, while the length of the building runs along Market Street. The open area with horses is the site of the later Fountain Square.

While turning out farm machinery, Whiteley's duties centered on the perfection of the reaper, Fassler ran the machine shop, and Kelly handled the assembly and painting of the products. Whiteley at this time began to call the reapers and other machinery the "Champion "products. Later when the business expanded with more factories, the entire complex was called the Champion Works. The 1850s had proved to be a favorable time to gain a footing in farm machinery manufacturing, for when the Civil War began in 1861, the need for reapers and other machinery grew rapidly, as many younger farmers had left the fields for the Union Army, and labor saving machinery became prized by farmers with limited field hands.

As farm prosperity continued into the post war period, competition between Whiteley and the Warder partners became intense. In the aftermath of field trials that had demonstrated the superiority of the Champion reaper and other Champion products, Warder concluded that he could improve his company's fortunes by paying a royalty to Whiteley for the right to manufacture the Champion machinery. Should this be done, it would mean that Warder would cease production of all his former machinery and exclusively manufacture Champion products. The deal was concluded in 1867, and in the same year Whiteley created another Champion company, known as the Champion Machine Company. Incorporated with Amos Whiteley as President, it would be located at Gallagher and Monroe streets along the rail line, just about four of five blocks southeast of the Whiteley works at Market Street. This company with a new building and the latest production equipment soon became the third major player among Springfield's farm implement manufacturers.

These three entities, all with separate management nevertheless were united in the exclusive manufacturing of the Champion products. They all built from the same patterns, allowing parts to be shipped between the three factory works as needed. Cooperation between the three factories also extended to sales territories, and accordingly the national market was divided. Warder would sell in the north and northeast, Whiteley in the east, and Amos' Champion Works covered the south and southwest. This division gave Warder and his partners the Chicago and Illinois market, and thus Glessner would remain in Chicago to lead the sales effort in McCormick's backyard.

The McCormick empire in Chicago, having no part of a geographic sales division, continued to sell nationally, and through the 1860s outperformed all of Springfield's farm machinery companies, as the following U.S. manufacturing census figures shows.

	Springfield		McCormick	
	# workers	product value	# workers	product value
1860	132	$229,471	294	$ 529,000
1870	750	$1,494,190	734	$ 2,081,000

(The above figures include a total of eight farm implement manufacturers in Springfield)

During the 1870s, Springfield's Champion interests surged ahead of McCormick in sales and product value, but the lead was due entirely to the loss of the McCormick physical plant in the great Chicago fire of October 8, 1871, in which the city lost over 17,000 residences and over $200 million in property value. McCormick's reaper factory and most of his other buildings were destroyed. After the insurance settlement, McCormick's loss still came to about $ 600,000.[8]

Whiteley expands

As McCormick was rebuilding his destroyed works, Whiteley driven as ever, was expanding his Champion interests in order to produce an even larger number of machines. In 1874, working in the interest of all three Champion companies, Whiteley began to create two adjunct companies, which would produce supplies for all three manufacturing companies, allowing them to more rapidly assemble reapers and other machinery. First to open was the Champion Malleable Iron Company, which would produce cast iron. This worked well, for by the mid 1870s, the company was annually shipping about 3,000 tons of iron to the manufacturing companies.

The second adjunct firm, also on line by the mid 1870s, was called the Champion Bar and Knife Company, and it would supply rivets, nuts, washers, knifes, and chains for the efficient assembly of the farm implements. Both plants were built anew at Monroe and Linden streets, near Amos' Champion Manufacturing Company. These companies built along the rail line had efficient connections to Warden's Laconda works.

In order to secure a dependable supply of coal, iron, and timber, Whiteley separate from his partners purchased in late 1879 a railroad, called the Springfield, Jackson, and Pomeroy. The line extended about 160 miles to Ohio's southeastern coal and iron fields, principally in Jackson County. Renamed by Whiteley the Southern Railroad Company, it was of benefit to the Champion companies, but it never became profitable, and Whiteley sold the line to an Indianapolis company. Some solace was taken in that the railroad remained a part of the Springfield network[9]

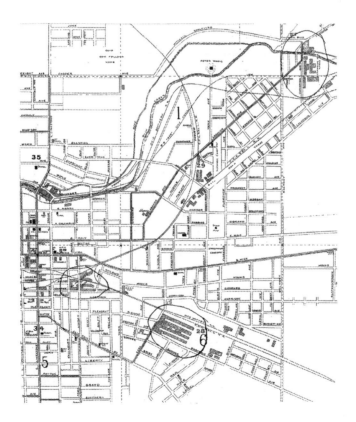

This 1894 map indicates the location of the East End Shops (circle at right). The left circle indicates the site of the Champion Machine Company, Bar and Knife and Malleable Iron companies. At upper right is Warder's Laconda works, all part of Whiteley's Champion empire.

Whiteley's expansion of his Champion empire during the 1870s had resulted in a striking production increase during the decade. The 1880 census of manufacturing showed a fourfold increase in product value over that of 1870. Where 1870's product value was $1.5 million, the corresponding 1880 figure was $5.7 million. However, by the latter part of the 1870s, McCormick was making a rapid recovery from his fire devastated works. He had purchased an additional 127 acres along the Chicago River and was building an ever larger manufacturing capacity. Yet in the Whiteley versus McCormack horserace, the effects of the Chicago fire was too much to overcome, as the 1880 U.S. manufacturing census showed a significant Whiteley and Springfield lead over McCormick

	# Workers	Product value
Springfield	2379	$ 5,738,382
McCormick	1021	$ 2,699,480

These figures were often used by Springfield boosters as a basis to assert that the Whiteley empire was a national leader in farm implement production. But the important point to make is that by 1880 McCormick had fully recovered from the fire, and his production was trending sharply upward. In spite of the fact that the fire had caused a shutdown of McCormick's production facilities in the early 1870s, he had by 1880 actually produced nearly $ 700,000 more in product value than he had in 1870 (see comparative figures above). By 1882, according to McCormick's figures, he was beginning to out produce the Whiteley empire. This trend was of course not lost on a man Whiteley's driving and competitive nature.

The East Street Shops

Whiteley's answer in order to maintain his market share was to expand production by building more manufacturing capacity. He proposed to leave the downtown area of High, Market, and Washington streets and build entirely new works in the southeast section of Springfield. This was the origin of the legendary East Street Shops that would be built on a large swath of land Whiteley had owned since 1867 that extended from East Street about a half mile east along the later Big Four owned railroad tracks.

The ambitious construction plan resulted in the breakup of the twenty-five partnership with Jerome Fessler, and Oliver Kelly, neither of whom favored such a large investment. Whiteley moved ahead on his own. Encompassed in the East Street Shops were plans for new machine designs, the transition from wood to all steel as a raw material, and completion of Whiteley's invention of the All Steel Binder and Mower. Whiteley began construction of his new works during the Winter of 1881-82. His singular drive was expressed by Prince: "While Whiteley had ambition, . . . he did not wait the time or season . . . Salamanders were used to prevent walls from freezing. He did not figure the expense, and they say he lived in the future." Of his impulsive nature in his drive to complete the East Street Shops, Herbert Casson, author of the 1908 book, Romance of the Reaper, wrote: "As the millions came pouring in so fast Whiteley's head was turned and he began to run amock."[10]

On an investment of $1.5 million, Whiteley's shops consumed about a million square feet over nearly fifty acres. This would be the largest construction project in Springfield history and when completed in the Spring of 1882, the works consisted of:

a. A six-story main building fronting 60 feet on East Street and extending 600 feet along the railroad tracks. To this building, five wings were attached: three wings were each 550 x 60 feet, and four stories high with a basement and attic. A fourth wing measured 200 x 60 feet, four stories high

b. Between the second and third wings was a boiler and engine room measuring 112 x 96 feet, containing six steam engines totaling 900 horsepower. There was also ample acreage for storage and warehousing.[11]

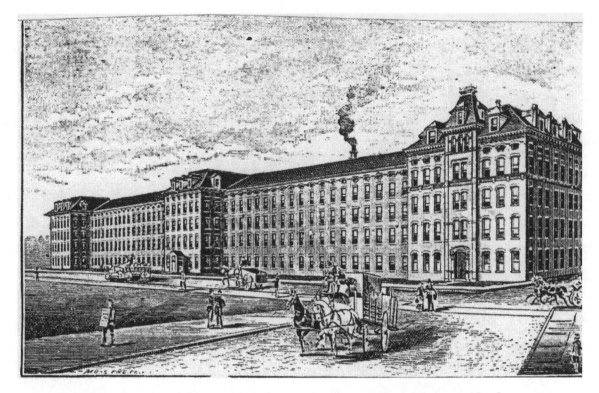

Henry Howe's drawing of the East End Shops. Closed in 1887 and destroyed by fire in 1902.

When up and running, a work force of 2,000 men was able to manufacture over 600 machines per day or about 100,000 annually. As the East Street Shops opened, Whiteley in order to carry out the transition from wood to steel, created the Whiteley Steel Corporation, and steel formations were soon rolling off the line. By 1884, the value of machinery produced in the shops came to about $ 4,000,000, and the production of the All Steel Binder and Mower was well underway. It appeared that Whiteley's investment in the new and larger facilities would pay off.[12]

Crash and Aftermath

It will never be known how the East Street Shops would have worked out over the long term, for in June 1887 due to an unrelated business event, Whiteley lost his new manufacturing works, and 2,000 men were suddenly unemployed. Briefly the story of Whiteley dramatic fall began with his relationship with E.C. Harper, a Vice-President of the Fidelity National Bank in Cincinnati where Whiteley deposited company funds. Whiteley and Harper had signed notes with each other, making each liable for the other's investments. Harper then made a speculative

bid on the Chicago Futures Exchange in an attempt to corner the wheat market. When the prices turned against Harper, he lost four million dollars of borrowed money. Whiteley was liable for the loan, and the creditors pounced, forcing Whiteley who lacked ready funds to file for bankruptcy and cease production of the East Street Shops.

Casson writing of the event in <u>Romance of the Reaper</u> shed some light on Whiteley's business character.

Whiteley lost millions in the crash—and with comparative indifference. It was never the profits he fought for. At heart he was a sportsman rather than a money-maker. He craved the excitement of the race itself more than the prizes. To win—that was the ambition of his life. And he did not shrink from spectacular methods to accomplish his ambition.[13]

Though Whiteley lost a fortune in his 1887 industrial collapse, he did not lose his entrepreneur drive. He first went to Muncie, Indiana, where in the late 1880s he built a factory, but it was destroyed by fire in 1894. Back in Springfield, he built with farmer backing a factory, called the Cooperative Reaper Factory, but it was unsuccessful. He then created the Whiteley Machine Company in an attempt to manufacture farm machinery, but the venture also failed. Whiteley never again came close to his former business glory. He died in 1911 without even funds to cover his medical bills.

Whiteley former partners, Jerome Fassler and Oliver Kelly, however fared much better than Whitely after the breakup of the partnership, as both enjoyed successful second careers. Fessler left Springfield for New York City where he became involved in the planning and design of the city's subway system. Kelly remained in Springfield and within a year after leaving the partnership, he purchased the Springfield Engine and Thresher Company, turning it into a long and successful enterprise as the O.S. Kelly Company. In addition, when Whiteley departed the downtown, Kelly purchased from his former partner the Champion factory at High and Market streets, and turned the $ 100,000 investment into one of the city's most historic and dominant commercial enterprises. (More on Kelly's second career later).

As to the East Street Shops, the entire complex was sold in late 1891 to Charles Fairbanks of Indianapolis for $ 200,000. The shops were then divided and leased to various industries.

Farm implements after Whiteley

Since the Whiteley empire was such a dominant player within Springfield's farm implement sector, the fall of the East Street Shops meant that the local sector would never again be a national force. Yet the Whiteley collapse was not the entire reason for Springfield's relative national decline. Nationwide trends dating from the 1870s had been working against Springfield and other Ohio farm machinery manufacturers. Large scale agriculture had been moving west to the large states of Illinois, Kansas, and Nebraska. This changing economic geography supported by Chicago's superb railroad network had put the McCormick works and the growing Illinois based John Deere Company in a commanding position over Ohio manufacturers as each competed for the large, western agricultural market. The following federal manufacturing statistics show the increasing dominance of Chicago in the product value of farm machinery.

Product Value

	1890	1900
Springfield	$ 5,221,008	$ 5,272,636
Chicago $	11,883,976	$ 24,848,649

Thus Chicago from doubling the product value of farm machinery over Springfield in 1890, had by 1900 a nearly fivefold product value lead over Springfield.

Apart from the national picture, Springfield's farm machinery sector was far from dead, largely because Warder, Bushnell, and Glessner remained very much alive. The sector would continue to play a significant role in the local economy. The figures above show that in both 1890 and 1900, the city's value of farm implements produced was a moderately respectful $ 5.2 million, which came from the following nine companies:

Warder, Bushnell, and Glessne Began	1850
P.P. Mast & Co	1856
O.S Kelly Co	1842
Mast, Foos & Co	1875

Thomas Manufacturing Co	1873
Superior Drill Co	1867
A.C. Evans Mgf. Co	1873
Foos Manufacturing Co	1883
E.W. Ross Co	1860

The largest of these companies was Warder, Bushnell, and Glessner, which after the East Street Shops closed, purchased the Champion production rights and continued manufacturing at its sizable works in Laconda. Collectively the above nine companies employed just over 3,000 workers in 1890, about half of whom worked at the Warder plant By 1900, the work force had been reduced to about 2,300, but the product value, as we saw, was maintained.

Did Springfield Suffer?

After the Whiteley crash, the slogan "Whiteley both made and broke Springfield" was repeated and passed on by Springfield historian, Prince in his 1922 history. This belief persisted well into the future. In a 1937 lookback article the Daily News painted a dire economic picture of Springfield in the aftermath of the fall of the East Street Shops. In part the article stated:

> Then in 1887 came the financial crash of the great East Street Shops With this failure many other firms went bankrupt and thousands of Springfield wage earners lost their jobs.
>
> The cessation of the East Street Shops booming whistle affected the butcher, baker, and banker. The heavy loans previously negotiated by the Whiteley firm helped to bring about a crisis which marked in red all merchantile accounts and threatened ruin to the whole financial fabric of Springfield. [14]

Reading such a gloomy assessment of the Springfield economy, one might get the impression that the city in the 1880s was a one industry town. In fact the city and county were highly diversified in the latter 19th century, and diversification would continue well into the 20th century. More to the point, the newspaper's assessment of the aftermath fails to square with the federal manufacturing statistics for the rest of the century. In 1890, three years after the crash, the manufacturing product value for all sectors of the Springfield economy exceeded that of 1880,

and by 1900, the total product value exceeded that of 1890. Thus, continued growth was the pattern after the East Street Shops closed. The exact figures from the U.S. census are.

	1880	1890	1900
Total product value	$ 8,462,443	$ 10,760,965	$ 12,777,173
# of workers	3,788	6,693	6,615

Although there was a steady climb in product value, the local workforce did decrease by 78 after 1890, but this is a small number compared to the 2,000 men who lost their jobs when the East Street Shops closed. In this period, Springfield's economy continued to grow, allowing Whiteley's unemployed to find work in the city's ample industries.

If Springfield's economy took a severe hit, one would not expect in the wake of the Whiteley crash to see an increase in the number of corporations. Yet in fact the number of corporations continued to increase, a fact that would indicate a still viable job market. The Springfield City Directory shows the number of corporations in the immediate years after the crash.

Year	# of Corporations
1887	43
1888-89	51
1890	59

The growth of product value, the increased number of corporations, and expanding population illustrate that the slogan "Whiteley broke Springfield "was an exaggeration, with little substance.

Other Industrial Giants

James Leffel: In addition to Benjamin Warder and Whiteley, and their partners, Springfield could point to many other industrialists who left a lasting mark on the city's business history, principally in the post Civil War period. Prior to the 20th century, it was an age when an individual alone or with one or two partners could create commanding industrial firms. One of the first such individuals was James Leffel, who we met earlier in connection with his Buck Creek foundry and

the mill race. However, Leffel's enduring legacy was his invention of the double turbine water wheel, which led to his long established manufacturing firm. Leffel began work on his invention in the 1850s while still operating his foundry. In brief the invention was a horizontal pump that was able to produce a greater and more efficient amount of water power. By 1862, Leffel had secured a patent on the water wheel, and in that year the James Leffel and Company was organized as a partnership consisting of Leffel, William Foos, and John W. Bookwalter, all with equal shares. Foos, President of the Second National Bank, provided much of the financing, while Bookwalter served as head of sales. Before the end of 1862, the new company had purchased a building on the northwest corner of Limestone and Washington streets.

Leffel died in 1866, but by this time his inventive work on the water wheel was complete, and his partners, along with Leffel's widow were able to successfully run the company, soon adding boiler production to the company line. Foos left the partnership in 1878, leaving most operations to Bookwalter, who in the early 1880s moved the company to Laconda Avenue, near the railroad crossing. This move resulted in larger works with additional buildings. In 1890, the company now with about 200 employees, was incorporated with Bookwalter as President who continued to increase the product line to include steam engines, couplings, and pulleys. Bookwalter remained as President until 1917, and died the following year. Beginning in the early 1920s, the company continued for many decades doing business from its facilities at East Street.

Phineas P. Mast: Mast's business career spanned over forty years—from 1856 when he came to Springfield from Urbana until his death in 1898 at age 73. In his initial year in Springfield, Mast, just 31 year old and John Thomas, age 30, formed the agricultural implement company of Thomas and Mast, locating it at North Limestone and Warder streets, and using the water power of Buck Creek. One of their first products was cider mills, having in their first year purchased the patent rights from the inventor. Other products included plows, harrows, and rakes. In the early years, Mast took on sales duties, which included loading a wagon with rakes and travelling the rural roads until he sold the entire load.

The successful partnership ceased in 1871, when Thomas left in order to form his own farm implement manufacturing company. Mast then incorporated the company as the P.P. Mast and Company. During the 1870s, Mast secured a number of patent rights, which allowed him to manufacture the Buckeye Grain Drill, as well a cultivators, and corn plows. The growth of the company in the 1870s necessitated the purchase of property east of the plant over to Water Street.

Here Mast built 400-foot long, three story manufacturing building and a large warehouse, as well as laying out space for lumber years. The expansion of the works allowed Mast to employ over 500 workers by the mid 1880s. By this time, Mast had made contributions to I.B.W. railroad for a spur line to his factory site.

The enterprising Mast also had other interests. In 1869, he and other investors created the Citizens Street Railway Company. The mule and horse pulled cars ran along High Street to the west side in an attempt to encourage the wealthy to develop this area. Such transportation also may have been behind Mast and John Foos formation of the Mast, Foos, and Company, which they located on the west side. (Both Mast and Foos gave up control of this Company when it was incorporated in 1880).

Along with his industrial interests, Mast also served as President of the Springfield National Bank. His principal interest, however, continued to be the P.P. Mast and Company. In order to help sell his products, he agreed with encouragement from others to establish in 1877 the publication, <u>Farm and Fireside.</u> This trade magazine would after Mast's death develop into one of Springfield's greatest corporations. (More on this later).

Unlike many industrial firms that that survived long the founders death, such as James Leffel and Company and Robbins and Myers, the P.P. Mast and Company did not endure long after Mast's death in 1898. The company soon went into receivership, and in 1905 was absorbed by the American Seeding Machine Company.

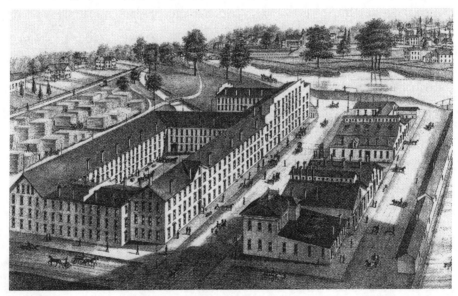

P.P. Mast & Company works. Located north side of Buck Creek and east of Limestone Street. View looks across the creek to the downtown.

Oliver S. Kelly: After Kelly ended his nearly quarter century relationship as a partner in Whiteley's Champion empire in 1881, his impact on Springfield's business and political history was far from over. Hitting the ground running after leaving Whiteley, Kelly soon purchased the Springfield Engine and Trusher Company, located along Limestone Street on the south bank of Buck Creek. Within two years, Kelly had added 25,000 square feet to the existing 120,000 square feet of floor space, and by 1884 employed about 250 men, and had sales between $ 800,000 and one million dollars annually. In 1890, the company was renamed the "O.S. Kelly Company."

In addition to presiding over a manufacturing company, Kelly had another project in mind. When Whiteley moved his operations to East Street, Kelly purchased the downtown factory at High and Market streets and re-developed the site into the Springfield Arcade and Hotel. Opening in 1883, the Arcade, as it came to be called, soon became a centerpiece of the downtown's growing commercialism. (More on the Arcade later).

Years earlier, Kelly had been bitten by the political bug, and had served from 1863 to 1869 on the Springfield City Council. Still interested in government, Kelly found time amid his business interest to serve as the city's Mayor during 1887 and 1888, and played a significant role in the planning for the 1890 City Building.

At his death in 1904, Kelly's son Oliver Warren Kelly, assumed control of the company until 1916, when Oliver's son, Armin took over. In 1950, Oliver Warren's son-in-law, Cart Utes, bought the company, and as of the late 1960s, he and his son Carl Jr.controlled the company. By this time, the company had long ceased the production of farm machinery in order to manufacture piano plates. In the 1970s, the O.S Kelly Company moved from Limestone Street to the northwest corner of North and Spring streets, where it still produces piano plates.

The Foos Family: The Foos Family has had a long lineage in Springfield business history, beginning with Griffin Foos, who we have seen opened Springfield's first tavern in 1801 and established an oil mill on Mill Run in 1817. A few decades later, his three nephews would leave their mark on the city. Brothers William, born 1814 and Gustavus, born 1818, partnered in several business projects. In 1848 they purchased a track of land along East High Street and platted it into building lots that turned into an upscale residential street for the wealthy. (See Chapter 4). Real estate interest continued over the next several years. Then in 1858, they opened

a brokerage businesss, and in 1860 established a private bank that grew into the Second National Bank. William remained the bank's President for many years, and it was during this period, he became a partner in the James Leffel and Company. Meanwhile, Gustavus left the bank after two years in order to become a wool buyer. The 1873 Panic destroyed Gustavus' wool business, leaving him with severe financial losses. He then turned to the manufacturing of a popular domestic item—the kitchen clothes wringer, which proved to be a success. By 1884, Gustavus formed the Foos Manufacturing Company, incorporating it the same year with his sons, William and Robert. The company became well established manufacturing grinding wheels other farm products at a Sheridan Street plant near Whiteley's East Street Shops. Gustavus died in 1904, but his sons having little interest in the business sold it to the Bauer Brothers, who turned it into a long lived Springfield company.

John Foos, several years younger than his brothers, William and Gustavus, was not associated with their enterprises. After thirteen years in Springfield, John purchased the Barnett Oil Mill in 1861, and in 1870 was a principal in the Cottage Paint Company, located on the south side of Buck Creek, near Factory Street. He remained involved with both businesses until the early 1890s. John became friends with P.P. Mast, which led to the formation of the Mast, Foos, and Company in 1876. The company became successful in the manufacture of turbine wind engines, Buckeye force pumps, and iron fencing. As we saw earlier, when the company was incorporated in 1880, both Foos and Mast became uninvolved.

In 1875, John Foos and other investors organized and incorporated the St John Sewing Machine Company (St John was the surname of the Bellfountaine, Ohio inventor that patented the machine). The factory complex, consisting of a large five-story building and two smaller ones, was located on the edge of downtown at the northeast corner of Main and Center streets. Initially business was good with about 350 workers employed in the early 1880s. But the industry became highly competitive with many companies manufacturing sewing machines in the east. Such competition forced the closing of the business in 1888.

John Foos was not an inventor. His gift was to take another's product, build a company, and market the product. Such was the case with the gasoline engine. Invented by Clark Sintz of Springfield, Foos, P.P. Mast, and Henry Voll provided financial support and organized in 1889 the Foos Gas Engine Company, which became Springfield's most successful gas engine company, lasting until the early 1940s.

John Thomas: Thomas, born in 1826 in Maryland, moved to Columbus in the late 1840s, then to Springfield where he completed his law studies in the early 1850s. After about two years of practice, he was elected in 1855 to a two year term as Clark County Recorder. This was the same Thomas who, as we saw, partnered with P.P. Mast to form the farm implement company. After he left Mast in 1871, he had his own farm machinery company in operation by 1874. Called the Thomas Manufacturing Company, it was located on South Limestone Street at the south side of Monroe Street, a convenient location astride the railroad tracks. Today the site is occupied by the YM-YWCA. With ample funds from his Mast partnership, Thomas began his own company on a solid financial basis. The manufacturing works consisted of a five-story 400-foot long building, a smaller three-story building, and a foundry for making casts. Successful from the beginning, the company sold hay tedders, hay rakes, lawn mowers, and iron pumps to a national market. By the early 1880s, sales reached between $800,000 and one million dollars annually, while employment was just under 200.

As was common with successful industrialists in the latter 19th century, Thomas became associated with banking, serving as a director of the First National Bank in the 1880s. While running his company, Thomas also won elections to the Springfield City Council, for years in the 1870s serving as Chairman of the Finance Committee. He also accepted an appointment for a term as a Trustee of the Springfield Water Works.

At his death in 1901, the Thomas Manufacturing Company employed about 235 men. His sons who had been active in the company continued the business to the early 1930s when it closed.[15]

Influence of the Railroads

In the post Civil War era of coal, steam, and electric, Springfield factory owners had no incentive to locate their plants on the banks of Buck Creek, Mill Race and the Mill Race. When factories were no longer dependent on water power, the railroads became the primary factor in company location, as all industrialists wanted proximity to rail transportation, both for the convenience of shipping and the receiving of supplies.

As the city's network of rail lines expanded, many areas became available that were near the rails. Three areas became favored by company owners, and these sites soon grew into factory

clusters. The center cluster developed near the downtown depots along Jefferson and Washington streets, principally on the south side of the tracks between Spring and Center streets. Today this area is largely occupied by the Kuss Auditorium, the Clark County Public Library, and their adjoining parking lots. A second cluster had two nodes, both along the same set of tracks that passed through the downtown, extending southeast as far as East Street. The third factory cluster was located on the west side in the area where the rail tracks crossed Main and High streets. Principal side streets in the area were Bechtle Avenue, Isabella Street, and Dakota Avenue.

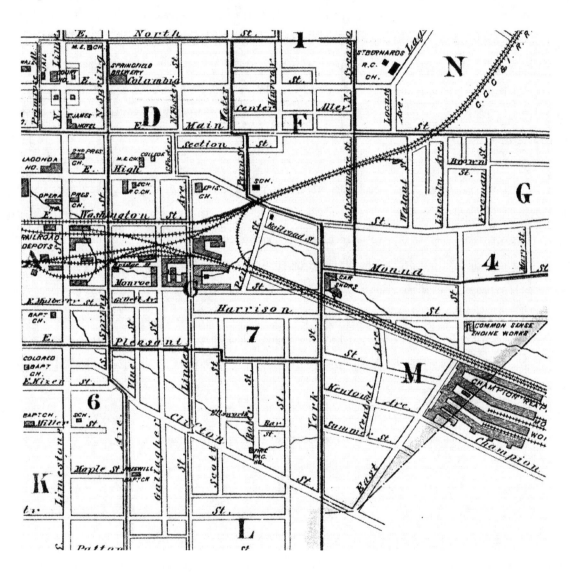

This 1882 map detail depicts the factory clusters in the downtown area. The southeast factories are along same rail line and extend to the East End Shops at far right.

Center Cluster

One of the early manufacturing companies following the Civil War was the Superior Drill Company, dating from 1867. Known first as the Springfield Agricultural Works, it was located at the northeast corner of Limestone and Jefferson streets, along the railroad tracks. (Today this site is just east of Limestone Street, across the street from Kuss Auditorium). One of Springfield's many agricultural implement companies, Superior Drill, as it was known after 1883, manufactured the Superior Grain Drill, as well as cider mills and presses, hay forks, and cultivators. The company remained successful in the growing farm market, and by 1884 employed about 130 workers, increasing to 175 by 1891.

When Amos Whiteley's Champion Machine Company ceased business in 1897, Superior Drill secured its patents, machinery, and moved into its building at Monroe and Gallagher streets, a few blocks from its former Limestone Street location along the same rail tracks.

In 1903, Superior Drill was absorbed by the American Seeding Machine Company. As a branch plant it remained at the same site for another three decades manufacturing farm products. American Seeding formed in 1900, was something of an early conglomerate. Soon after its formation, it bought the west side farm implement company, A.C. Evans. At about the same time, American Seeding also purchased the old P.P. Mast company after Mast's death, operating that plant at its Warder street location until 1916. Shortly after 1900, American Seeding purchased the Richmond, Indiana based Westcott Motor Car Company. American Seeding continued until 1929, when it was itself acquired by the Oliver Farm Equipment Company.

John Thomas' company, mentioned above, was also part of the center cluster, being located on Limestone Street, very near the rail tracks. Other companies in the area in the last quarter of the 19th century included the Springfield Brass Company at 80 South Limestone, the Springfield Mattress Company at 27 W. Washington Street, which was adjacent to the Finch Shoe Company. Finch was one of the few manufacturing companies that employed more women than men. Around the corner at 17 S. Center Street, the Standard Ice Cream Company operated a few years in the 1880s.

Lasting much longer was the Patric Furnace Company, which opened in 1872 at 12 S. Center Street, near Main. Later in the early 1880s, Patric purchased a plant on W. Washington

Street, just east of Center, remaining there until 1905, when the company moved again, buying an empty factory on the west side at Dibert and Yellow Springs streets, near the railroad tracks. Patric remained in business until about 1955, its last location being in the 2100 hundred block of West Main Street.

The Curved Elbow Company was another 1872 company in the area, located on E. Washington Street near Spring Street. This company manufactured stovepipe elbows for the plumbing industry, and had a market in nearby states. It ceased business in the mid 1880s. Just to the west of Curved Elbow, the Ludlow Soap Manufacturing Company opened on Washington Street in 1878. Before ceasing business about 1885, the company employed about fifteen workers, turning out laundry and toilet soap, offering such brands as Ladies' Choice and Snowflake.[16]

Southeast Cluster

The southeast cluster was characterized by two factory nodes. One centered around where East Street crossed the railroad tracks. This was the site of the East Street Shops of the 1880s. Recall that after Whiteley closed these shops, the new owner began leasing the large space to other manufacturers. Before being forced out by the 1901 fire, the following ten industrial firms were doing business from the former Champion works.

Krell French Piano Company
Grant Axle and Wheel Company
Miller Gas Engine Company
Owen Machine Tool Company
Champion Chemical Company
Progress Furnace and Stove Company
Springfield Foundry Company
Green Manufacturing Company
Kyle Art Glass Company
Indianapolis Frog and Switch Company [17]

In addition to the above leasees (except for Krell French Piano, which had purchased its space), the Wickham, Chapman and Company, later becoming the Wickham Piano Plate Company, opened in 1889 at Hubert and Belmont Avenue, just west of the East Street Shops. By 1915, the

company moved a short distance to 1817 Sheridan Avenue on the north side of the tracks. For several decades, Wickham remained a successful Piano Plate Manufacturer, employing 300 to 400 workers in the early 1920s. The company closed in the early 1970s.

The second node in the southeast was located at the Monroe, Harrison, and Gallagher area. The two factories of the Whiteley empire operated there until closed in 1887. These were the Chanpion Bar and Knife and the Champion Malleable Iron Company. In addition, Whiteley's Champion Manufacturing Company operated until 1897, when as we have seen, the factory was taken over by Superior Drill.

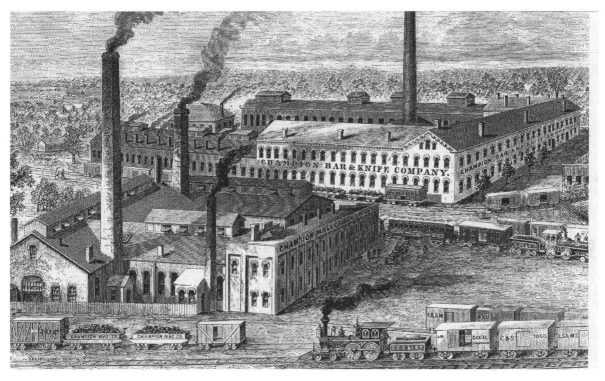

A drawing of the Champion Bar and Knife and the Champion Malleable Iron companies located in southeast Springfield.

A still continuing company in the southeastern area is the Champion Chemical Company (no relation to the Whiteley empire). This company evolved from the Hill Fluid Company, when in 1878 Dr. A.A. Baker, a physician, bought the embalming company. Baker changed the name, but continued to concentrate on the development of embalming fluids. Always interested in expanding services to funeral homes, the company in the 1880s bought the patent rights to an air sealed metal vault. At this time Champion did not have the facilities to manufacture the

vault at its Harrison Street plant, and contracted the production of the vault to the Springfield Metallic Casket Company.

Dr. Baker ran the company until his death in the late 1890s, at which time his son Scipio Baker became President, holding the reins until his 1921 death. Scipio's widow, Jesse Foos Baker, who was John Foos daughter, continued the family control of the company, as she held the presidency for the next two decades. At Jesse's death in 1946, her daughter, Margaret E. Baker, became President.

In the early 20th century, Champion developed other product lines, including operating tables and casket carriages. Because of the new products, the company in 1927 dropped "Chemical" from its name and became the Champion Company. In 1922 Champion established a Service and Research Department, which was the first of its kind in the industry. From this department came new and superior embalming fluids and other products needed by the funeral industry.

New products meant the need for larger facilities. Significant expansions included the construction of a vault manufacturing plant in 1928 and the 1956 lease of 50,000 square feet at a Kenton Street building for its metal shipping containers. Still another expansion was made in February 1967, when Champion purchased the former Foos Gas Engine Company in the southeastern area of the city. This expansion gave the company about 200,000 square feet of production space. With sixty to seventy employees, Champion reminds in business concentrating on the design and manufacture of storage containers.[18]

The Foos Gas Engine Company that was mentioned in connection with the Foos Family summary became one of the prominent manufacturers in the southeastern area. Beginning operations in 1887, this company became one of the early pioneers in the development of the internal combustion engine. Eyebrows were raised in its initial year, when the company attached a pair of five-horsepower engines to one of the city's horsedrawn streetcars, and successfully drove it on North Limestone Street, thereby helping to demonstrate the practicality of the engine. Beginning in the early 1890s, the Foos Engine Company made a commercial success of a one-cylinder engine mounted on wheels for use by farmers in order to power saws and trushers. Another Foos engine was marketed to telegraph companies that needed a source of reserve power. The company's engines also powered self-contained electric lighting systems, which were popular with travelling carnivals.

In its first decade, the company was located in the St. Johns Sewing Machine Company building at the edge of downtown, the sewing machine company having closed about the time the gas engine company was ready to begin operations. In 1897, the engine company moved to the southeast section, where it would remain for the nearly half century of its Springfield life. For about two years, the company leased space in Whiteley's former East Street Shops, and from there, the company moved permanently into Whiteley's former Bar and Knife Company factory at Linden and Monroe streets.

John Foos left the company in 1899, followed by the appointment of Scipio Baker, Foos son-in-law, as President. (Recall that Baker at this time was also President of the Champion Chemical Company). Under Baker, the company grew in sales and expanded factory capacity. Baker died in 1921, and the Baker family ran the business until 1942, when it was sold to the Fulton Iron Works, whose board moved the business to St Louis.[19]

West Side Factories

Springfield Malleable Iron Company: One of the largest west side companies was the Malleable Iron Company. Organized and incorporated in 1878, the company had a large site at Bechtle Avenue and the railroad tracks. Initially its iron castings were sold locally, but by the mid 1880s, the company's market expanded to include neighboring states. In addition to its large foundry building, over 400 feet long, several smaller buildings were in use at the site. At the end of the century, the company employed 300 to 400 men. During the 1920s, business began to decline, and in 1929, the company ceased operations.

Mast, Foos & Campany: Mentioned earlier in connection with John Foos, this company was another large west side company. Established in 1876 by P.P. Mast and John Foos, it was located on Isabella Street between Main and Columbia streets. The company was incorporated in 1880, and manufactured a line of products that reached many classes of people, including turbine wind engines, the Buckeye force pump, portable boilers, and lawn mowers. Within a decade after opening, company sales reached one million dollars annually and employed about 200 men. Success continued into the 20th century, but in December 1915, a fire destroyed the upper two floors of its three-story building. Within two years, a new building was constructed on its Dakota Avenue property, where it remained until 1943 when the company moved to Innisfallen Avenue, also on the west side.

In June 1957, Mast, Foos was purchased by an outside company, Musgrove, Inc. for $500,000. Then in March 1969, Boise Cascade bought the company, and changed the name to Outdoor Power Products. In August 1973, Boise Cascade closed the ninety-five year old company.[20]

The A.C. Evans Company, referred to earlier, opened in 1876 at Liberty Street and the railroad tracks. It was successful for about two decades manufacturing corn planters, harrows, and other farm implements, but began a decline from 1894, when the owner died. Shortly after 1900, American Seeding Machine Company bought the Evans company, keeping Evans' machinery and selling the factory to Patric Furnace.

A company that operated during the 1880s only was the Tricycle Manufacturing Company, located on Dakota Avenue at Columbia. It not only produced bicycles and tricycles, but children's wagons and wheelbarrows. At its peak, the company employed sixty-five. When it ceased business in 1890, Mast-Foos and Company bought the building.

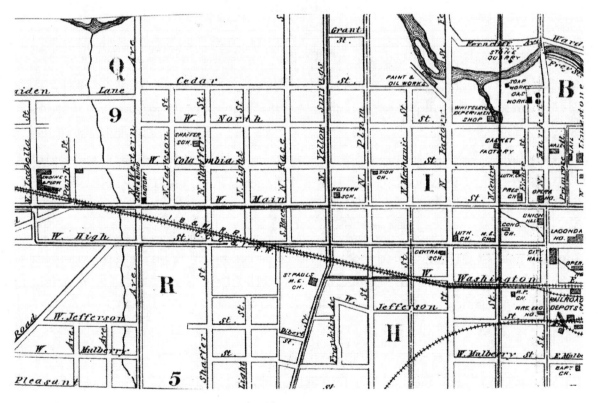

West Side factories are shown on this 1882 map.

Two notable companies opened in the 1890s, and remained on the west side for several decades. The Miller Improved Gas Engine Company, however, began operations at the former East Street Shops in 1898. The 1902 fire (to be mentioned later) forced its relocation to the west side, where it built a new factory on Fair Street at Plum, and remained in business until the late 1930s. A longer lasting company was the Springfield Machine Tool Company, which began in 1891 on Southern Avenue near the railroad tracks. By early in the 20th century, the company employed over 100 men, turning out a wide variety of machine tools until its 1971 closing.

Crowell Publishing Company: One of Springfield's greatest success stories was the nearly eighty year life of the Crowell Publishing Company, later to be called Collier-Crowell Publishing Company. Crowell had a modest beginning, growing from a semi-monthly publication of the P.P. Mast and Company. Called Farm and Fireside, the magazine was first suggested to Mast by John S. Crowell, a farm journal editor in Louisville, Kentucky. Crowell thought a company publication would promote sales of Mast's products. Mast liked the idea, and in October 1877 Farm and Fireside was first published. With Crowell as editor, the magazine attained such an early success that Mast, Crowell, and Mast's nephew, T.J. Kirkpatrick organized a partnership for its continuation, and in June 1879, Farm and Fireside was separated from the Mast company.

The new independent farm journal was initially edited by Kirkpatrick with a national perspective. The partners with Crowell having overall control moved the journal's operation from the Mast plant to the Republic Building on Main Street between Limestone and Market streets. Farm and Fireside's continuing success allowed the firm, with Mast's financial backing, to purchase land and construct its own building at the northwest corner of High and Factory streets, (Wittenberg Avenue after 1907) a location that allowed room for expansion. The new 1881 three-story building was constructed of brick with continuous windows along its High Street front of 100 feet and 75 feet along Factory Street. Topped by a well defined cornice, the building had a striking, arched entrance, elevated up several steps that were set at an angle to the corner of High and Factory streets. The News-Sun wrote: "The plant of Crowell Publishing Company is in reality one of the delights of the city. Those who have not had the pleasure of exploring it recently do not realize just what a grand thing it is for Springfield."

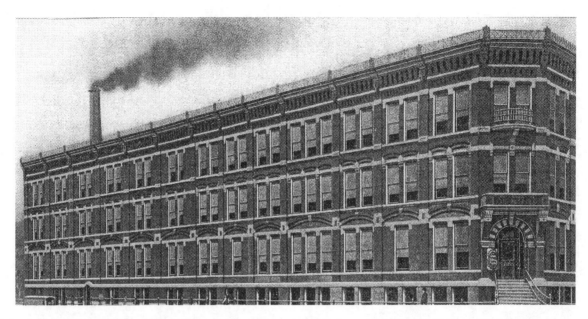

The right half of the Crowell Building is the appearance of the original 1881 factory. This drawing shows the factory as it was extended in the mid 1920s. By the end of the 1920s, the Crowell plant did not resemble this picture.

In 1885 the company made its first acquisition, purchasing the Cleveland based Home Companion, which later became Woman's Home Companion. As the 20th century approached, organization changes began, when P.P. Mast died in 1898. Crowell and Kirkpatrick then bought his interest from the executors and continued the partnership until 1906, when Crowell purchased Kirkpatrick's interest. In that year, the company name became Crowell Publishing Company.[21] (more on Crowell later).

Two companies not a part of the above clustering need to be mentioned because of their impact on Springfield industrial history. These are the Robbins and Myers Company and the Springfield Metallic Casket Company. The older and longer lasting of the two is Robbins and Myers, which began in 1878 when Chandler Robbins purchased the Leaver Wringer Company, a gray iron foundry located on Columbia Street near Center Street. Shortly after the purchase, James Myers joined Robbins as a partner. After a year, the partners moved to a rental location on Laconda Avenue. Sales of iron castings grew, and by 1885, the firm had purchased eleven acres along Laconda where the rail tracks crossed the street and completed its own building and a machine shop. During the 1890s, the partners saw a better future in electricity and gave up producing iron castings. The company, a corporation since 1889, began the production of electric fans and small motors for such items as sewing machines and vacuum cleaners. In the

late 1890s, as factories were switching from steam to electric power, Robbins and Myers began the manufacture of large motors and generators for industrial use. This directional change, however, took place largely without the original founders, for Chandler retired in the mid 1890s and Myers died in 1904. The success of electric motor production led to the expansion of the Laconda works from 74,000 square feet to 171,000 square feet between 1911 and 1915. Motor manufacturing continued into the 1960s, but by this time, its fluids division was carrying the company. Today R&M, as the company is now known, exclusively produces fluids at its plant at the west end of Jefferson Street. [22]

The Springfield Metallic Casket Company got its start in 1884 making wooden caskets on the second floor of an old building in Walnut Alley between High and Main streets. In the Spring of 1886, the company incorporated, and was given a financial boost by Ross Mitchell, the retired Warder partner. Now very wealthy, Mitchell bought a large block of casket company stock, and a few months later, the company moved into a Mitchell owned building at Main and Lowry Streets, just west of downtown. Here the company developed a line of metal caskets, the popularity of which, demanded a larger manufacturing plant. Accordingly, Metallic Casket purchased the former building of the Silver Plate Company on Center Street, north of Columbia. The company soon acquired a second building across Center Street and connected the two with a tramway over Center Street.

Over the next thirty years, Metallic Casket made six more additions to its works, the largest being a $250,000 expansion in 1929. During its period of growth, the company had sales offices in Detroit, Philadelphia, and St Louis from which salesmen covered all forty-eight states, and could offer customers over 100 styles and caskets types from which to choose. The company's future began to dim in 1958 when it was purchased by an outside corporation, and became a subsidiary of Thermometer Corporation of America, which closed Metallic Casket in 1974.[23]

Water

Springfield's growing indusry until the early 1880s could be inconvenienced and even handicapped by the absence of city supplied water into the factories. Although many factories dug their own water wells, those that did not were forced to depend upon a rudimentary system of delivery. No Council minutes exist from 1826 to 1850, when Springfield was a town, but a few records exist in the water department file at the Clark County Historical Society. These

records show that by 1845, the town council had begun to build cisterns for the collection of rain water, the first being located at Limestone and Columbia streets. Over the next two decades, the town and then the city constructed about twenty-five cisterns in the downtown area, and during this period began to convey water to downtown buildings through wooden pipes.

For residences, more individual effort was required. According to water department files, by 1854 a public reservoir had been built near South Limestone and Mill (Monroe) streets. Today this would be across the street from the public library. As rain water filled the reservoir, water was pumped to a cistern at Limestone and Main streets, where residents dipped out what they wanted.

In the 1870s, the City Council began to receive complaints about the quantity and quality of the water. Quick fixes, as the council's order to deepen the well at Main and Factory, would not satisfy for long. The council heard various proposals in the 1870s, such as constructing a hydraulic system to bring Mad River water into the city. Another rejected proposal was to build a large reservoir on Brain's Hill. Finally in the late 1870s, the council agreed to the construction of a comprehensive water works system. It would be expensive, but the state legislature approved a $400,000 bond issue for the city. Construction began in 1880, and when completed in 1882, city water was supplied from two, 24-foot wells, fifteen to twenty feet in diameter drilled under Buck Creek in the Laconda area. The pumping station also at Laconda was driven by six steel boilers. A water tank, called the Standpipe, was built at West Main and Florence streets, near the Greenmount Cemetery, and to complete the system, a thirty-mile network of iron pipes carried water to various parts of the city. The entire system was overseen by a newly appointed Board of Trustees, made up of O.S. Kelly, John Thomas, and George Frey.

In April 1891, another state authorized bond issue provided $110,000 for water department improvements, consisting of a new ten million gallon pumping engine, new batteries for the boilers, erection of an additional building, and the construction of a new well line from the pumping station to the Standpipe.

It seemed, however, that the city just could not get it right, for in 1895 supply problems were being encountered. Moreover, water being taken from Buck Creek, affected the water rights of businesses and residents below or to the west. Consequently, the entire water complex was relocated the southeast, in the Beaver Creek area. After this move, city officials believed that the water supply was adequate to handle any fire in the city. This belief would soon be tested.[24]

Market Square and Expansion of Springfield

Springfield's early physical growth began shortly after Demint completed his 1801 plat. Demint himself was first to make expansions to the original plat of ninety-six lots. Between 1805 and 1815, he filed three additional plats that increased the number of Springfield's lots to 295, having an average size of 99 x 198 feet.[1] The additions stretched the lots west to about Race Street or about seven below blocks west of the original plat and a block north to Cedar Street. Although platting of building lots would correspond closely with Springfield's actual size, legal boundaries in 19th century Ohio were set by the state legislature. The map below from the city engineer's office shows Springfield's changing boundaries to 1956 as annexations took place.

This annexation was prepared by the city engineer's office in 1956. Note the 1803 boundary. The city's largest annexation came in 1882.

Before getting to Springfield's internal growth within its changing boundaries, a feature of Demint's original plat needs noted. As shown below, this plat set aside near its center a public square, devoid of building lots and streets. In order that the square forever remain as public space, Demint stipulated that should public use be denied, the area would revert to the ownership of his heirs. Past historians have agreed that Demint intended that the public square was to be an open square, that is, with no intersecting streets. Oscar Martin in his 1881 history wrote.

> The public square as designated in the plat, and now occupied by the court house, county buildings and Soldiers Monument, was intended as an open space, the center of the future city, but the wishes of the founder in this respect have not been observed, and the lots have always been occupied to the street.[2]

Benjamin Prince in 1922 agreed writing: "The four corners of Limestone and Columbia streets . . . were designed to remain vacant, with business interests centering around them; it was to be a military square."[3]

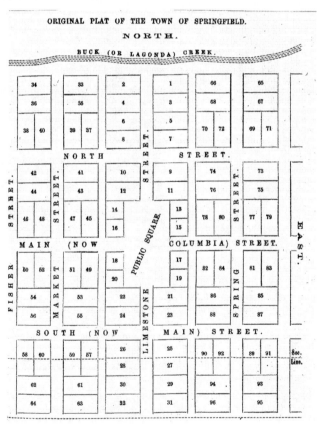

Demint's 1801 plat showing all 96 lots and an open public square. Action by the County Commission in 1819 extended Limestone and Columbia streets so they intersected. Then the Courthouse was built at street line, thereby negating an open square.

Past and current residents of Springfield know that because Limestone and Columbia intersect with structures built to the sidewalk, there is no open public square. The demise of Demint's planned open space took place after his death when the county commissioners began to consider the construction of the county's first courthouse. By March 1819, several residents had pledged money for a new courthouse, provided it be located on Demint's designated public square. Pledges from sixteen residents came to $ 1333 with Maddox Fisher highest at $300. Griffith Foos, whose nephews would figure prominently in later Springfield history, pledged $25. According to Martin's history, ". . . the commissioners ordered Col. John Daugherty (Demint's 1801 surveyor) to find the true lines of intersection of what is now Limestone and Columbia streets in order that a new building might be located there."[4] The key word in the directive is "intersection,"for if the streets intersected the possibility of an open square would be negated. In May 1819, the commissioners awarded a $3,972 contract to Fisher and John Amber to construct the walls and roof of the new building. When finally completed in 1828, the courthouse stood at the northwest corner of the intersecting streets of Limestone and Columbia, near the street line. The courthouse would remain in use until 1878, when it was demolished. The succeeding courthouse was built on the same site.

The 1870 map below shows clearly that the county's first courthouse is located at Columbia and Limestone streets. Although violating Demint's intend for an open square, the county has forever honored his stipulation that the area around Limestone and Columbia be reserved for public use. In addition to the courthouse, the other three corners have always had a county structure or public monuments. For years afterward, as if to ward off the heirs, this intersection was called the "public square."

This 1870 map shows that the open square at Limestone and Columbia is gone, the two streets having been forever intersected.

In one of his later plats, Demint again designated another area for public use. This area of three lots along the north side of Columbia Street between Center and Factory was set aside for a public cemetery. The intent of this donation has been honored by governmental authorities, and it remains to this day a cemetery. It has never been given a formal name. Dement in his plat called it the "Burying Ground." By later usage, had been known as the Demint Cemetery and

the Columbia Street Cemetery. After about 1844, however, this cemetery has received little use, as families have preferred Greenmount (1844) and Ferncliff (1864) as burial sites.

A New "Public Square"

Had Demint's open square been established, it was his intent, according to Martin, that the square and immediate area would become the focal point of the downtown. We know that this never became a reality. Yet by happenstance and not by planning, Springfield began in the 1830s a long process of acquiring an open square in the downtown. The square would be called Market Square (later Fountain Square), and it would be located just outside the 1801 plat on Market Street, south of High Street. How this square evolved into the downtown's central hub is of some interest. To retreat a bit, we should note that Springfield's first market house built in the Fall of 1826 was not located on Market Street, but on North Street, near today's Fountain Avenue. Then in 1827 a new market house was erected on the west side of Market Street, just north of High Street, about where the State Theatre is today. This plain wooden structure, costing $ 200, served shoppers for about five years. The third market house, built in 1832, was also located on Market Street, but on the south side of High Street into the area of the later Esplanade. The background for the siting of the third market house is crucial to the later development of an open square.

In 1832 two private plats were separately laid out by two notable Springfield businessmen. Peter A. Sprigman platted lots 301 to 316 in the southeast area of High and Market streets,and donated to the town land enough for "market purposes." At about the same time, James Lowry platted lots 312 to 337 around the southwest area of the intersection, and like Sprigman, gave sufficient land for a "market house."[5] The town council accepted the donations, and in order to satisfy both Sprigman and Lowry that their gifts were put to the intended use, ordered that the new 1832 market house be built in the center of Market (West) Street, thereby spanning the land donations of each. (The council followed to award Sprigman a $1,200 contract to construct the market house.)

Since the market house was in the center of Market Street, the street therefore had to be divided with a traffic lane to each side of the market. Thus as buildings later were erected along each side of Market Street, the building lines were set much farther back than they would have if there were no building in the center of the street. When the market house was demolished

sixteen years later, Market Street was therefore very wide, wide enough for an Esplanade and to be called a square.

This 1882 map shows the very wide Market Street between High and Washington, made possible when the 1832 market was constructed in the center of the street about where the work "Market" is written. A traffic lane to each side forced the building line back on each side. The city hall shown in the square was demolished in 1882.

However, when the 1832 market house was demolished and replaced in 1848 with a combination market house and city hall, the new market was given an unfortunate location that prohibited the full development of an open square. When completed, the new building faced High Street on the east side of Market Street, thereby negating a wide entrance into the square.

Aesthetically, the new market house was a wart protruding on the square's east side. For the next step in the square's development, the public would have to wait until 1882 when the latest market would be demolished, an event that finally allowed for the full development of an open square.

The 1848 market house, however poorly sited in relation to the square, was in itself a marked improvement over its predecessor. It was Springfield's first brick constructed market, and larger than the others, having a fifty-foot front facing High Street, and extending 100 feet to the south, along which stalls opened on the square. The building's second floor housed the city council chambers, giving the council its first permanent meeting site. The upper floor was large enough for a 1000 seat auditorium, providing the city for the next twenty years with its only venue for large meetings and entertainment. A tall steeple overlooked High Street, giving the building the appearance of a New England meeting house

An early user of the new city hall auditorium was Wittenberg College, which in September 1851 used it for the college's first commencement, graduating nine white men. The auditorium also hosted many lectures given by prominent individuals, such as Frederick Douglas, Springfield's own Samuel Shellabarger, who served in Congress during the 1860s, and Horace Mann, president of Antioch College in nearby Yellow Springs, who was invited several times by Wittenberg students. In addition, well known performers, as the singer Jenny Lind and Violinist Ole Bull entertained the audience in the auditorium.[6]

Construction Growth

A potentially viable open public square would be a major asset to Springfield, but its vitality would principally depend upon a growing downtown in the several blocks adjacent to and near to the square. Two years after the market house opened, Springfield's population totaled 5,108, while that of Clark County was over 22,000. Over the next few decades, the city and country's growth was significant, as reported by the U.S. census.

		City	County
1860 population		7,002	25,300
1870	12,652	32,070
1880	20,730	41,948

With a population increase of over 5,600 during the 1860s, Springfield's downtown was expanding. In 1868, the city directory in its 1870 edition reported that 250 buildings were erected in the city at a cost of about $ 900,000. Of these buildings, thirty-five were erected on Columbia Street, twenty-two on Main Street, fourteen on High Street, and fifteen on Limestone Street. All of these streets passed through the downtown. Rapid construction continued into 1869, as over 200 buildings were erected. Two buildings constructed in 1869 became assets for several decades in the downtown. At the northwest corner of High and Limestone streets, the 140 room, five story Laconda Hotel opened in September. Among the investors was John Bookwalter, whom we met as an initial partner of James Leffel and Company. The hotel thrived in the downtown's busy environment of passenger train travelers, many of whom were members of trade associations holding annual meetings in the city. Destroyed by fire in October 1895, the Laconda was largely rebuilt by Bookwalter, re-opening in 1900 as the Bookwalter Hotel. It survived until 1940, when the Woolworth Company purchased it as the site for one of its five and dime stores.[7]

From 1869 the city hall and market building was no longer the only location for large meetings and stage productions. As the city was growing, a large hall with modern facilities became necessary. Andrew Black, a city dry goods merchant since the late 1840s, opened the $100,000 Black's Opera House in 1869. Located at the northwest corner of Main and Market streets, the second floor of the five-story building held a 1,000 seat auditorium and theatre with a stage for dramatic and musical performances. The street level was designed for retail outlets, while the upper floors were reserved for business offices. The opera house continued to hold meetings, entertainment and musical shows until it was destroyed by fire in February 1903 and never rebuilt. However, by that time Black's had been surpassed as an entertainment venue by the Grand Opera House, located about three blocks away on South Limestone Street, where Regent Theatre was later built. With financing help by John Bookwalter, the Grand opened in 1881 with a seating capacity of 1,200. The ground floor location of the theatre was a factor in its popularity over the second floor theatre of the Black.[8]

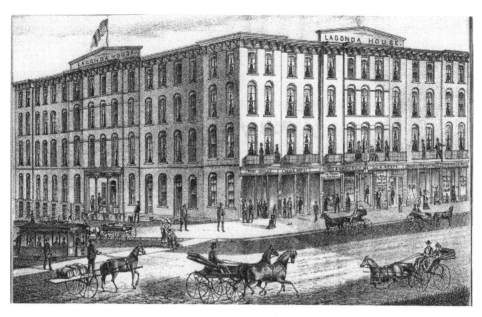

Laconda Hotel, 1900 to 1940, at northwest corner of High and Limestone. Replaced by Woolworth's in 1940.

County Buildings

The late 1860s was also a construction period for the Clark County Commissioners. By this time, the county's first courthouse at the northwest corner of Limestone and Columbia streets lacked the space needed by the growing county. Accordingly, the commissioners ordered two buildings constructed at the Limestone and Columbia intersection. The first was the East County Building, completed at the southeast corner in 1868. This building, diagonally across the intersection from the courthouse, housed the offices of Treasurer, Recorder, Auditor, Board of Agriculture, and the commissioners. The following year, still needing additional space, the commissioners built the West County Building at the southwest corner of the intersection, directly across Columbia Street from the courthouse. The Probate Court and the county surveyors set up business in this 1869 building. The same year, the commissioners demolished the 1824 jail on the northeast corner and replaced it with the Soldiers Monument. Dedicated in May 1870, the monument of a Civil War soldier standing on large granite pedestal gave the entire structure a height of just over twenty feet.[9]

A major intersection change began in 1878, when the original 1828 courthouse was demolished, and the construction of new, larger courthouse began on the same site. Completed in early 1880, its total cost was $115,000 including furnishings and a jail to the rear. Unlike

its predecessor and subsequent courthouses, the 1880 courthouse fronted Columbia Street rather than Limestone. It was in the words George Berkhofer, "a massive piece of highly eclectic, late Victorian architecture."[10] This impressive courthouse, however, survived just thirty-eight years, having been gutted by fire on March 12, 1918. Fortunately, most county records were undamaged, as they had been stored in the West County Building. After the fire, many county functions were moved to the two-year old Memorial Hall, and remained there until October 1924, when the still present courthouse at the same site was dedicated.

However, well before the courthouse burnt, the commissioners near the turn of the century had become dissatisfied with the 1869 West County Building and ordered it demolished late in the century. It was replaced in 1901 with a stately, Roman inspired new west county building, officially called the County Offices Building. Its symmetrical front faced Limestone Street, and was enhanced by a large, arched entrance that was flanked by stone columns. In an 1951 article on the building, the News-Sun was unimpressed with its appearance, writing that the "County Building contributes little architecturally to the appearance of downtown Springfield." Further, the paper added that the building was "unimposing dispite its rising concrete columns . . ."

In July 1976, the building was renamed the A.B. Graham Building in honor of Albert B. Graham, who was superintendent of schools in Springfield Township in the early 20th century and in 1902 was founder of the county 4-H Club.

Prelude to Further Downtown Development—Mill Run

All the new construction downtown was impressive, but Springfield 's downtown would not take on the appearance of a modern commercial center until the problem of Mill Run was solved. Even in its pre-Civil War glory period as the power source for much of Springfield's early industry, the stream could be a nuisance to the town. Extending across Market Square, Mill Run on many occasions flooded the square. During heavy rains, the banks of the stream would overflow, flooding streets and cellars of nearby properties on High, Main, and Center streets. Many times the council was forced to hire men to drain and ditch sections of the stream.

In the pre-Civil War decades when the Mill Run powered many Springfield mills, the flooding and nearly always swampy shore could be overlooked in a town that put industry on an elevated plane. But as the age of coal and steam arrived, Mill Run became increasingly unnecessary as a

power source, and the stream's liabilities became its primary focus. Therefore in 1877, it came as no surprise that the City Council ordered the Run covered with stone over the entire distance from Market Square to its confluence with Buck Creek.

This action may have looked like a permanent fix, but it was far from it. The stream quickly became the city's truck line sewer. Residents and at times the city attached subsidiary sewer lines to the larger line, thereby sending garbage and debris into Buck Creek and thence to the Mad River. Although the city would later pay a price for the unregulated sewer, for now in this innocent 19th century age, it was not considered a problem. As we will see later, Mill Run would continue to be a thorn in the city's side, and incredibly it would be a century until a permanent solution was found.

With Mill Run out of sight and apparently out of mind, entrepreneurs continued building downtown, changing the architecture, pushing out private homes, and turning it into a modern central business district. An early change was a major renovation of the 1850 Union Hall on Market Street between High and Main streets. This 1874 remake turned Union Hall into a popular site for both retail and business offices. The City Council found the renovated building more satisfactory for its meetings than the aging city building on the square. Council meetings would continue in the Hall until the 1890 City Building opened. From 1877 until 1890, the public library operated from the second floor. Beginning in 1876, the Odd Fellows and the Masons met on the top floor of the building. The Masons remained until 1882, while the Odd Fellows continued meeting there until the late 1920s. The ground floor that opened onto Market and later Fountain Street was a favored site for retail stores until Union Hall was demolished in the early 1940s.

Downtown Banks

Always a presence in the downtown were the banks, and by 1875, Springfield's original two banks had increased to five, now with new facilities and name changes. The city's old 1851 Springfield Bank, formed under the free banking laws of Ohio, had obtained a federal charter in 1864 and thereafter became the First National Bank, which would become the city's primer bank. Its first President was the wealthy druggist, Dr John Ludlow, who was Asa Bushnell's father-in-law. When Ludlow died in 1883, Benjamin Warder of Warder, Bushnell, and Glessner became President, serving until his 1894 death, at which time Warder's business partner, Asa Bushnell, assumed the bank presidency. Like his predecessors, Bushnell held the reins until his

1904 death. Bushnell even held the title of president while he served as Ohio's governor between 1896 and 1900.

Initially, First National was located on the west side of Limestone Street between Main and High, but when the Bushnell Building opened in 1895 on Main Street, the bank moved around the corner into the ground floor. It remained at the Bushnell Building for three decades, until its 1927 purchase of the Fairbanks Building at the northwest corner of Main and Fountain streets (the site of the old Black's Opera House). The same year, First National absorbed the Farmers Bank and the American Trust and Savings Bank. The merger altered the bank's name to First National Bank and Trust Company.

In 1929, First National grew even larger when it merged with Springfield's first bank, the 1846 Mad River Valley Bank, now the Mad River National Bank. The merger resulted in the disappearance of Mad River's name, while the First National name would continue.

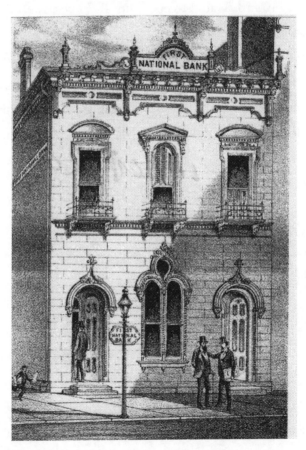

Original First National Bank. Located on west side of N. Limestone, near Main Street. The bank moved to Bushnell Building in 1905.

Bank mergers around the turn of the century appeared to be the order of the day. We saw earlier that the Foos brothers had organized the Springfield National Bank in 1863, which continued to serve customers until 1898, when it was absorbed by the newer Citizens Bank. Some thirty years later, Citizens Bank saw the beginning of its end when it merged in 1927 with the well established Laconda National Bank that dated from 1873. Since 1881, the Laconda had been located at the northeast corner of Main and Fountain. This bank building, which is still standing, became the home of the Laconda-Citizens National Bank. This dual title lasted until 1934, when the bank was reorganized with a new charter and larger capitalization, and once again became the "Laconda National Bank." It continued to provide an attractive appearance at its prime downtown intersection, undergoing a remodeling in 1961, just five years prior to a relocation.[11]

The Springfield Savings Bank was in its early decades unique among the city's banks. Its emphasis was on customer savings at a time when the commercial banks did not have a savings department. From the beginning, the bank was a non-profit institution without stockholders, operating solely for the benefit of its depositors who collected semi-annual dividends. First opening at the southwest corner of Main and Market streets in January 1873, the bank was in larger quarters by 1879 in the Republic Building (predecessor of the Bushnell Building). In 1899, the profitable Springfield Savings Bank (after 1913 it became the Springfield Savings Society) opened its own building at 9 East Main near Fountain Avenue, where it would remain until 1961.[12]

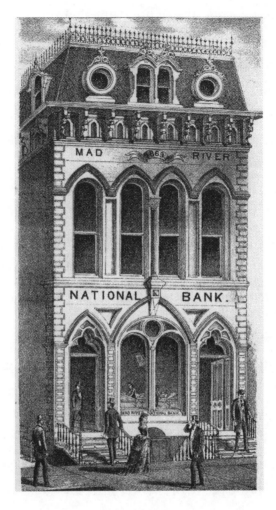

First Mad River National Bank. Located on north side of Main Street between Fountain and Limestone. Although the façade has changed the building still remains, as part of today's Springfield Savings and Loan.

In the 1870s and continuing into the early 1890s, heavy construction activity took place on South Limestone Street between Main and High streets. At the southwest corner of Main and Limestone, the Fisher Building was completed in the early 1870s. On the Fisher's south side, the Commercial Building opened in 1875, and next to it, the Phoenix Building opened also in the early 1870s. Recall that at the end of the block, that is, at the northwest corner of Limestone and High, the Laconda Hotel had opened in 1869, its entrance being on High Street, allowing on its Limestone side space for four retail outlets. The west side of Limestone became during the 1870s a busy block, as all buildings housed growing retail. The city's most prestigious department store, Wren's, got its start in the Commercial Building in 1877, though at that time it was Kinnane

and Wren. After Black's Opera House burnt in 1903, M.M. Kaufman, who rented at Black's, moved to the north side of the Commercial in 1904 and remained for fifteen years selling men's clothes.[13]

One of the most prominent buildings erected in the 1880s was the Mitchell Building, funded by retired Warder partner, Ross Mitchell. As mentioned earlier, when Mitchell left Warder in 1881, he turned his attention to real estate development, and the Mitchell Building completed in 1882 was one of his first projects. Located at the northwest corner of Limestone and High streets, Mitchell purchased the site from the First Baptist Church for $ 25,000. The new brick and stone building was five stories high, the fifth story having a Mansard design, meaning the front wall was sloped back while windows remained vertical in line with those below. The building was completed the same year as the city's new water works came online, and thus, the building had piped city water upon opening. The ground floor with large windows opening to the Limestone Street sidewalk was reserved for retail use, while the upper floors were leased for offices. One of the first tenants on the upper floors was the Champion City College, a recently organized business school, which remained a tenant for about four years.[14]

The Arcade

In the decade of the 1880s into early 1890, Market Square became cemented as the city's downtown hub and gathering place, the site for future parades, rallies, and informal sitting on the many benches of the Esplanade. By 1890, the square was bookended by two of Springfield's largest and grandest of all city buildings. One, built as the City Building and Market House, still stands well preserved, and in significant use as the Clark County Heritage Center. The other, Kelly's Arcade and Hotel, commonly called the "Arcade" survived just over a century, a victim largely of changing shopping patterns and the decline of passenger rail service.[15] The Arcade was built by Oliver S. Kelly of Whiteley, Fassler, and Kelly fame. Located on the east side of the square, the Arcade was made possible by Whiteley's decision to move his manufacturing operations from the downtown, thereby opening up a prime site for retail development. Kelly, as we have seen, severed his association with Whiteley and did not follow the company to East Street, choosing instead to purchase the Champion factory and real estate from Whiteley for $ 100,000. Upon Whiteley's vacating of the building in the Spring of 1882, Kelly and his architect, Charles Cregar, moved rapidly on the hotel and arcade project.

Both the construction of the Arcade and the future development of Market Square were given a boost when the 1848 market house was demolished in 1882. The old market had been deteriorating for many years. Prior to the Arcade construction, the Springfield Weekly Republic called the market building a "flagrant nuisance" and being aware of Kelly's plans, called on the City Council to raze the building. Historian Oscar Martin in his 1881 history criticized the market as "old and dilapidated."[16] As we have seen, the City Council by the mid 1870s had found its second floor chambers unsuitable and transferred its meetings to the Union Hall. Such public criticism of the old market house made it easy for the council in early 1882 to order the razing of the market and city hall building. The absence of the market, just a few feet from the side of the Champion factory made it easier for Kelly to proceed with construction of the Arcade, not to mention that the square was now open on the east side. (The 1882 razing of the market house meant that the city would be without a market and permanent quarters for city offices for eight years).

Kelly and Cregar's plans did not call for a total razing of the factory. The four-story northwest section that fronted High Street was retained. Several feet to the east, Kelly then constructed an identical four-story section to match the retained part. Over the space between, a high arch was built that would designate the entrance to the arcade mallway. When completed the front along High Street measured 138 feet.

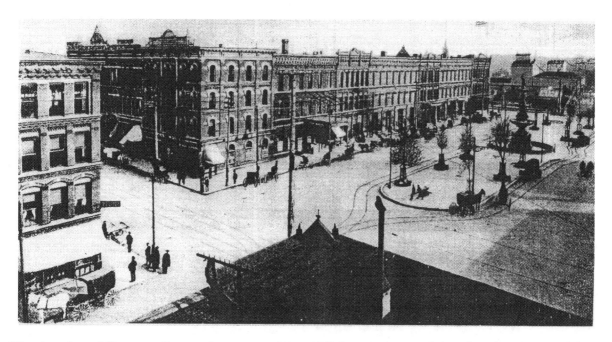

The Arcade and Fountain Square about 1900. Note Kelly's Fountain on the Esplanade. The Arcade and Hotel was built by Oliver Kelly in 1883 from the Whiteley factory after he closed it. The four story section was retained from the factory and faces High Street, while the three-story elongated part covering 340 feet was altered from the factory. The east side of the factory was demolished and a parallel side was built to equal the original. The space between the two sides was covered with glass, thereby creating the arcade that extended the entire length from High to Washington streets. On each side of the arcade, 20 to 25 retail and office spaces were built. The 130 hotel rooms were located to each side of the arcade on the second and third floors. The guest rooms were equipped with electric lighting, steam heat, and call bells connected to the fire department. For the convenience of the guests, two elevators were available. The amenities included a large ball room, a billiard room, and a restaurant located at the Washington Street end. The hotel registration desk was located at the Washington Street entrance, just a few feet from the depot.(Photo from Clark County Historical Society).

After completing the Arcade, Kelly became Mayor of Springfield for the years 1887 and 1888. While Mayor, Kelly proposed to the City Council that if it constructed an Esplanade (a pedestrian island in the middle of the square raised to curb height) on the square between the Arcade and the planned city building, he would pay for a fountain to be set on the Esplanade. These projects moved along rather quickly, and on July 4, 1889 Mayor Kelly dedicated the Esplanade and fountain. Kelly said: "There seemed to be a general concurrence of opinion that the old square should be made to present a better appearance, conspicuous as it is in sight by all who enter of pass through our city." The fountain, constructed in New York City at a cost of $8,000 stood forty-one feet high, with a basin of thirty feet in diameter. It was decorated with figures of Neptune and crowned at the top by the goddess of liberty.

In November 1889, the City Council passed an ordinance changing the name of Market Street to Fountain Avenue, and thereby Market Square became Fountain Square.

Completion of Market Square

On February 13, 1890, the new City Building and City Market opened on the west side of the now renamed Fountain Avenue looking across the square at the Arcade. With the Esplanade and the Kelly Fountain between the two, Fountain Square had reached its aesthetic peak. There could be no doubt of the public demand for a new market after the previous one had been demolished eight years earlier. In the interim, the voters had cast ballots three times supporting a new market. Replying to a City Council request to spend an initial $ 75,000, the voters in April 1884 approved 3,489 to 425. In April of the following year, the state legislature authorized the city to issue bonds up to $ 150,000 for construction. The required voter approval was granted by a margin of 5,679 to 384. By April 1887, the Council had purchased the building site for $65,110, and in January 1888 excavation began. The next January, the legislature allowed the city to issue more bonds totaling $ 75,000, which the voters again approved. With this amount, the building was completed including furnishings.

Its length was longer than any structure in the downtown, stretching 462 feet, covering the entire block from Fountain Avenue to Center Street, making it nearly five times longer than the previous market, though it fifty-foot width was the same. Each end and the corners were constructed of stone, while the sides were brick constructed. Looking down on the square was a 150-foot clock tower, nearly matched by the 125-foot tower at Center Street. Although the ground floor market with spaces for wagons to each side was the most visible feature, the building was much more. As with the former market house, the new building's second floor was designed for City Council chambers and city offices, in addition to space for police headquarters and the county board of elections. The council chambers, near the center of the building measured 40 x 60 feet and extended upward into the space for the third floor, which allowed room for a visitors' balcony. Stained glass windows on each side gave the chambers a bright and open appearance. At the west end of the second floor, and like the council chambers, extending into what could have been the third floor was a 1,200 seat theatre and auditorium. From the stage to the rear seats, the distance was 116 feet, covering the width of the building. The eastern third of the building contained a third and the highest floor with offices for the police judge and the prosecutor. The

basement held the stables for police horses. The day after it opened, the Daily News wrote in praise of the building.

> The city building, at first a dream, is today a triumphant reality
>
> And what a building: grand in conception, perfect in execution, complete in its utility, and colossal in proportions, it is at once a source of universal pride and a fit subject for pardonable panegyric.[17]

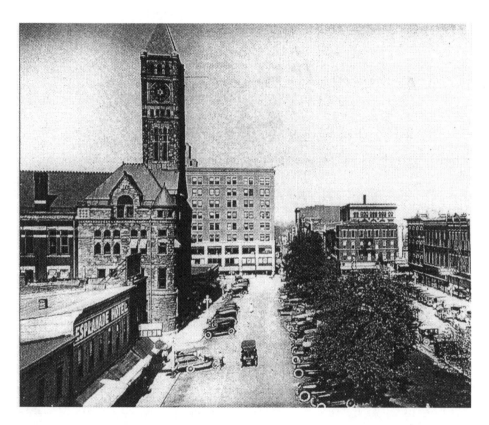

Fountain Square in the early 1920s. The date would be prior to Dec 1924, for then the clock was installed in the City Building,s tower. The round appearance at the top of the tower is a design, not a clock. Note the 1917 Arcue Building directly behind the tower. Part of the Arcade is seen at the far right. It was a busy day at the Square, judging from the many parked cars. By this date the 41-foot fountain had been removed. (Clark County Historical Society photo).

Before leaving the summary of the City Hall and Market building, it may be of some interest to say a word regarding the management of the market proper. Those who pine for the so-called limited government of the 19th century may be surprised at how heavy the hand of city government could be. From the legislative act of 1850 allowing the city to appoint a

superintendent of markets (later known as a market master), various regulations had been in force. By 1900 these regulations had become quite detailed. Some of these were: sausage cannot be sold with added ingredients, such as spare ribs; all meat sales must be in designated stalls; fish sales must be in certain stalls and covered with zinc; butter can be sold only in pound increments; re-selling market items at a higher price is prohibited; no sitting on counters; no defacement of stalls; no profane language; no selling by auction or loud speaking. In addition, wagon parking was regulated by position and all weights and measurements were regulated for honesty. The market master was given authority to seize and destroy any meat he deemed tainted. Finally the market master had the authority to arrest and levy fines for disobedience of lawful orders.[18]

The 1890s

Following the opening of the City Building in February 1890, the Warder Public Library opened the same year. Located at the northwest corner of High and Spring streets, the $100,000 building was the gift of Benjamin Warder to the city in memory of his parents who came to Springfield in 1830. It was the city's first building devoted exclusively for library use. Hereafter, the library would no longer have to rent space in a business or retail building. Built of gray limestone and trimmed with red sandstone, the Romanesque styled building also was distinguished by a red tile roof and a conical tower. This library served the city until 1989 when a new and larger building opened about two blocks away. Today the Warder building remains well maintained, serving as the Clark County Literacy Center.

In its Sunday issue of February 11, 1940, the Springfield News-Sun carried several articles devoted to the city's history. The lead front page article carried the headline: "Modern Development of the City Began in 1890." Impressed by the number of events crucial to the city's future, the paper opined that 1890 was a "milestone of unsurpassed importance in Springfield history." Three events in particular were sited by the paper as paving the way for the growth of the city's civic, business, and cultural environment. These were the completion of the City building and Market, the advent of natural gas, and the opening of the Warder Public Library. Also cited by the News-Sun as having long term civic benefits was the 1890 completion of the city's first federal building, giving the city for the first time its own post office facility. In addition the creation of the Board of Trade in 1889, and the electrification of the street railway system were considered as positive events in the modernity of Springfield.

The events cited by the News-Sun were of course significant and few would disagree with the paper's choices. Yet changes were occurring so rapidly in the city, especially in the downtown that had the paper used 1895 as its culmination point, it may have at least given honorable mention to three buildings completed in the early 1890s. These were the Zimmerman, the Gotwald, and the Bushnell buildings, all located in the downtown within one block of each other. John L. Zimmerman, an 1879 graduate of Wittenberg College, began a successful practice of law in 1882 from an office in the Commercial Building. By 1889 he had completed the first part of the five-story Zimmerman Building on the north side of Main Street between Fountain and Limestone, followed in 1891 by a second part, also five-stories, attached to the east side of the first part. An early steady tenant was the Springfield Hardware Company, which took part of the ground floor and remained there for fifteen years. The building's best known tenant, however, was J.C. Penney's, the national department store that occupied the ground floor from 1933 until the early 1970s, when it was targeted for demolition.[19]

The Gotwald Building, completed in February 1892, was made possible by the razing of the nearly half century old King Building at the southeast corner of Main and Limestone streets. Purchased by David King in 1845, the retail and office building had housed numerous tenants over the years, including the post office in the 1860s. By 1890, it was controlled by King's daughter, who had married into the Gotwald family, and now decided to sacrifice the old structure for a modern office building. For some eighty years after its opening, the Gotwald remained one of the downtown's most prominent buildings, its signature feature being the 125-foot conical tower, seen from all the shopping and business area. The five-story limestone structure covered fifty-feet on Main Street and spanned eighty-feet on Limestone Street where its arched entrance was located.

Upon opening, the Springfield National Bank rented the Gotwald's street level northeast corner, remaining there about thirty years. The Gotwald's upper floors became a popular office location for attorneys, as the courthouse was just one block away. However, the Gotwald's most significant tenant in terms of the future was the Merchants and Mechanics Building and Loan Association, which occupied most of the first floor beginning in 1897. After two decades as a tenant, the newly named Merchants and Mechanics Savings and Loan Association chose to purchase the building, and soon made extensive internal renovations, giving the building its own name, thereafter known as the M&M Building.

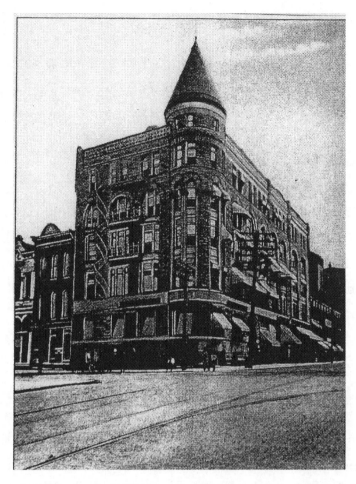

Gotwald Building in early 1900s, located at Limestone and Main streets. In the mid 1920s, it became the M&M Building. The building became a victim of the downtown renewal plan of the 1970s.

By the late 1920s, Merchants and Mechanics or M&M was continuing its significant growth since its 1894 founding. Its assets in 1927 totaled $ 13,500,000, having increased by nearly two million dollars over the previous year. Accordingly, M&M began to use its cash for future expansion. The Daily News reported in January 1928 that M&M had purchased two adjacent buildings, one being the vacant Ludlow Building on East Main Street. The other was the Citizens Bank Building on Limestone Street, the bank having recently merged with the Laconda Bank and relocated. The price of both, according to the Daily News, came to $ 250,000. No immediate expansion was planned by M&M, its president stating to the Daily News that plans would firm up over the next few years. The few years, however, turned into twenty-seven years, as it was not until 1955 when M&M built a new facility next to its original building on South Limestone Street. The 1930s depression followed by the war apparently delayed the project.[20]

The Bushnell Building, according to some observers exceeded both the Zimmerman and the Gotwald buildings in architectural merit. Historian William Rockel in his 1907 history called the Bushnell ". . . perhaps the most substantial building that has been erected in Springfield at any time." Designed by the Chicago architectural firm of Shepley, Rutan, and Coolidge in the Beaux Arts and Second Renaissance Revival style, construction began in late Summer 1893 and was completed about one year later. The front façade was distinguished by three large stone arches over the second, third, and fourth story windows that comprised the center of the building. Arches were also used for the entrance and for the much smaller fifth story windows. A well defined cornice further enhanced the building. In 1903, a large section, perpendicular to the original was added to the rear, which extended west and fronted on Fountain Avenue, thereby forming an "L." Asa Bushnell and his architects intended that the building be for commercial and office use. One or the building's early prominent tenants soon after opening was the First National Bank, which remained on the west side of the ground floor for over twenty years. The bank's neighbor on the other side of the first floor was Kinnane's Dry Goods Store. Along with the Gotwald Building, the Bushnell was also popular with attorneys. In 1907, for example, about twenty lawyers leased offices on the upper floors. For about the first two decades after opening, the Masons leased the fifth floor. Having had caring owners over most of its history, the Bushnell still survives. Since 1979, it has been on the National Register.[21]

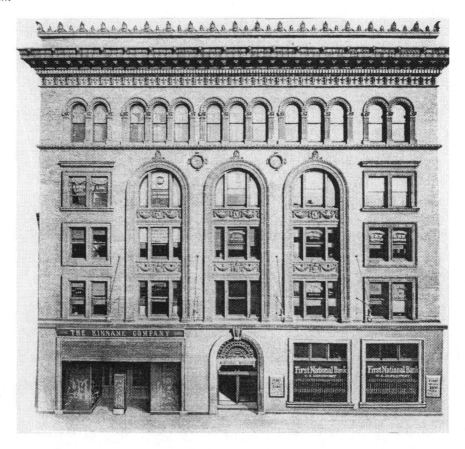

The Bushnell Building as it looked in 1914. By this year, the Home Store owned by Edward A. Tehan and H.J. Fahien, had replaced the Kinnane store, and in 1925 the partners purchased the building. When the bank moved from the building in 1927, the Home Store took most of the building for its department store. This arrangment lasted until 1939, when Wren's purchased the building and absorbed the Home Store. Wren's would remain at the former Bushnell for nearly 50 years.

The Laconda Club Building was the downtown's last significant building of the 1890s, having been completed in 1895 during the midst of an economic recession, known as the 1893 Panic. Yet Springfield by virtue of its diversified industry was not hit hard, allowing its wealthy to continue to use their ample funds to enhance the city's built environment. The new building at the northwest corner of Spring and High streets was built as a clubhouse by upscale individuals for those of similar economic standing. The well respected architect, Frank Andrews, who had designed the state capitols of Kentucky and Montana was given the design commission. He did not disappoint. The attractive, twin arched stepped up entrances faced Spring Street, across from the 1890 Federal Building. Befitting the financial standing of the members, the interior of the clubhouse was lavish, featuring red Spanish leather upholstery, stained glass windows, silver moldings, velvet satin draperies, a grand staircase, and of course electric fixtures.

It could have been a downtown social setting for decades, but unfortunately, the building's owners were victimized by poor timing. Before the building's second decade, it had become clear that the city's wealthy would re-establish themselves farther north to the new upscale Ridgewood residential development, north of McCreight Avenue. To the north of Ridgewood beginning at Home Road, the Springfield Country Club, had re-organized in 1906 with ample grounds, which would soon have an 18 hole golf course. The country club's well manicured, but rural setting would doom the Laconda clubhouse, as the wealthy continued the migration north, making the country club their social venue.[22]

—**Summary**

By the late 1890s, the large commercial, banking, and other fine buildings had turned Springfield's downtown into a modern commercial center. Such unconforming structures as factories and single, detached houses had largely been displaced. The departure of the Whiteley reaper factory and the James Leffel & Company plant, for example, had allowed such downtown attractions as the Arcade and the Grand Opera House to be built. Similarly, the growing disappearance of private homes freed up needed space for hotels and retail buildings. In 1890, it would have been hard to imagine that where the Laconda Hotel stood that the previous structure was a large private home. At the southwest corner of North and Limestone, where once the YMCA stood, the site previously was the private home of Jacob Seitz (of gas engine fame) from the 1870s.

Churches also departed the downtown. Recall that preceding the Mitchell Building at Limestone and High, the First Baptist Church had occupied the site, and at the same intersection, the Christ Episcopal Church had occupied the same ground as the later Bookwalter Building and the Wren's Department Store. The Second Presbyterian Church, however, remained prominently on Limestone Street next to a bank until 1921, when it was replaced by the Boston Store.

As the 19th century was coming to an end, Springfield's downtown could provide its over 38,000 residents with a comprehensive and lively shopping area characterized by the following retail shops, all of which listed below were within easy walking distance of each other.

Downtown Retail—Mid 1890s

Clothing and Dry Goods
19, 34, & 37 S. Limestone
2,6 & 49 W. Main
13, 29, 35, & 59 E. Main
12 S. Fountain
SWC Main & Fountain
SEC High & Fountain

Drug Stores
28 & 41 E. Main
39 W. Main
22 & 51 E. High
60 S. Limestone
SWC High & Limestone
SEC Main & Fountain
NEC High & Fountain

Cigar Stores
12, 25, & 29 E. High
6 W. High
24 W. Main
37 & 99 E. Main
16, 99, 107 S.Fountain
NWC High-Limestone
Kelly Arcade

Hat Stores
4 & 35 E. Main
2 W. Main
38 & 79 S. Fountain
45 S. Limestone
SEC High & Fountain

Meat & Daily Markets
16 E. High
8 S. Fountain
28 N. Spring
City Market Bldg

Grocery Stores
67, 95, 115 W. Main
54, 60, 88 E. Main
14 & 20 S. Fountain
19 & 31 S. Fountain
City Market Bldg

Shoe Stores

17 & 49 W. Main
25 & 81 E. Main
11 & 33 S. Fountain
Kelly's Arcade

Hardware Stores
42 W. Main
36 & 71 E. Main
28 S. Fountain

Restaurants
15 & 77 W. Main
21 & 67 E. Main
37 E.High
2 W. High
SWC Fountain & High
19 N. Fountain

Saloons: Downtown saloons in the 1890s were concentrated on East Main and South Fountain. On East Main from Fountain Avenue two blocks to Spring Street, there were eight saloons. On South Fountain Avenue from High Street through the Square and three blocks to Pleasant Street, there were six saloons.

(Number of above businesses taken from 1893-94 city directory)

Growth of Neighborhoods

In the earlier years of Springfield's industrialization, prior to and just after the Civil War, it was common for owners of growing enterprises to live near their companies, which in many cases met the downtown area. As the number of wealthy began to increase after 1870, many from the upper economic class began to take their large and unspent funds to new and pristine residential areas away from the dirt and grime of their factories in order to build large and expensive homes for their families. In addition to the desire to escape the city, the wealthy also wished to live among those of similar class and economic circumstances. The munificence of the homes indicated that many wanted to make a social statement in addition to the desire to live in a clean and comfortable environment. Two neighborhoods developed by Springfield's affluent grew concurrently, approximately between 1870 and 1900.

East High Street and South Fountain Avenue

The development of East High Street for the economically privileged was substantially aided by two real estate developers who visualized the street as a domain for the wealthy. These were the brothers William and Gustavus Foos, who we met earlier in later life as they entered the manufacturing and banking fields. Their initial business success, however, began in 1848, when in their early thirties, they purchased some ninety acres along the south side of East High and platted forty-three residential building lots. Beginning about where the railroad tracks crossed under High Street (about one-third mile east of downtown) and extending about four blocks east to East Street, they measured off twenty-one lots fronting on High Street. The remaining lots were laid out to the rear or south of the High Street lots.

Although the reality of the Foos brothers vision would wait until after the Civil War, the first of the great houses that still stand was built in the mid 1850s by Charles M. Clark, whose family came to Clark County when Charles was just three years old. As he matured, Clark built a successful wool buying business that gave him the means to purchase a Foos lot and complete a brick, Italianate house, surrounded by an iron fence that still remains.

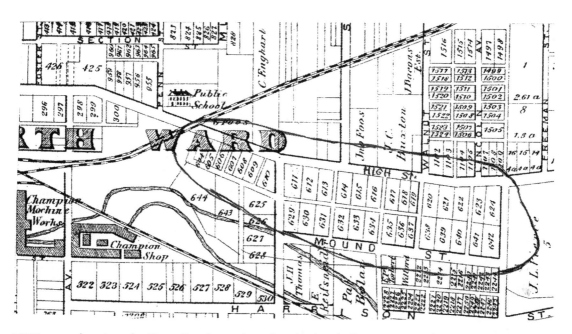

An 1875 map showing the Foos Brothers plat of 1848 (circled). Across High Street, younger brother, John Foos built a house, note name on map. To the right or east of the Foos house, Asa Bushnell built his mansion.

The house of course has passed through various owners. In the 20th century, E.L. Buchwalter and his wife owned it. After Mrs Buchwalter died in 1922, Buchwalter gifted the house to the Women's Town Club, becoming then the meeting place and social venue of the Springfield Women's Club. Today the house, well maintained, still serves the same purpose.[1]

By the early 1870s, two additional distinguished houses were completed on the Foos' lots. Immediately to the east of the Clark house, the Rinehart-Bowman House at 815 High Street was occupied in 1873 by John Rinehart, a founding partner of the successful farm implement firm of Rinehart-Ballard Company. His brick house built in the Renaissance style was characterized by a symmetrical front façade of smooth limestone. Six steps led to the arched entrance, flanked by a single window to each side. Rinehart died in 1876 after just three years in the house. His widow remained in the house until 1882, when she sold it to S.A. Bowman, a prominent attorney

The immediate neighbor of Rinehart was Asa Bushnell, who as a Warder partner was already building his fortune. Completing his house in 1870, the Bushnell family continued to live in this two-story brick home with Italianate features until 1888, when the family moved across High

Street. This short move by Bushnell and his wife was understandable, for by 1888 Bushnell had completed what would be the most prestigious (at least until the Westcott house twenty years later) of the many East High houses built by the city's wealthy businessmen. Usually referred to as a mansion, it was not part of the Foos plat, for it was on the north side of the street. The mansion was designed by Robert Robertson in the Richardson Romanesque style, using rock-faced granite with windows and archways trimmed in dark stone. The extended length of the house is striking, made even more so by the attached, arched carriage house. The Bushnells entertained heavily, and the absence of a front door from High Street allowed for long inside open area, extending the length of the house, a feature that accommodated a large guest list. Entrance was gained from the carriage house on the east side. The view of the mansion was enhanced by a long front lawn, stretching to the High Street sidewalk, terminated by a low granite wall.

After Bushnell's death in 1904, the mansion remained in the family until 1919, when Asa's son John sold it L.B. Prout. In 1939 a young mortician, Austin Richards, purchased the home, and spent about two years renovating it for use as a funeral home, opening it in August 1942 as the Austin Richards Memorial Home. Richards took on Frederick Raff as a partner in 1956, and the two ran the business as the Austin Richards & Raff Memorial Home until Richards' death in 1978. By this time, Rick Dunbar had joined the firm, and upon Raff's retirement in 1989, Dunbar became President of the incorporated memorial home. Owners Rick and Anne Dunbar have maintained the splendor of the mansion, completing a million dollar restoration project in the mid 1990s.[2]

A fifth notable house of architectural merit in the immediate area is the John Foos House, which is still extant on the west side of the Bushnell mansion. Like Bushnell, Foos did not choose a lot surveyed by his older brothers. Whatever the reason for his choice of lots, it is of interest to note that the north side of High Street in this area allowed for a more spacious lawn than the smaller platted lots on the south side of High. Thus, both Foos and Bushnell were able to site their houses well back from High Street, unlike the houses in the Foos plat, which were built much closer to the street. These five houses—three on the south side of High and two on the north side—comprise the core of the East Side Historic District, as designated in 1974.

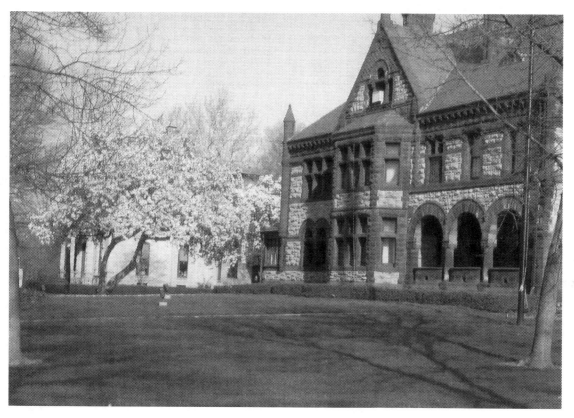

Contemporary photo of Bushnell mansion in the foreground and the John Foos house in the background.

Upscale houses continued to be built along East High at a steady pace throughout the 1870s and 1880s, and into the 20th century. By 1882, fourteen of the twenty-one Foos lots that faced High Street were built upon, and thirteen of the twenty-three Foos lots to the south of the High Street lots contained a house. A short distance east of the Foos plat, John S. Crowell, soon to sell his majority interest in Crowell Publishing, completed in 1905 a Georgian Revival mansion on the south side of High Street. On a large lot of three acres, the house with eight Corinthian columns around the porch, was well set back from the street, allowing a grand view of the home and its setting. Crowell lived there until close to 1920, when he was stricken with cancer. Soon after his death in 1921, Springfield attorney, Paul Martin purchased the house, and kept it until the late 1930s, afterwhich the house fell into disrepair. In 1945 the city's Greek community purchased it for the nominal sum of $ 17,000, thereafter becoming the Greek Orthodox Church. In short order the congregation made extensive renovations, transforming the second floor into the chapel. Following a fire in 1949, the congregation built a large addition to the rear for a new

chapel. The church has remained as one of the showpieces from the glory days of East High Street.[3]

There is still enough of East High Street left from the late 19th and early 20th centuries that allows the assumption that it was once a residential neighborhood for Springfield's upper crust. The assumption is valid in part because of the preservation of the Westcott House, a Frank Lloyd Wright designed house completed in 1908 on the north side of High Street at Greenmount Avenue. The house with the Wright trademark of horizontal lines contained twelve rooms, including a family room 20 x 60 feet, was built when Burton Westcott still had his wealth, both from an inheritance and the early success of the Westcott Car Company. But as we have seen, the car company began to fail soon after 1920, forcing him into bankruptcy followed by his surrender of the house to the bank. For many years, the house had a history unworthy of its early quality. During the 1960s, the owner divided the house into five rental units. In 1989, Ken and Sherri Snyder purchased the house, but when the husband died in 1992, his widow was unable to put the needed money into the house.

In the year 2000, the house began a turnaround, for in that year the Frank Lloyd Wright Building Conservancy purchased the house for $300,000. This national organization had been formed in 1989 in order to preserve Wright designed houses. In turn the Conservancy resells to a local organization that is able to restore the house. The local effort through the Westcott House Foundation was successful, and in October 2005, the house after a $5.3 million dollar investment had been restored to its 1908 condition. Since then the house has been open to the public for paid tours.

A pleasant greenspace along East High has existed since 1844, when the city purchased twelve acres between Greenmount and Florence streets on the north of High for a cemetery. It soon became the cemetery of choice for Springfield families, as the Demint Cemetery was largely forgotten as a burial site. Known as Greenmount Cemetery, the first interment was in December 1844, and by the late 1880s all burial lots had been sold. By then few would have cared, for in 1865 the large and more prestigious Ferncliff Cemetery had opened, and Greenmount was forgotten. Springfield compilers Anne Berston and Joyce Gerhardt wrote in their history of Ferncliff that Greenmount is "long abandoned," and in spite of the many uncared for monuments "it retains a quite beauty, with rolling hills, with an abundance of trees and shrubs."

East High Street in the latter 19th century was not entirely upper crust. At the far east end of the street, between Belmont and Burnett streets, an ordinary, middle class neighborhood was developing as the Foos plat was filling up. Promoted in 1869 by Alfred Raffensperger, who had laid out the plat, which extended from the south side of High Street for about four blocks with two principal streets carrying the lots to the south. These streets were Raffensperger Avenue and Burton Avenue. At the time, the plat was outside the city limits and known then as East Springfield. By 1882, the large annexation of that year had brought the plat into the city. The neighborhood remains middle class, consisting mainly of large frame, two-story houses with an attic, characterized also by large porches extending the width of the houses.[4]

Springfield's second area that developed into a residential area for successful industrialists and other businessmen was South Market Street (renamed South Fountain Avenue in 1889). This street began to be opened for housing construction in 1853, when John Patton platted lots 829 to 847 on the west side of Market Street, between Jefferson and Mulberry streets, or between two to four blocks south of Market Square. Beginning also in 1853, Letitia Baker began platting building lots on the east side of Market, from Jefferson Street south for about six blocks. By the mid 1860s, building lots had been laid out along Market Street to Liberty Street, about seven blocks south of Market Square. In the 1860s, platters had moved a block west to Limestone Street and surveyed lots along the west side of Limestone as far south as Liberty. Thus, houses on the east side of Market and the west side of Limestone would share a common alley, where barns and carriage houses were built for the horses and buggies of the wealthy home owners. Although the alleys were initially needed, later as upscale neighborhoods, namely Ridgewood, were developed in the nascent automobile age, the affluent would frown on the alleys as driveways came into vogue.

One of the first houses built on South Market was by Oliver S. Kelly at number 403, near Jefferson Street, a short walking distance to his place of employment while a Whiteley partner, and later as the developer of the Arcade. The peak period of the construction of the grand houses, however, came after Kelly's home. In 1876, Francis Bookwalter built a large, Second Empire house at number 611. To Bookwalter's immediate south, Oliver Warren Kelly, son of O.S. Kelly, built a brick home in 1880. Farther south, William Whiteley built at 1103 and Hector Urquhart, owner of the Springfield Baking Company, built at 1025. The stately and sometimes extravagant houses spanned a variety of styles. In the mid 1880s, there were two Greek Revivals, two Gothic Revivals, two Second Empires, seven Italianates, and four Colonial Revivals. By 1882, all but two of the twenty or so lots on the west side of Fountain were built upon, and on the east side, twenty houses had been built on the twenty-eight platted lots.[5]

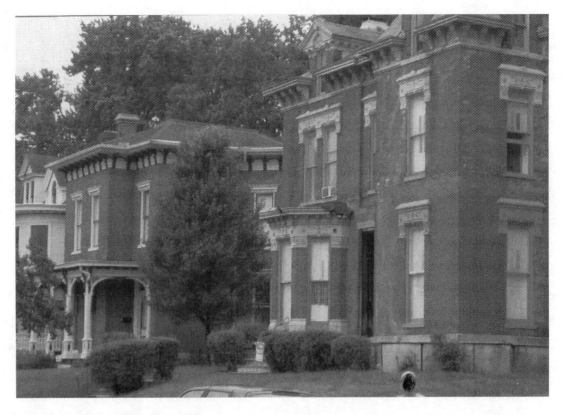

Contemporary photo of housing along South Fountain Avenue. Note the small lots, and therefore lack of yard space, which by the early 20th century made the street unattractive to the wealthy.

The West End

Although the wealthy industrialists could afford to live away from their factories and travel by horse and carriage from home to work, their workers of much lower economic means were forced to remain in undistinguished housing within walking distance of their factory work sites. Two areas of Springfield will illustrate the worker housing and factory geographical unit. These are the southwest and southeast areas, both platted and developed principally in the latter 19th century. Starting at Main and Factory streets (Factory Street after 1907 became Wittenberg Avenue), the southwest section can be defined as extending west to Isabella Street and the Old Dayton Road area and south for about ten blocks. Railroad tracks from the late 1840s had entered Springfield from the west, running southeast, and crossing several streets—Isabella, Bell, Western, Main, High, Yellow Springs, and Factory before entering the downtown along Washington Street. Prominent factories along the route were Mast, Foos, and Company, Steel Poducts Engineering Company, Cold Storage and Ice Plant, Springfield Malleable Iron, A.C. Evans, and soon the rapidly growing Crowell Publishing Company. As factories for convenience

were built as close as possible to the railroad tracks, residential lot platters wanting to squeeze as many lots as possible from their properties also surveyed lots as near as they dared to the tracks.

As early as 1849, thirty-two lots were platted in the area of Isabella and Columbia streets. Heavier platting, however, took place in the late 1860s through the 1870s, as the city's population increased by about 8,000 to reach 20,730 by 1880. Most of the platting was done by individuals, purchasing enough land to section off as few as four or six lots up to twenty-five. But a few larger plats were notable. In 1869 for example, 116 lots were laid out south from High Street along Yellow Springs Street. Other larger plats included.

1874-93 lots south of Fair Grounds to Southern Avenue

1879-86 lots along Western Avenue to Main Street

1882-131 lots in the Southern Avenue and Yellow Springs Street area.[6]

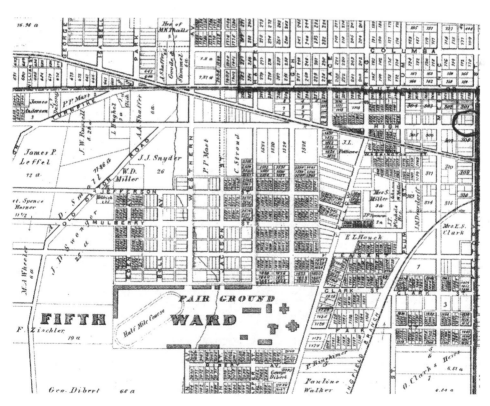

This 1875 map shows the progress of the platting and therefore housing development. Note Yellow Springs Street running in front of the Fair Grounds. The county fair was held at this site from 1853 to 1925, afterwhich the area became a city park. In the mid 1940s , the front section became the site of Fulton School, and in 1972, the rear part was dedicated as Davy Moore Park.

As the above map shows, the principal north—south street through the West End is Yellow Springs Street, passing in front of the Fair Grounds and extending north to Buck Creek. Although mostly residential, this street soon became dotted with retail outlets. By 1895, nine grocery stores and four daily markets had opened between Main and Southern Avenue. Pleasant Street, extending east and west, just north of the Fair Grounds also developed retail shops, and in 1895 was home to a meat market, three groceries, and a drug store at the intersection with Yellow Springs Street. Saloons at this time were common in Springfield neighborhoods. Yellow Springs Street had three saloons in 1895—not many in view of the fact that city wide, the total in that year was over 140.

The quality of housing in the southwest started out as substandard, and would remain an area of largely inferior housing stock. This true was for whites as well as blacks. The lots were small, the houses were mostly frame, and many of poor construction. Indoor plumbing, though common on East High, was uncommon in the working class areas in the latter part of the 19th century. (Recall that the city water works were not built until 1882). Building regulations were either non-existent or not enforced. As the authors of the black history of Springfield, "175 Years of Struggle" wrote." Any lot owner could build any type of house—a shack built from used lumber, tin, or any material that offered shelter for a family, with out-houses included." Painting, the authors continued, was not done or not done beyond the primer coat. The area of black concentrated housing on the West End was known in the 1870s and 1880s as "Need More," a reference to substandard housing, sidewalks, curbs, and sewers.

Not all housing was inferior. Along, Main, High, and Yellow Springs streets, several well built houses could be seen. A substantial stone house a 215 Yellow Springs Street was the home of Elizabeth "Mother" Stewart, who in the 1870s led a failed effort to ban liquor in the city. The house is occupied today, but in a poor state of repair, fitting in well with the many uncared for houses in the southwest area of Springfield.

A measure of cohesion over the West End was provided by the many churches and schools that grew in number as housing increased. By 1895, ten churches all protestant had been built, five of which were Lutheran, and three of these were German. Zion was located at Columbia and Plum, St Luke's at Race and North, and St John's at Factory and Columbia. Mentioned earlier was the English Lutheran at High and Factory, while at Liberty and Center streets, the Third

English Lutheran held services. Three Baptist Churches served the West End, two of which were colored (see below). In addition there were two Christian Churches.

Like churches, public schools also followed the population. The new Board of Education opened an elementary school in 1854 on Main Street near Yellow Springs Street. Over the rest of the century, the Board built Dibert, Fair, Lincoln, and Fulton schools in the West End. The city's first dedicated high school was constructed in the West End. In 1875 Central High opened at the southwest corner of High and Factory, just across High from the future Crowell Publishing. Central would remain a high school until Springfield High opened in 1911. The building then became Central Junior High until it was demolished in the early 1930s and became a Crowell company parking lot.[7]

By 1870 about 2,000 blacks lived in Springfield, the largest concentration residing in the southwest to the east and north of the Fair Grounds. Since Springfield had become a city in 1850, segregated patterns of life between the races had been common. This was especially true with regard to the public schools and churches. Since its organization in the 1850s, the Board of Education had maintained a policy of separate elementary schools for blacks. Black parents in 1872, recognizing that their children's schools were inferior in terms of funding and supplies, petitioned the school board for integration of the schools (several whites also signed the petition), but the Board rejected the petition. In the same year of the petition, the Board opened the all black school, Garfield Elementary, on Pleasant Street near Center. In 1877, Ohio law prohibited segregated schools statewide. The local Board stalled on the issue, and the state goal of integrated schools in the city would continue to be a struggle, as large sections of the public continued to favor segregation.

Racially segregated churches were never the contentious issue as were segregated schools, and without controversy blacks and whites continued to open their own churches. A notable black church on the West Side was the Second Baptist Church dating from the early 1870s and located on Factory Street between Fair and Clark streets. About a decade later, the black community built the Third Baptist Church on Dibert Street.

An amenity of the southwest area was the grounds of the Clark County Fair, located along the west side of Yellow Springs Street. The fair at this site began in 1853 when the Clark County Agricultural Society purchased ten acres. Later more acreage was added, giving the agricultural

society forty-nine acres. In 1876, the county commissioners purchased the fair grounds from the society, and Clark County continued to hold fairs at the site until 1925. No fair was held again until 1947, but from this date the county fair was held at the former Springfield Airport site along South Charleston Pike.

Sometime after the fair ceased at the Yellow Springs Street site, the Springfield City Commission purchased the property, and turned it into the city managed Fair Park. Then in the late 1940s, the front half of the park that faced Yellow Springs Street was acquired by the school board for the construction of Fulton Elementary School, the old school on Dibert Avenue having been closed. The large area behind the school was continued as Fair Park until 1972, when the grounds were dedicated by the city as Davy Moore Park. Moore was a black resident of the southwest area who became featherweight boxing champion of the world from 1959 to 1963. Moore died in 1963 from head injuries sustained in the ring.

Irish Hill

The working class neighborhood in the southeast section of the city became known as Irish Hill, which developed near and adjacent to the factories located near the intersection of Mill (later Monroe) and Harrison streets and along the nearby railroad tracks. These factories were the same ones noted earlier as part of the southeast factory cluster. Again they were the Champion Bar and Knife and the Champion Malleable Iron Company, both part of the Whiteley empire. The Champion Chemical Company (no relation to the Whiteley interests) was also located nearby. About four blocks east along the same tracks, the East Street Shops were located and nearby the Wickham Piano Plate Company, the Superior Gas Engine Company, and Commonsense Engine Company also turned out their products. All of these factories were within easy walking distance from any street in Irish Hill.

The western boundary of Irish Hill is usually taken to be Limestone Street south of the downtown. The neighborhood then extended east to East Street, while on the south Clifton Street (later Salem Avenue) formed the boundary. On the north, the railroad tracks bordered the area. Thus, this working class neighborhood began only about three blocks south of the wealthy East High Street.

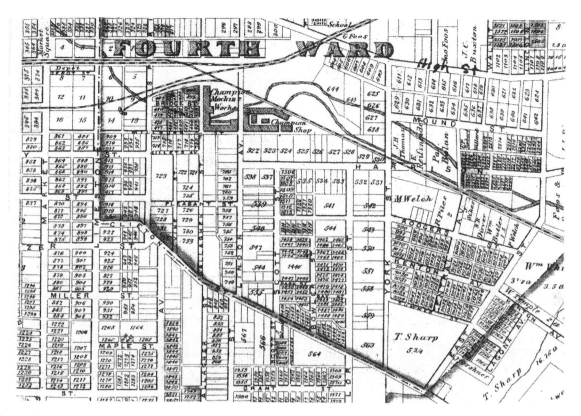

This 1875 map shows the Irish Hill area. The north side of the neighborhood is the railroad, indicated by the slanded dotted line. The dark line below the rail tracks is Clifton Street (today's Salem Ave). East Street is seen on the right, while Limestone is at the far left. Note the factories along the railroad tracks.

Irish Hill growth paralleled that of the southwest area, as significant platting took place in the 1870s and 1880s. However, two rather large additions occurred much earlier. In 1848, forty-seven lots, known as Reeder's Addition, were platted long Mill and Gallagher streets to Clifton Street. An 1854 addition of sixty-eight lots were laid out from Cherry Street (in 1874, Cherry was renamed York Street) east to East Street, near the southern side of the neighborhood. After this date, the new additions were small, many less than ten lots. A somewhat larger plat of twenty-one lots were laid out on Kenton Street near East Street. And in 1882, seventeen lots were platted along Mound Street at the northern edge of Irish Hill.[8]

As the name implies, the Irish were the dominant ethnic group of the neighborhood. A small number of blacks, who worked for the High Street wealthy, lived along Mound Street, which was convenient to their work places.

During the 1880s, four Protestant churches had been established in Irish Hill. The large Second Lutheran Church was built in the early 1880s, fronting Clifton Street at Pearl. The building still survives, but the Lutherans departed about 1988. Other area churches included the Clifton Street Methodist Episcopal Church, the East Street Baptist Church, and the AME Church on Summer Street. These churches, however, were dwarfed in prestige by the St Joseph Catholic Church. As the city's number of Catholics grew, the St Joseph parish covering all of Irish Hill, as well as adjacent areas, was formed. The parish's first building was not, however, the church, but a three-story elementary school opening in Fall 1883. Located on Kenton Street, about three blocks west of the East Street Shops, the school doubled as the site for parish masses until the church was opened.

By 1892 construction of the church had begun next to the school, but work was halted for financial reasons in 1893 and 1894. The Gothic Revival church, costing $ 25,000, was dedicated in October 1897. Work would continue over the next decade, as permanent windows and pews were installed in 1904 and an organ in 1908. To round out the complex, a parish house was built in 1915, followed by completion of the St. Joseph High School in the early 1920s.[9]

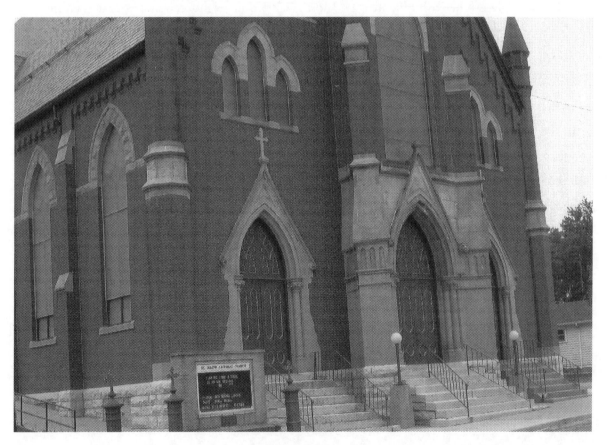

St Joseph Catholic Church. Completed on Kenton Avenue in Irish Hill area in 1897.

The church's first priest, Father Berding, established a Total Abstinence Society in which members pledged to avoid all alcohol consumption. The success of this society was doubtful, as the heavy drinking Irish over previous years had established many saloons in the neighborhood. The 1883 city directory listed about twenty-two saloons throughout the housing area. There were four each on Taylor, Pleasant, and Scott streets, two each on York, Clifton, and Gallagher streets, and the others scattered among the area. Thus, for any resident it was a short walk for a drink. The Irish Hill saloons outnumbered the neighborhood grocery stores, of which there were nine in 1883. By the 20th century, Clifton Street (later Salem) developed several retail outlets, and by 1915 the street held nine groceries, two confectioneries, a drug store, a cigar store, and a billiard room.

North Fountain Avenue

Springfield's area north of Buck Creek developed later than the wealthy and working class neighborhoods south of the creek. This area from the Buck north to McCreight Avenue was incorporated into the city by the 1850 legislation that designated Springfield as a city. Well before incorporation, however, two early settlers recognized that the northern area held promise for growth and purchased large tracts of land between the creek and McCreight. In the 1830s, Dr Robert Rogers bought a tract to the east of Limestone Street (then the Urbana Pike), followed in a decade by Isaac Ward who bought on the west side of Limestone.

The establishment of Wittenberg College in 1845 may have signaled to Rogers that growth of the area was certain, for in 1848 he registered his first plat, consisting of twelve lots east of Limestone and a short distance north of Buck Creek. Two years later Rogers laid out a parallel row of fifteen lots on the north side of the first plat. Still optimistic for the area's future, Rogers in 1873 platted over 100 lots north of his previous plats. Yet the area's growth was slow. An 1870 map showed that just thirty-four homes had been built on Rogers' platted lots

The slow movement to the north of Buck Creek prior to 1875 was no doubt due to the lack of bridges across Buck Creek. Only at Limestone Street had there been a bridge dating back to the early Demint plats. It was not until the early 1870s that a second bridge was built across the Buck. Although just a block west of Limestone Street, a Market Street bridge was supported by the college, because it would provide a shorter route than Limestone Street for city fire trucks. When the city procrastinated on the bridge issue, the college and Isaac Ward jointly built the

first Market Street bridge. The City Council in the early 1870s then agreed to be responsible for the bridge maintenance.

Wittenberg students especially wanted a bridge at Factory Street, which was a direct line between the campus and the First Lutheran Church attended by the students. Kinnison in his history of Wittenberg recounted that students were forced to use stepping stones in Buck Creek in order to reach the church and return to the campus. In the college newspaper, the students made an economic argument in favor of a city constructed bridge. The paper calculated that between 1845 and 1870, the college had contributed about $1.2 million to the local economy, while the city during the same period had spent just $ 20,000 for the benefit of the college.

The city may not have been swayed by the students' argument, for other bridges were given priority over a Factory Street site. An 1875 Springfield map shows a Buck Creek bridge at Limestone, Market, and Plum streets, in addition to one at Bechtle Avenue at the far western end of the city. The students were forced to wait until the late 1870s for a Factory Street bridge.

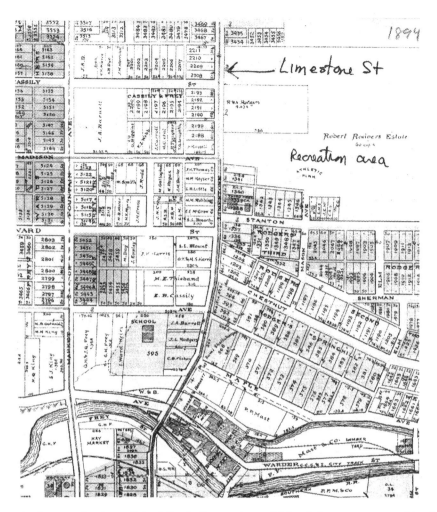

This map shows the heavy platting of the North Fountain and North Limestone neighborhood in 1894. The dark area on the north side of Buck Creek is the P.P. Mast factory site. The open area, labeled Park Area, was managed by the YMCA as a park and recreation area for all residents during the 1880s and 1890s, prior to the city obtaining Snyder Park. In the early 20th century, the area gave way to real estate development

After the bridges were in use, platting picked up north of the creek. In 1875 and again in 1882, George Frey laid out about thirty lots covering most of the large square block fronting on Market Street (Fountain Avenue) and back to Center Street, between College and Ward streets. Throughout the 1880s and 1890s, new plats continued to be filed along Fountain Avenue north to McCreight. Many of the residents north of the Buck were members of the First Lutheran Church, located south of the creek. By the late 1880s, they formed a congregation and began buying lots along North Fountain for new church. Until a church building was completed, the congregation held church services in the chapel of Wittenberg's Recitation Hall. In the late

1890s, the Fourth Lutheran Church opened on North Fountain Avenue near Ward Street It remained the Fourth Lutheran until about 1988, when the Good Shepherd on the southeast side of the city closed, and at that time, the Fourth Lutheran, still in the original building, became the Good Shepherd Lutheran Church.

Into the 20th Century

As Springfield's 19th century gave way to the 20th, the city could look back and see decades of steady progress in industry, commerce, education, and civic life, but if the subject of city parks arose, a city booster would have little to say. For Springfield was well behind other Ohio cities, which in the latter 19th century had established public parks for the enjoyment and relaxation of its residents. In this period, many reformers labeled city parks as the "lungs of the city," a place of respite away from dirty air and grime of the industrial city. Aside from its cemeteries—the small Dement Cemetery, the larger Greenmount, and the very large Ferncliff—Springfield had no place for a quite retreat.

This urban deficiency was remedied in a large part by John and David and Snyder, who in 1894 donated 217 acres of natural land to the city for use as a public park. Located on the west end, just outside the city's 1882 boundary, the land was shaped in roughly, a quarter circle that began at Plum Street, then extended west, then south, where it met the National Road, near the Mad River. The lush area of ample trees, shrubbery, and meadows was enhanced by Buck Creek that flowed through the parkland on its way to the Mad River. The City Council would formally name the gift Snyder Park. Large enough for natural areas, boating, picnics, music programs, shelters for family gatherings, and a golf course, the park soon became a popular destination point.

David Snyder added to the land gift by endowing the park through his will for $ 200,000 to be used for maintenance. Later the brothers gave $ 25,000 for the construction of a steel truss bridge across Buck Creek in memory of a third brother, William. The land and subsequent monetary gifts made it Springfield's most enduring and by far its largest gift, more than doubling Benjamin Warder's $ 100,000 for the 1890 public library and Thomas and Mitchell's $ 100,000 for the city's first hospital.

The gift came with the stipulation that the city would soon spend $ 20,000 from its budget for such park amenities as walking paths, a lagoon, bandstand, a boathouse, and the like. The

city moved relatively fast on the requirement and exhausted the $ 20,000 by 1897. Although all this came during the 19th century, much of the large improvements were not completed until after 1900. In the 1920s, a golf course was laid out and ready for use. During the 1930s, the city obtained New Deal funds from the Works Progress Administration (WPA) for the construction of tennis courts, horseshoe pits, and a golf clubhouse. A significant 20th century change was the city's annexation of the park in 1910.

In appreciation of the Snyder brothers gift, a public fund drive led by Asa Bushnell secured the funds for the construction of Memorial Arch at the Western Avenue entrance to the park. Designed by noted Springfield architect, Robert Gotwald, the large stone structure was built for the ages. It was dedicated on July 4, 1905.[1]

Arch in memory of the Snyder Brothers who donated the land for Snyder Park. Located at Western Avenue entrance to the park. Dedicated July 4, 1905.

Festering 20th Century Problems

In spite of Springfield's promising economy and recent recreational assets, there remained cogs amid the prosperity that 19th century Springfield had allowed to fester, leaving the warts

to future generations. We left the 1890s with the city's new water system established in the southeast section. The improvements made in the new works after its transfer from Laconda gave city officials confidence in its future performance. Such confidence proved to be ill founded, for the fire department was soon plagued by low water pressure leading to financial losses and major asset depletions to the city.

Water Problems

Between 1890 and 1904, sixteen major fires plagued the city. While many had been controlled by hose lines using pressure from nearby hydrants, the more serious fires exposed defects in the system that made it impossible for the fire department to contain certain fires. Springfield's fire chief in his 1890 annual report informed the City Council that water pressure was low in many areas of the city, a problem made more acute for the downtown's multi-story buildings that required increased pressure for the water stream to reach the upper floors. Since 1895 the fire department had an up to date steam engine, which in this period was considered essential for fire fighting, as the purpose of such engines was to increase the water pressure of poor performing hydrants.

The new water plant and steam engine got their first meaningful test on December 28, 1900, when the Hamma Divinity School at Wittenberg College caught fire. As the fire chief feared, the water pressure from the hydrant at the bottom of the campus hill was so low that the water stream failed to even reach the building. A steam engine was called and driven part way up the hill, and the hydrant hose attached to it. The water stream was increased, and the fire was extinguished, but because of the time needed to get the steam engine in service, the building and its contents were a total loss.

Low water pressure was also a handicap in two succeeding fires. In January 1901, the E.W. Ross Company on Warder Street (north side of Buck Creek) was destroyed by fire, low water pressure being cited as a factor. The largest of all fires occurred in the city's largest building, the East Street Shops that William Whiteley had built in 1881-82. After the collapse of the Whiteley works, many companies had leased space over much of the building. On February 10, 1902, fire began in one of tenant companies, and in the absence of firewalls, the flames spread quickly to other businesses. Upon arrival of the fire department, two firemen climbed to a fourth floor site intending to flood the floors below, but little water came from the hose. All building occupants

suffered losses, but the most severe was felt by the Krell French Piano Company, which just a year earlier, this Cincinnati based company had purchased the north side of the building, and had plans to produce 12,000 pianos annually. Low water pressure had prevented specific attempts of the fire department to save the company. Krell's loss was $ 250,000. A bitter Albert Krell made the following statement to the newspaper.

> There is no excuse for the lose of the East Street Shops. I consider it criminal negligence
> on the part of the city . . . We applied for proper fire protection, but the city refused to
> aid us. The town is to blame and is responsible.

The supervisor of the water works maintained that water pressure was adequate, pointing out that the water system was not designed to take the place of steam fire engines that are necessary for fighting large fires. The following year, water pressure was not a problem at the Black's Opera House fire. The loss of the 1869 building at Fountain and Main streets was attributed to the problem of getting a hose attached to a nearby hydrant and a delay in sounding a second alarm for another steam engine to the scene.[2]

In addition to low water pressure, Springfield had historically experienced problems with water quality. A 1956 doctorate dissertation focusing on the city's industrial development pointed out that as far back as 1880, Springfield's water had been "hard, "that is, having a high concentration of iron and lime. This condition resulted in higher costs to the city, as plumbing repairs rose, insurance rates increased, and the life of water meters decreased. In 1935, the state health department, citing insufficient purification, condemned the city's water as unsafe, leading to a state Supreme Court order in 1938 to remove the toxins. Fear of impure water in this period resulted in the U.S. Public Health Service to prohibit passenger trains from taking on water in Springfield. According the 1956 dissertation, state health department officials actually discouraged industrial firms from locating in Springfield, citing undependable and poor water quality. The city administration was not blind to these events, and made attempts in the 1940s to rectify the city's water problems, but was blocked by citizens fearful of increased water rates.

It was not until the mid 1950s that a comprehensive solution to plaguing water problems was made. In late 1955, the voters passed a bond issue that enabled the city to abandon its 1895 water works. The following year, the city purchased fifty-one acres of farmland at $ 750 per acre near Eagle City in Moorefield Township, where a new water works was constructed.

The new works in northwest Clark County appeared to give Springfield a dependable source of water, both as to purity and supply. The new water source was the Mad River, which has a lower mineral content than previous sources.[3]

Mill Run Problems

In chapter two, we pointed out that Mill Run in 1877 had been covered with stone from Market Square to Buck Creek in order to eliminate flooding and muddy conditions. This action, however, turned the stream into a truck line sewer, creating disposal problems and endangering buildings over it. These problems were largely ignored in the 19th century, and were not solved until well into the 20th century.

An academic study of Clark County in 1904 concluded that Mill Run was receiving the contents of 175 sewers, most of which were constructed by individuals. When the stream was initially covered, the bottom was not lined, allowing garbage to become stuck in crevices along the uneven bottom. The city made little attempt to clear the mess. During heavy rains, the strong water flow flushed out some of the filth, putting more burden on Buck Creek. In December 1903, the state health department, according to the 1904 study, "scores the city on account of these disgraceful conditions, and states that the present system is a gross blunder." The city health officer presented a plan for a new sewage system, but it was rejected by the state health department, which recommended the construction of a filtering plant for the city's sewage. This, however, was about three decades away.

A different problem of Mill Run concerned the continuing deterioration of its stone structure, resulting in subsidence beneath downtown buildings. In 1911 along South Limestone Street, a wall of the Columbia Theatre (later the Regent Theatre) collapsed into Mill Run, killing two workmen. A new theatre was built, but no permanent solution was made to Mill Run as a sewer. In 1929, a section of the Arcade fell into the sewer. Again in 1935, part of Ripley Motors on North Street collapsed, resulting in several cars falling into Mill Run sewer.

The voters passed a $ 1.75 million bond issue in 1928 for Mill Run improvements, but most of the money was directed by the city for construction of a sewage treatment plant that was completed on the far west side in 1935. The much needed treatment plant was built largely with a WPA grant as part of the federal New Deal program. The new treatment plant had immediate

benefits, as its intercepter sewer line diverted sewage from Mill Run to the plant. But by 1952, the now seventeen year old plant had become overloaded, and the state Water Pollution Control Board ordered the city to double its capacity. After three studies and numerous state permit extensions allowing the 1935 plant to continue operations, an improved and larger treatment plant went on line in 1961, thereby sparing Mill Run sewer a deluge of sewage.

Meanwhile, through the years, the Mill Run sewer continued to structurally deteriorate. City Manager, Harold Caplinger in January 1967 took a walking tour of larger sections of the sewer, and found clay tiles cracked, keystones hanging loose from the ceiling, and wooden beams rotting. After an engineering study, a nine million dollar bond issue was put before the voters, but in November 1968 it was rejected by a two to one margin. In the early 1970s, federal grants finally allowed a permanent fix of Mill Run, at least in the downtown area (southeast of the downtown Mill Run is still exposed, but there it was never covered for a sewer).[4] See illustration of the fix below.

The uneven line illustrates the historic path of Mill Run through the city to Buck Creek. The dotted line represents the mid 1970s deep sewer pipe that intercepted Mill Run sewer water at Fountain and High. The new line did not empty sewage into the creek, but from another line not shown diverted sewage to the west side treatment plant.

Racial Problems

Racial relations in Springfield had historically been contentious and discriminatory to blacks, reflected in school segregation, but in the early 20th century relations came to a violent head in the wake of a shooting death of white police court bailiff by a black man, Richard Dixon. Dixon had been ordered by the police chief to stay away from a woman, Mamie Corbin, with whom he had been living unless accompanied by a police officer. On Sunday, May 6, 1904, the bailiff, Charles Collis, accompanied Dixon to Corbin's home so he could pick up personal belongings. When Corbin refused to admit Dixon, he in the presence of the bailiff, pulled a pistol from his pocket and shot Corbin in the chest. As the bailiff grabbed for the gun, Dixon then shot the bailiff. Dixon immediately ran to the police station in the City Building and surrendered, shortly to be locked in the county jail behind the courthouse.

Corbin was not in serious condition, but Collis, the bailiff, died in the hospital the next day. As the news spread overnight of the circumstances and the bailiff's death, a white mob gathered at the jail, and on Monday evening broke into the jail, dragged Dixon out, and shot him to death. The next day, a white mob again formed, marched to a black area called the "Levee," which was located along the Washington Street railroad yards between Spring and Gallagher streets, and set fire to several black homes and businesses. Five members of the mob were later brought to trial, but all were found not guilty, as all witnesses testified that they did not see the charged men do anything illegal.[5]

Other violent confrontations occurred between whites and blacks, notably in 1906 and 1921. Racial relations in Springfield, poisoned by such violent incidences, remained in tension at least until the federal civil rights legislation of the 1960s.

Housing

We have seen that working class housing in the southwest area, and by implication also in the southeast, was largely substandard as it was built in the 19th century. Into the next century, improvement was not seen. Much of the housing was built on small lots, in backyards of earlier built homes, and even along alleys. The many factories within these areas added to the unkempt and uncared for appearance of the neighborhoods. Moreover, the educational level of the residents was low, and many residents were transient, resulting in a low interest in civic pride. Hence,

organized attempts at neighborhood improvement was not possible. In the early 20ᵗʰ century, other than street repair, government help could not be expected.

When federal housing legislation began to be passed in the 1950s, neighborhood housing studies began to be made, which painted an unflattering picture of the west side and the southeast areas. For Irish Hill, a 1950 federal housing census found.

1. 47% of dwelling units were substandard.
2. 27% of all structures were recommended for clearing, including all alley housings.
3. 41 % of all houses were in need of major repairs, and 33% needed minor repairs.
4. Many streets needed paved, and gutters, sidewalks, and sewer mains needed repaired.

In the East Street area of Irish Hill, adjoining the site of the old East Street Shops, the census found that home ownership was less than 50 percent, and 37 percent of housing needed cleared. In this area of the neighborhood, 59 percent of housing was rated substandard. Substantial housing demolition occurred throughout Irish Hill in the late 1950s, which reduced the percentage needing cleared in the East Street area from 37 to 18 percent.

For the West Side, the 1950 census included the area to Buck Creek, as well as the southwest section. The study found the area predominately tenant occupied, but with little crowding. Specifically, the census showed.

1. 32% of all housing was substandard (decreased to 16% in 1960 due to demolitions.
2. 23% of all houses were recommended for clearance.
3. 67% were in need of major repairs.

Moreover, the 1950 census concluded that the area had a strong potential for increased dilapidation, due to the many alley dwellings, inadequate side yards, and the ongoing conversion of single family houses into multiple family units and rooming houses.[6]

New Businesses and Changing Culture

As important as the resolution of the foregoing problems may seem, they did not in the early 20ᵗʰ centry appear to rank high on the public's radar screen. The water problem could be

seen as a non urgent issue. After all, the city had not experienced a threat to public health, nor had there been a serious water shortage. Racial strife could easily be forgotten as the riots ended. Although poor housing would continue in the working class areas, this too could be overlooked as new middle class housing areas opened in the new century. The early decades showed a steady population increase in Springfield, which boded well for commerce and industry. The federal census showed.

1900	38,253
1910	46,921
1920	60,840
1930	68,743

Bolstered by such population growth, the city's economy would continue to hum, while any social problems stayed beneath the surface. For most springfielders their interest was directed at changes within the business environment. These concerned the corporate culture and the relative position of the local economic sectors.

Fading rapidly were the independent entrepreneurs of the previous decades, who with one or two partners founded their companies, built them as they saw fit, and financed expansion from profits or took out a loan from a personal banker. Many as James Leffel and William Whiteley, not only had the entrepreneur drive to build their companies, but also invented the product. As their companies grew, the 19th century owners acquired a paternal outlook toward their creations, and tended to take a dim view of attempts by labor unions to interfere with company management and personnel matters. This controlling attitude did not mean that the founding industrialists lacked compassion for their workers. Many of the 19th century owners took worker welfare seriously. This could take the form of establishing an employee cafeteria, funding on site medical care, and even helping workers finance a house.

Many of the past century owners had the energy and civic spirit, as Benjamin Warder and his partners, to concurrently (not waiting until retirement) serve on bank boards, church governing bodies, and the YMCA board. Others, such as Oliver Kelly, P.P. Mast, and John Thomas served on the City Council, and as was the case with Mast and Kelly, served a term as mayor.

Charitable and religious giving was characteristic of the early wealthy industrialists. P.P. Mast gave $ 35,000 to the Methodist Episcopal Church and in his will left $ 7,500 to the Grace Methodist Church. Ross Mitchell and John Thomas together gave $ 100,000 for the city's first hospital. The Episcopal Church benefited over the late 19[th] century from the benevolence of Asa Bushnell, and after his death, Bushnell's widow gave 15,000 to Christ Church for a parish house. Bushnell further gave $ 10,000 each to the YMCA and the Masonic Home. William Whiteley donated $ 10,000 to help with the construction of the Laconda Hotel in 1868. Mentioned earlier was Benjamin Warder $ 100,000 gift to the city for the construction of the Warder Public Library.[7]

But as the clock rolled into the new century, Springfield's 19th century business giants were a dying breed. One of the first to pass was James Leffel in 1862. Others who left a large footprint on Springfield were.

William Foos	1892 died	Asa Bushell	1904
Benjamin Warder	1894	Oliver Kelly	1904
P.P. Mast	1898	John Foos	1908
Gustafus Foos	1900	William Whiteley	1911
John Thomas	1901	Ross Mitchell	1913
			John Crowell	1921

The new 20th century corporate heads in contrast to their 19th century forebears were teamwork and committee oriented, and compared to a Whiteley or a Kelly, could be considered dull, cautious, and adverse to risk. If money was needed, the new heads called on the investment banker who handled a stock offering, or a finance committee met for a discussion. For philanthrophy, a committee issued a collective decision. If employee problems arose, a personnel department was on hand.

Economic Sectors

The new style of corporate leadership was not necessarily wrong, just different. The test of the success of the new corporate culture would always in a commercial city be growth and profits. And for the century's first thirty years, the profits would continue. In these years, total manufacturing value in Springfield grew at a steady pace, but the relative strength of the economic sectors were changing, as new sectors made their appearance. Among the new sectors and those growing

stronger were primary metals, fabricated metals, machinery, and transportation equipment. The major primary metals firms were.

1. Western Foundry and Mgf. Company, founded in 1914.
2. Ohio Steel Foundry Company, founded in1917.
3. Springfield Aluminum Plate & Castings Company, founded in 1919.
4. Springfield Brass Company, founded in 1914.

The prominent fabricated metals firms were.Murray Black Company, founded in 1912 and Yost Superior Company, founded in 1915.

The recent machinery companies were.

1. Western Tool and Mgf. Company, founded in 1906
2. Thompson Grinder Company, founded in 1905.
3. Duplex Mill and Mgf Company, founded in 1908.

The major transportation equipment company was the Steel Products Engineering Company, founded in 1917. This company would expand considerably later in the 20th century.[8]

Springfield's 20th century manufacturing executives would no doubt have been pleased with the aggregate growth of product value. U.S. manufacturing statistics for Springfield showed the following growth pattern.

	# Employees	Product Value
1904	6,258	$ 13,392,000
1909	7,405	19,246,000
1914	7,868	27,722,000
1919	12,264	67,759,000
1929	12,003	110,223,000

One of the more interesting companies making up part of the above figures was the Westcott Car Company. Burton J. Westcott, born to a wealthy Richmond, Indiana family,

came to Springfield in 1903, and made the city his home until his death over twenty years later. His business career began while working for his father, who was president of the Hoosier Drill Company, a manufacturer of farm implements. When the company was absorbed by the Springfield based American Seeding Machine Company in 1903, Burton moved to Springfield to become Treasurer of the company.

Westcott is best remembered in Springfield as the manufacturer of the Westcott automobile. The car company had been established by the elder Westcott in Richmond, and produced its first car in 1909. Burton, well established in Springfield by 1916, brought the Westcott Motor Car Company to the city in that year, and shortly purchased the works of the former P.P. Mast and Company on the north side of Buck Creek between Limestone and Spring streets. The Mast plant, as we have seen, had been purchased in 1903 by Westcott's current employer, the American Seeding Machine Company.

Westcott had about a nine year run with the car company. His best year was 1920, when over 1,800 of his touring cars were manufactured. The average cost of the many Westcott models was about $ 2,000, compared, for example, with the $ 600 price of Henry Ford's Model T. Unable to compete with the Detroit giants, the Westcott Company began to bleed badly after its peak year, and by 1925 the company was in receivership, owing about $ 825,000 to suppliers.

As his car company was moving toward bankruptcy, Westcott became seriously ill in 1925, and died at his Frank Lloyd Wright home on East High in January 1926. Near the end of his life, with his wealth dissipated, Westcott was forced to turn over his splendid home to the bank.[9]

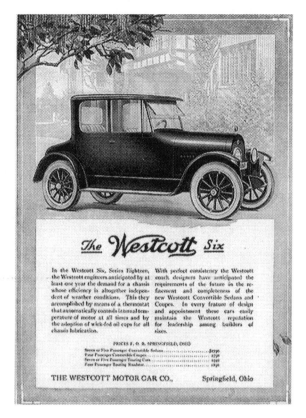

An advertisement for the briefly popular Westcott car.

Farm Implements and International Harvester

If Springfield's once dominant farm machinery would continue to hold its own among the other local economic sectors, it would largely be due to Warder, Bushnell, and Glessner, which as we have seen, continued as an independent company after the Whiteley crash of 1887. But soon after 1900, Warder would no longer be an independent company, becoming instead a branch plant of a much larger corporation, the giant International Harvester Company or as it would become known, IH. The background to the Warder's loss of independence can be readily highlighted.

The root of the mergers that created International Harvester was product overproduction. As far back as the Whiteley crash, the nation's farm machinery manufacturers throughout the 1880s and 1890s had been putting more farm equipment on the market than the farmers needed. Pricing wars, accompanied by increasing sales and advertising costs, sharply reduced profits. For example, in 1882 a six-foot binder sold for $ 325, but by 1900 an eight-food binder could be purchased for $ 110. Led by Illinois producers, McCormick and Deering, a consolidation

attempt in the mid 1880s with eighteen competitors had failed. Price wars, referred to as "guerilla warfare" by McCormick salesmen continued through the 1890s. By the turn of the century, McCormick and Deering brought in the J.P. Morgan investment bank to lead merger negotiations. Led by Morgan partner, George Perkins, a merger was agreed to in July 1902. The terms called for McCormick and Deering to buy a minority interest in each other's company. Then the two would acquire three other large manufacturers: Plano Manufacturing Company in the Chicago area, Milwaukee Harvesting Company, and Warder, Bushnell, and Glessner. The new name, as suggested by Perkins, would be International Harvester. In the early years, the merger had little of no effect on Springfield. The Warder works would remain in Laconda manufacturing farm machinery under the Champion banner, but the plant would be known as the Champion Division of IH.[10] Later the name became the Champion Works and finally the Springfield Works.

For nearly the next two decades, the old Warder firm continued to manufacture farm implements under the parent company in Chicago. During this period, Springfield's farm machinery product value (PV) increased from 1914 to 1919, but other sectors grew at a higher rate, leaving the farm machinery sector with a smaller percentage share of the whole, dropping from 21 percent to under 11 percent.

Sector Decrease of Farm Machinery

	#workers	PV farm mach.	PV total	% of total for farm mach
1914	1,447	$ 5,762,000	$ 27,721,000	21%
1919	1,575	7,206,000	67,759,000	10.6%

In 1906, International Harvester entered the truck manufacturing business, designing an "auto buggy," a large wheel delivery truck that farmers could drive on rough, rural roads. Seeing trucks as a future major product, IH continued to design and manufacture trucks of various models. The change in Springfield came in 1920, when the parent company began to re-equip the Laconda plant for truck production, and spring 1921, the International Model "S" Speed Truck began to roll off the line. Hay presses continued to be manufactured until 1925, but thereafter the Springfield Works would be entirely devoted to truck production.[11]

In November 1953, IH purchased 537 acres three miles north of Springfield, just east of State Route 68 for a future factory, which opened summer 1966. The new plant covered 1.75 million square feet. (Recall that Whiteley East Street Shops covered about one million square feet). The Laconda plant was kept open until 1988, assembling truck cabs for the new Springfield factory and for the Chatham, Ontario plant.

Administration and name changes followed: In November 1984, IH sold its entire agricultural equipment business to Tenneco, Inc. of Houston, Texas, thereby divesting itself of the products upon which the company was founded. The sale also transferred the right to the International Harvester name and trademarks. The new company name selected by he Board in January 1986 was Navistar International Corporation, and the Springfield Works became the Navistar International Transportation Corporation.

A significant expansion of the new works north of the city came in 1987, when Navistar opened a $ 78 million state of the art paint facility. As of June 1988, Navistar's Springfield employment was about 6,000.[12]

Crowell Publishing

A major event in Springfield's economic history is the phenomenal 20th century growth of the Crowell Publishing Company. The origin of the company was outlined previously up to 1906, when John Crowell acquired full control, and then in turn sold a controlling interest to Joseph Knapp of New York City for $750,000. Of the company sale, the News-Sun wrote in November 1937 that Crowell was "an old Kentucky printer" . . . who "when his magazines rolled up circulation of about a half million each, became so appalled by the problems of big scale publishing that he decided to sell out." After the sale, Crowell continued with the company, serving as Vice-President until 1908. He remained in Springfield, apparently enjoying his East High mansion he had built in 1905. In 1910, he took a position as vice-president and treasurer of the Kelly Motor Truck Company, and from 1912 to 1919 he served as president of the Elwood Myers Company. During these years, Crowell was named a director of the First National Bank, and also served on the Board of the YMCA.[13]

Outside ownership would matter little to the Crowell employees, for over the next five decades, Crowell Publishing employed thousands of Clark County residents, becoming a

keystone in the local economy, as illustrated by a few prominent statistics regarding number of employees and company payroll. Just prior to the acquisition of Home Companion in 1885 (later Ladies Home Companion), Crowell employed about thirty-five workers, with a weekly payroll of about $ 400. By 1900, as the sales of both Home Companion and Farm and Fireside grew, the weekly payroll was $ 2,250 and increasing to $ 3,500 by 1905. Acquisitions by the new owner of American Magazine in 1911 followed by the purchase of Collier's Weekly resulted in a further leap in sales. Collier's Weekly, dating from 1888, published both fiction and non-fiction, and had pioneered the short-short story of about 1,000 words. Fortunately, Crowell kept the same editorial policy, and saw sales grow from 1.5 million copies in 1926 to 2.5 million in 1931. By 1931, sales of American Magazine totaled 2.4 million, while Farm and Fireside sold 1.2 million copies. The workforce continued to increase, as the printing run in 1926 came to 11,000,000 copies per month, and the payroll for 1926 grew to $ 46,000 per week from $ 8,500 ten years earlier.

Growth moved ahead through the depression decade and through World War II. (In 1939 the company name was changed to Crowell-Collier Publishing Company). By 1947, the printing run had nearly doubled that of 1926 to 20,000,000 per week, while the weekly payroll more than tripled to $ 160,000.

During the 1930s two magazines were dropped. Farm and Fireside was renamed Country Home in 1930, but thereafter sales were disappointing, and in 1939 the magazine that started the company in 1877 was cancelled. The Mentor, a 1921 purchase focusing on the arts and travel never developed a wide readership, and was dropped in 1930.[14]

Physical Facilities: Additional space was of course needed to accommodate the growing printing run. John Crowell, while still owner, made the first addition to the original building in 1906 by extending the building on the north side or toward Main Street. The new owner followed in 1912 with an addition along Wittenberg Avenue (in 1907 Factory Street was renamed Wittenberg Avenue). Four additions in the 1920s extended the building along High Street west to Lowry Street. The large 1924 addition to the west also destroyed the original angled entrance at High and Factory in favor of new entrance facing High Street that was out of proportion to the large building. This addition also increased the height of the building to seven floors, the original building being three floors. The expansion included a 40,000 gallon water tank, perched on the roof over the entrance that was to be used to fight a fire. The addition of

1927 and 1929 were the ones bringing the building to Lowry Street. At the end of the 1920s, the plant had 726,000 square feet, as contrasted with original 1882 building of 50,000 square feet.[15]

The possibility of another expansion arose in March 1931. The News-Sun devoted most of its first page accompanied with photographs to announce that Crowell Publishing had purchased the square block directly across High Street from the Board of Education. Nearly all the block was occupied by Central Junior High School, an 1875 building originally constructed as the high school. The purchase price was about $ 425,000, making it according to the paper, the largest single land deal ever completed in the city. The president of Crowell announced that the purchase was part of the company's future plans. In the end, the school was demolished, and the square block became nothing more than a parking lot for Crowell employees.

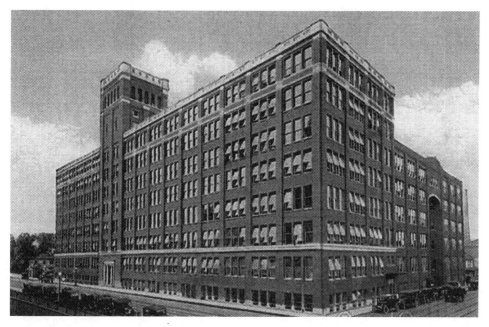

The Crowell-Collier Building after the expansions over a 40 year period. Compare with the original building in Chapter 2.

Decline and Fall: When Crowell-Collier made its final building expansion in 1947 by an extension to Main Street, the approaching power of television may not have appeared obvious to company management. Television programing in fact had begun in 1941, and by 1951, there were ten million sets in the country. It is easy to assume that Crowell-Collier was brought down by the reading public largely giving up their magazines in favor of television, but the

News-Sun reported that in 1956 when Crowell closed, circulation figures for the company's three magazines—Collier's, the American, and Women's Home Companion—were at their all time high. The crucial fact in assessing the company downfall was that advertisers were taking their advertising dollars out of magazines and buying television time. By the mid 1950s, Crowell-Collier was losing revenue on every magazine it sold. For Women's Home Companion and Collier's, the loss was nine cents for each magazine sold. Such financial data made the plant closing inevitable. While not considered a major factor in the company closing, the News-Sun, having its ear to the ground, reported that trade union negotiations were costing management thousands of dollars. In spite of the many worker skills, the employees were not represented by one large union, but by a union for each skill. The seemingly never ending negotiations were costly and frustrating to management, and was thought by the News-Sun to have played a part in the closing.

The closing announcement was made on December 15, 1956, and on the following Monday, over 400 workers were dismissed. By the end of 1957, all 2,275 employees had lost their jobs.[16]

The building was soon sold to another publishing company, R.R. Donnelley and Sons of Chicago, which stripped the building of its equipment, and donated the shell of a building to the University of Chicago. It proved to be of no use to the university, but it was stuck with the structure until 1972. At that time it appeared that the city of Springfield might purchase it, for the city then was thought to have access to federal funds necessary for the building's demolition, about $225,000. There was littledoubt that the city wanted it razed. Mayor Robert Burton stated that ". . . the city does not want that monster to remain an eyesore and a reminder of a long deceased industry." In the end, the building was acquired in 1972 by Harry Denune of Columbus, who used the building mainly as a storage depository.[17]

Neighborhoods

Industrial growth of the early 20th century promoted a general prosperity citywide. This was reflected in the number of dwelling units constructed and building permits issued. The Todd academic study of 1904 concluded that from 1900 to 1904 more dwellings were erected than in any other period of the city's history except that of the late 1860s and early 1870s. The Springfield News reported in December 1905 that over the past three years, about 450 new

houses had been erected, and for 1905 based on permit numbers about 400 new buildings would be constructed.[18]

Such figures of course indicated the establishment of new neighborhoods, a few of which were North Fountain Avenue, Elmwood Place, Warder Park, Northern Heights, Ridgewood, and Harshman Place. Underlying the new neighborhood growth was Springfield's increasing population. In 1880 when many neighborhoods south of Buck Creek were expanding, the city's population was 20,730. By 1920 when the new neighborhoods north of Buck Creek were flourishing, the population had reached 60,840.

North Fountain Avenue: We mentioned earlier the heavy platting along North Market (North Fountain Avenue after 1889), North Limestone Street, and the side streets following the construction of the Market Street Bridge in the early 1870s. In the 1890s, two upscale houses designed by Robert Gotwald were completed on the west side of Fountain Avenue a short distance north of Buck Creek. Both remain today and in good repair. After 1900 construction of North Fountain intensified; most of the private homes were large and architect designed. One of the most impressive was theatre magnate, Gus Sun's large brick, Federal style house at number 840. Today the house belongs to a Wittenberg sorority, still with the white portico reaching to the roof line and supported by four classical columns.[19]

In the November 1916, Sunday News ran a several page spread with photographs of seven North Fountain houses. The News wrote of these homes: "They are owned and occupied by a people whose first pride is in their homes and the surroundings which are to be provided for growing families."[20] Today many of the large homes, oversized for modern families, have been purchased by Wittenberg student societies, which has proved to be a convenient method of preservation.

Elmwood Place: This addition was platted in 1902 and attracted upper middle class families, who have preserved the property well for over a century, and remains one of the city's better neighborhoods. This addition fronts south side of East High Street for four blocks between Belmont and Clairmont avenues. From High Street, Elmwood Place extends south about four blocks. In the early 20th century, the sub-division was marketed as having perfect drainage, wide streets, cement sidewalks, and planted throughout with American elm trees. The show place

street continues to be Arlington Avenue, extending south from High. The avenue features a center parkway, planted with trees with a traffic lane to each side.

A contemporary photo of the attractive Arlington Avenue in the Elmwood Place neighborhood.

Warder Park: This neighborhood is unique for who conceived it and made it a reality. In 1911 Springfield was in the midst of a housing shortage, especially for families of factory workers, as the city's industry was hitting on all cylinders. Consequently, the Commercial Club (predecessor of the Chamber of Commerce) stepped forward and platted about 340 building lots for working class housing in the far northeast side of the city. The addition extended from Belmont Avenue east to Burnett Road. On the south, it was bordered by Hillside Avenue and extended north to Columbus Road. The plat was conveniently located, for it was within walking distance of several large factories, including International Harvester in Laconda, and Robbins and Myers and James Leffel Company both on Laconda Avenue. The Kissell Real Estate Company handled the sales, pricing a two bedroom house at $ 3,200. Warder Park remains today a clean and orderly appearing neighborhood of many, small, one-story houses on small lots.[21]

Northern Heights Addition: Nearly abutting the North Fountain neighborhood, the 265 lots of the fifty-eight acre Northern Heights addition went on sale in October 1913. The addition,

handled by the Northern Heights Realty Company, was located on the east side of Limestone Street and extended four blocks east to Murphy Street. Bounded on the north by McCreight Avenue, the addition covered the two blocks south to Cecil Street. The sales advertisement touted graded streets, cement sidewalks, natural gas and electricity, adequate sewers, and streets shaded by giant maple trees. Lot prices ranged from $1,000 to $ 1,350 on Northern Avenue, which was especially favored by Maple trees. Cecil Street lots sold between $525 and $ 850. The houses built in this neighborhood were more pedestrian than those on North Fountain, but solidly middle class.[22]

Ridgewood, In the Country Club District: Following the early development of North Fountain Avenue, there would be many housing developments in Springfield's north end. One, however, was unique from the others, this being Ridgewood, in the Country Club District. Conceived for the city's affluent by local real estate developer, Harry Kissell, Ridgewood in terms of design, landscaping, and overall planning stood at the apex of Springfield's housing developments. Kissell, a native of Springfield, was the son of Cyris Kissell, who had founded his own real estate company in 1884. A short time after graduating from Wittenberg College in 1896, young Kissell joined his father's company, and in 1903 upon the death of his father, Harry then twenty-seven became head of the Kissell Real Estate Company.

In the early 20th century, East High Street and Fountain Street still were the neighborhoods of choice for the city's wealthy. Yet while the affluent continued to build on these streets (recall than John Cowell built his East High mansion in 1905), there was a growing feeling that the neighborhoods—specially South Fountain—were becoming somewhat dated. Kissell having grown up on South Fountain understood these views, which largely grew from recent technological changes and changing living patterns for the wealthy. South Fountain houses, more so than those on East High, had been built on small lots, allowing only small front and side yards. Moreover, South Fountain had been platted with alleys in order to give access to carriages and horses. By the early 20th century, the alleys were not only unsightly, they were in the automobile age redundant. Another problem concerned electricity. The grand houses had been built before the electric age, and therefore later had to be retrofitted with wires and conduits, which were sometimes exposed.

This was the negative side of Kissell's thinking. On the positive side was his knowledge of earlier planned residential communities, notably J.C. Nichols Country Club District in Kansas

City beginning in 1906. With an eye on such trends, it was easy is for the talented Kissell to visualize a planned residential community for Springfield. As his plans were formulating, Kissell had his eye on a 120 acre tract of land between McCreight Avenue and Home Road, an area that had been within the city limits since 1882. An advantage to this acreage was that its northern edge was adjacent to the Springfield Country Club property, whose rural setting began at Home Road. A country club next door to the development would be an added draw, for many of the wealthy men building homes would be country club members. In addition, the site was favorable due to its elevation, which was about fifty feet higher than the downtown. With the Mad River valley to the immediate west, cool summer breezes would be felt in Ridgewood.

Kissell's right arm in the Ridgewood endeavor was Brown Burleigh, Wittenberg College graduate, who joined Kissell's firm in 1909 and soon became sales manager. By early 1914, Kissell and Burleigh had acquired all of the 120 acres up to Home Road. Kissell wasted no time getting the plat ready for presentation to the City Commission, which the governing body approved in July 1914.

Kissell would develop Ridgewood in a manner unlike any other Springfield addition. Previous platters took little long term interest in their plats. After the plat was approved and the lots sold, the platter was finished, leaving the utility hookups and the assessment to the new lot owner. Ridgewood, on the other hand was planned for the ages. Kissell's firm would design the streets as to width, paving, curbs, and sidewalks, and even to the location of telephone poles. Lots would be surveyed to allow for ample yards. All utilities would be brought in at company expense, thereby eliminating assessments on the new owners.

The key to Ridgewood's success was property restrictions, something nearly unheard of in all previous Springfield developments. Some of these restrictions were:

1. A 55-foot housing setback from the street.
2. The space between houses was defined.
3. No one-story houses.
4. No outbuildings
5. Fence types defined.
6. Minimum price of house set (varied with street).

The purpose of these restrictions was of course to protect the physical appearance of the entire community for decades to come, and thereby to maintain the property values. Ridgewood would never have a piecemeal look, as did earlier developments, including East High Street.

A small sample of the many well designed streets and yards in Ridgewood.

The spine of Ridgewood would be Fountain Blvd, which was an extension of Fountain Avenue. The new Boulevard, with a center parkway, extended from McCreight Avenue to Home Road, where it met the lane into the country club. The parkway with a traffic lane to each side made the Boulevard 100 feet wide. Streetcar rails were laid in the center parkway, remaining there until 1933 when the streetcars ceased running. Thereafter, the parkway was planted with trees over the full distance.

In spring 1919, Kissell was able to enlarge Ridgewood when he purchased forty-two acres on the west side of the original tract. The acreage had been owned by he Knights of Pythias, whose large, striking building fronted on McCreight to the west of Fountain Blvd. Unlike the initial 120 acres, the purchase was heavily wooded, and became prime housing sites known as the "Woods." The Woods plat was characterized by curved streets and irregular lots, which brought

a price of $50 to $60 per front foot, in contrast to many of the other lots that sold for $30 to $50 per front foot.

Kissell and Burleigh were satisfied with Ridgewood's early progress, but sales slowed during World War I, not only because men were drafted, but also because of a shortage of building materials. During the 1920s, sales and housing construction turned around to the point that by 1925 Kissell would bring the development work to an end. By 1926, 203 homes had been built, and by 1930 over 260 houses throughout Ridgewood were completed.[23] Today Ridgewood has long since been fully filled out. Whereas East High Street and South Fountain lost their panache after just thirty years, and the well to do largely turned away from those neighborhoods, Ridgewood now approaching its first century still remains a magnet for those of means. The development's detailed and careful design, accompanied by enforceable restrictions has fulfilled Kissell's dream of Ridgewood as a planned residential community for the ages.

Harshman Place: As Ridgewood became familiar to local real estate developers, they grew appreciative of the successful restrictions that Kissell had employed in Springfield. When the west side Harshman Place addition of 165 lots on the east and south side of Snyder Park went on sale in June 1923, the following restrictions were advertised. a) minimum price of house set at $5,000, b) set back lines at front and side of each house, c) no commercial buildings, and (d) height of fence specified. Furthermore, the Daily News advertisement promised a six inch water main, a for inch gas main, both storm and sanitary sewers, graded streets and fire hydrants. The lots began at Snyder Street and curved in a quarter circle, ending close to the National Road. The middle class neighborhood would remain well maintained and attractive into the next century.[24]

During the first three decades of the 20th century, developers kept busy surveying new additions and building houses, as the city's population had increased by 8,000 during the 1920s. For the latter half of the 1920s, the number of building permits and monetary value totaled.[25]

	Permits	Value
1926	27	$ 916,000
1927	285	879,000
1928	309	936,000
1929	245	790,000

The Downtown Again

As Springfield's industry undergirded the local economy, construction of significant new buildings continued into the 20th century. Although much of the new construction was in the downtown area, two buildings outside the center city are noteworthy for fulfilling special needs. The first was the City Hospital, which opened in 1904 at the intersection of Salem Avenue and East Street in the southeast part of the city. Then the area was suitable for a hospital—quite and semi rural, an improvement over both the facility and the noisy site of the city's first hospital on East Main Street near the railroad tracks. Although unsatisfactory, this 1887 facility was a noble effort on the part of Ross Mitchell and John Thomas, both wealthy industrialist, who provided the old Greenway Academy and $ 100,000 to convert the building into a hospital.

In spite of Mitchell and Thomas' generosity, it was a welcome day when in December 1904, their hospital was vacated, and the move began to the new City Hospital. Funded by a bond issue, the hospital was an impressively sited at the top of a long ascending hill, reached by steps that swept outward at the bottom, and lined on each side by an attractive iron fence. A driveway was provided on the West Side. Renovations were made over its nearly thirty-year life until it had a capacity for 135 patients. (Today the hill has been leveled, and the site's aesthetic value is nil, as a gas station occupies the site).

After three decades of service, the growing population of Springfield and Clark County necessitated the need for a larger hospital, which opened at High Street and Burnett Road in 1933. Called initially the City Hospital and later the Community Hospital, it with a large addition in 1971 served the area until October 2011.[1]

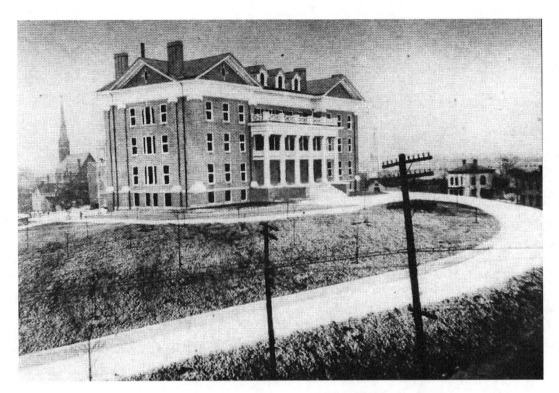

A 1904 view of the new City Hospital at Clifton and East streets.

Memorial Hall: The Clark County Memorial Hall filled the city's need for a large auditorium. Opening in 1915 at the southwest corner of West Main and Lowry streets, it was on the west side of the Crowell Publishing Company. Built at a cost of $ 262,000, the Hall soon became the venue for Springfield's many artistic and cultural events. Although such events could be labeled "highbrow," the building also hosted such "lowbrow" events as political rallies and wresting matches.

The building's exterior was distinguished by six classical columns across the front, while inside the Hall's most impressive feature was the 2,700 seat auditorium, which was the performance hall of the Springfield Symphony Orchestra from 1944 until 1985, as well as the stage for many musical shows and lectures sponsored by the Women's Club. Another prominent tenant was the Clark County Historical Society, moving into the Hall's third floor in 1917 and remaining there with its archives and museum until the 1985 closing.

The Hall became poorly maintained in its last two decades, failing by the early 1980s to meet the state building code, electrical code, and the plumbing code. In May 1985, the voters rejected a funding issue that would have provided four million dollars for renovations. Being too unsafe

to use and too expensive to renovate, the County Commission voted 2 to 1 to close the building in September 1985. In November 2010, the Memorial Hall was demolished.[2]

Downtown

The downtown experienced new and larger retail operations in the 1920s, as the city's population increased by over 30,000 from 1900 to the end of the 1920s. In December 1905, the Daily News reported that the first five years of the new century saw a "steady increase in the price of real estate," much of it in the downtown area, where property had increased by twenty percent, and downtown business property was selling in 1905 as high as $ 1,200 per front foot.

The first major building to rise in the downtown after 1900 was the eight-story, steel framed Fairbanks Building. Opening in 1906 at the northwest corner of Main and Fountain, it complemented the 1890s constructed buildings along Main and Limestone streets as commercial and aesthetic assets in the downtown. Constructed as an office building, the Fairbanks housed little if any retail. During the mid 1920s, a cigar store rented space along the Main Street side. Businesses were soon attracted to the prime office location. In the busy year of 1926, about 150 tenants were leasing space on the upper floors, one of them being the large Kissell Real Estate Company, which occupied several eighth floor offices. After the Ridgewood development began, Kissell advertised itself by erecting a large company sign on the building's roof. The Fairbanks, however, was not entirely office space, as it opened with a 1,000 seat theatre on the second floor with its entrance on the building's west side. The theatre remained a well used downtown asset until the late 1920s.

As mentioned earlier in connection with the early banks, the Fairbanks Building was purchased by the First National Bank in 1927, which renovated the first floor for its own use, and changed the building's name to that of the bank. Since 1927 to the present day, a bank has always occupied part of the street level floor looking at the Main and Fountain intersection.

About a half block west of the Fairbanks, the Springfield Building and Loan Association, which had been a part of the downtown since 1884, constructed in 1914 a new building at 28 East Main. The new building just west of the Bushnell Building, was characterized by two classical columns that flanked the recessed entrance, giving the financial institution a sturdy and safe appearance, enhancing the Main Street block between Fountain and Limestone streets.

A few years later, two other prominent downtown office buildings were erected. In 1917, the Arcue Building opened at the northwest corner of Fountain and High streets, diagonally across from the Arcade. Built by local real estate developer, Robert Q. King and his two sons, the building's most visible tenant in the busy retail environment of the 1920s was the popular men's clothing store, called the Hub, which occupied the street level Fountain and High corner continuously until the early 1970s. Never as popular an office building as the Fairbanks and Bushnell, the Arcue in the mid 1920s had about thirty-eight tenants on the upper floors. The building's unusual name is derived from the pronunciation of the first two initials of the builder's name—R.Q.

Just a block west of the Arcue, Springfield's tallest building, the ten-story Tecumseh Building opened in 1922 on High Street near Center Street. Built by local investor, Francis J. Drolla, the building is an example of Early Commercial architecture. The upper half is faced with brick, while the lower part is limestone. The Tecumseh is further distinguished by four pilasters covering the façade's second and third floors. In 1926, the many upper floor offices had just forty-four tenants.[3]

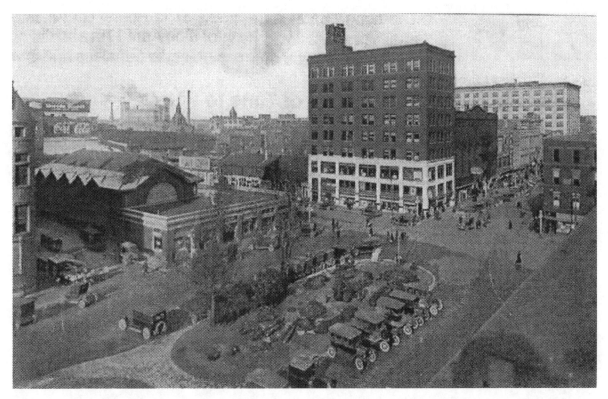

A view of the nine-story Arcue Building from Fountain Square. The mostly one-story Myers Market is to the front of the Arcue. To the rear side of the Arcue is Union Hall. The tall Tecumseh Building would later in 1922 be to the left of the Arcue. The Arcue was built in 1917. The date of photo is therefore between 1917 and 1922. (Clark County Historical Society).

Across High Street from the Arcue, the popular Myers Market was constructed in 1916 just inside Fountain Square, between the City Building and High Street. Myers soon attracted many shoppers to its food outlets. In 1926, thirteen businesses leased space in the market, including two groceries, a fruit stand, three delicatessens, two bakeries, and the long surviving Mattie Guthrie. By 1950, Myers Market still housed a meat market, produce stand, a grocery, a fruit store, a bakery, a deli, and the Mattie Guthrie restaurant. Mattie Guthrie's went on to serve breakfast and lunch to customers downtown until 2010, though at different locations.

Downtown Hotels: In the 1920s, the downtown hotels appeared to be doing well. Many of their overnight guests would have departed from the twenty-six passenger trains that stopped daily at the Big Four downtown depot built in 1911 at Spring and Washington streets. It was estimated by the publicity manager of the Big Four Railroad that in 1928 over 123,000 passengers passed through Springfield station, either debarking or embarking.[4]

Serving these potential guests were five nearby hotels. The older ones were the 1883 Arcade, two blocks west of the depot and the 1900 Bookwalter, a two block walk to High and Limestone. More recently the Shawnee had opened in January 1917 at Main and Limestone, the Bancroft Hotel on High Street near Limestone, and in 1918 the Heaume Hotel at Columbia and Fountain had opened.

Of the five only the Shawnee and the Heaume survives today as a building. The Bookwalter was demolished in 1940, the Bancroft closed in February 1975 and was demolished a short time later, and the Arcade went down in 1988. The Heaume has not been a hotel since the early 1970s. The six-story building appears sound today, and for many years has been recognized by a restaurant on the ground floor, the current one being the Infusion. The Shawnee, more upscale than the Heaume, was built by local real estate developers, Link and Link, after they bought the property at a courthouse sale in 1915. The Shawnee would serve overnight visiters until the early 1960s, when it became senior citizen apartments.[5]

Retail Outlets: Springfield hotels housed a number of the downtown's growing retail stores in the 1920s. The Arcade, as we have seen, was built as an office and retail venue to complement the hotel. During the 1920s, a popular retail outlet based in the Arcade was the When, a clothing store that faced on High Street. The Bookwalter Hotel, a block from the Arcade at the busy Limestone and High intersection housed several retail stores at the street level. During 1926,

these included a men's clothing store, a drug store, a watch maker, a cigar store, and a lunchroom. The same year the Shawnee provided space for six retailers at its Main and Limestone corner.

During the first two decades of the 20th century, downtown retail had grown both in quantity and variety. For example, men and women's clothing stores had increased from ten in the mid 1890s to thirty by the mid 1920s. Moreover, these specialty stores had been supplemented during the 1920s by national chain stores, beginning in 1921with the opening of the Boston Store on North Limestone Street. J.C. Penney's arrived in Springfield in the late 1920s at 78 W. Main, and in 1933 had relocated in the next block west on Main in the Zimmerman Building. Sears opened a store on Columbia Street near Limestone in 1927, and later moved to High Street across from the Bookwalter Hotel.

Movies and Five & Dime Stores: The downtown's variety expanded with th early 20th century appearance of Five and Dime stores and motion picture theatres, the popularity of both made them downtown destinations. The first of the dime stores was McCrory's opening in 1904 on the west side of Limestone Street between Main and High, followed in the next year by Woolworth's, located in the same block. (In 1940 Woolworth completed its own building at the northwest corner of Limestone and High, formerly the site of the Bookwalter Hotel). S.S. Kresge made its Springfield appearance in 1916, leasing space on Main Street between Limestone and Fountain, across from the Bushnell Building.[6]

Like the five and dime stores, motion picture theatres saw their start early in the century, the first being Philip Chekeres,' the Princess in 1908, located at 17 W. Main Street. Four years later, the Majestic Theatre opened on Christmas day at Limestone Street between Main and High. Though motion pictures were on the rise, vaudeville was not yet dead. Gus Sun, with a background in vaudeville came to Springfield in 1904, and began his career as a theatre operator and booking agent. Prince, in his history, called Sun the "dean of Springfield theatres." He soon opened a vaudeville show in a room of the Fisher Building at Main and Limestone, calling the theatre the Orpheum. In 1908, Sun purchased the site of the old Wigwam Building at Main and Center streets and built the New Sun Theatre as a vaudeville venue. During the early to mid teens, Sun had purchased the Grand Opera House on Limestone Street near Washington, demolished it and built the Columbia Theatre. The Columbia later suffered structural damage, and was rebuilt as the Regent Theatre, opening in August 1920.

By the mid 1920s, there were seven motion picture theatres in the downtown. These were.

Princess	17 W. Main
Majestic	23 S. Limestone
Colonial	31 E. Main
Hippodrome	57 W. Main
Liberty	16 E. High
State	19 S. Fountain
Regent	117 S. Limestone (Columbia 1911—1916)

In addition the Fairbanks and Sun's Band Box on W. Main were still booking live shows.[7]

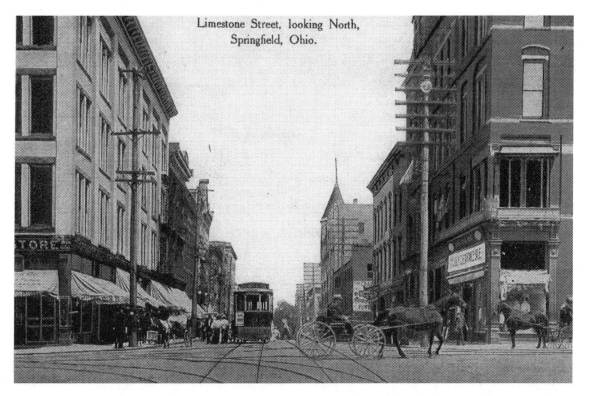

Limestone Street, looking North, Springfield, Ohio.

This is the intersection of High and Limestone streets looking north up Limestone. The Building on the left is the Bookwalter Hotel, completed in 1900. The street level floor contained several retail stores. At the very corner is the Morrow Drug Store. The first building on the right is the 1882 Mitchell Building. Up Limestone on the right, the conical tower of the Gotwald Building can be seen. (Clark County Historical Society photo).

Wren's: The five and dime stores, movie theatres, retail stores, and banks all combined in the 1920s and beyond to give Springfield and lively and viable downtown. Of all the retail, the

oldest, largest, and most prestigious was the locally owned Wren's Department Store, which in the 1920s was located on E. High Street, south of Limestone, and across from the Bookwalter Hotel.

Edward Wren, who became the principal owner, arrived in Springfield in 1848 from Ireland at age 15. The initial company was organized in April 1877 by James Kinnane, Edward Wren, and John Wren. Their store opened two months later in a 100 x 42—foot room in the Commercial Building at 15—19 South Limestone Street. John left the firm the following year and Kinnane retired in 1881. Although another Kinnane family member continued to have an interest, the firm became the Edward Wren Company in 1883. The store was a success from the beginning, selling clothes, notions, shoes, carpets, and many other items., and by 1893 its space in the Commercial Building had doubled, employees at this time reaching seventy-five.

In 1903, Wren's moved into the recently built Johnson Building on the south side of E. High Street, a short distance west of Limestone Street. On Wren's east side was the narrow Farmers Bank Building, and on the bank's east side was the Bookwalter Building, located at the corner of High and Limestone. By the early 1920s, the three-story Bookwalter Building was either extensively remodeled or demolished in favor of a new building. Photographs in the early 1920s show the corner building having four-stories and with a changed façade. In any case, the Wren building, the bank building, and the new appearing corner building were all meshed together. In 1928, Wren's, being enormously successful since its move to High Street, invested $ 100,000 in order to purchase all three building and unify them as one. Wren's then moved to the very southwest corner of High and Limestone, where in would remain until 1939. (Recall that the Farmers Bank had vacated in 1927, when it was absorbed into the First National Bank). In the mid 1930s, Wren's leased its former space at the west end of the building to Sears.

Although Wren's is widely thought of in terms of its association with the Bushnell Building on Main Street, it had been in downtown for sixty-six years when the Wren company purchased and moved its operations into the Bushnell Building in 1939. Here Wren's would be thought of as fixture, as it remained there for nearly a half century.[8] (more on Wren's in the next chapter).

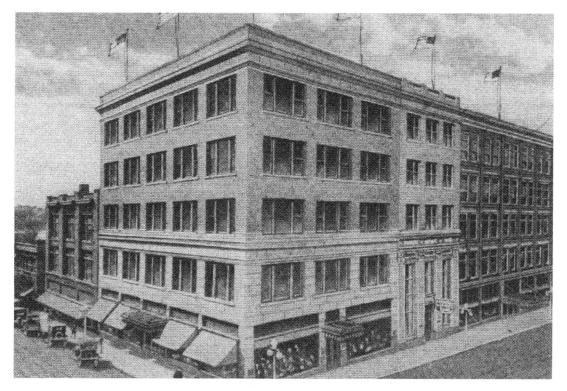

This is the northwest corner of Limestone and High streets In the early 1920s. Three buildings are meshed together along High Street. In the center with the tall first and second story windows is the Farmers Bank (acquired by First National Bank in 1927). At the right is the Johnson Building (slightly lower than the bank). Wren's Department Store moved to this building in 1903. At the corner is the former Bookwalter Building rebuilt to four stories. In the late 1920s Wren's purchased all three buildings and expanded into all three. However, by the mid-1930s, Wren's leased the building to the right of the bank to Sears. By this date, Wren's was laying plans for the Bushnell Building. (Clark County Historical Society).

Laconda Club Building: Never housing retail, the Laconda Building remained an attractive downtown structure at High and Spring streets even as it was getting less use, as the wealthy continued to relocate to the new Ridgewood development, and taking their social activities to the country club on Ridgewood's north. However, the building found new life when the Springfield Chamber of Commerce agreed to purchase the building in 1923 for its offices and headquarters. The Chamber preferred function over the Club's luxury, and created an interior more suitable for its business purposes. Gone would be the grand staircase and musicians' balcony. Lounges were divided into offices, and a large dining room was created on the first floor. On the fourth floor, a large auditorium was built for membership meetings. The Chamber left the exterior of the building unchanged, and for the next forty years, until the Chamber moved to the Shawnee Hotel in 1963, the Laconda remained an outstanding asset of the downtown.[9]

The new buildings of the 20th century in addition to those constructed in the last quarter of the 19th housed a wide variety of retail and entertainment venues by the 1920s. The heart of the downtown retail was the square block encompassed by Main, Limestone, High, and Fountain streets. The following chart based on the 1926 city directory shows the amount and variety of retail and other businesses that made the mid 1920s the peak years of Springfield's downtown.

Springfield's Downtown—1926

South Limestone Street, (Main to High)

East side	West side
M&M Savings and Loan	Kings Hat Store
(25 tenants over 5 floors)	Sun Bldg.—17 tenant, 3 floors
Citizens Nalt Bank	Confectionary
(11 tenants over 5 floors)	NY waist store
Ladies apparel shop	Keith Jewelry
Bennett Printing	Lunch room
Kroger grocery	Muir Drug Store
Macy's ladies store	McCrory's variety
Boston Store	Gold Jewelry
Sporting goods store	Majestic Theatre
Crystal Rest.	Woolworth's
Wurlitzer music store	Dial Bldg.—dentist & dance sch.
Mitchell Bldg.	Millinery shop
(42 tenants-5 floors)	confectionary shoe store

High Street, (Fountain to Limestone)

North Side	South Side
Hamlin Bldg	Arcade Building—15 tenants
Drug store & post office	Confectionary
Tailor	Farmer's Nalt Bank
Soft drink store	Wren's Dept Store

Confectionary

Shoe repair

Peoples bank

Liberty theatre

Barber

Meat shop

Schneider florist

Shoe store

Tailor

Bookwalter Hotel

Fountain Avenue, (Main to High)

East Side	West Side
Keymas hat cleaner	Building with 7 tenants
Sfatcos Rest.	Shoe store
Hat store	Jewelry store
Shoe store	Music store
Book store	Clothing store
Union Hall	Drug store
Odd Fellows and 6 tenants	New Plaza Rest.
Jewelry store	Clothing store
Drug store	Bakery
Needlework store	Shoe store
Cronstein clothing store	Jewelry store
Outfitting store	Optical shop
King bldg.	Hardware
15 tenants	Fox Rest.
Barber	Clothing store
Drugstore	Shoe store
Boot shop	Boot shop
Optical shoe	Lunch room
	Hub clothing

Main Street, (Fountain to Limestone)

North Side	South Side
Laconda Nalt Bank	Troup Drug store
Fried Jeweler	Boot shop
8 tenants	Shoe store
Millinery shop	Springfield Savings Society
Clothing store	Levy clothing
	4 tenants
Bushnell Bldg	Arm Jewelry
66 tenants	Hardward store
First Nalt Bank (front of Bushnell)	Nathan clothing
Mad River Nalt Bank	Lunch room
Ladies shop	Hat and Fur Company
Springfield Bldg & Loan	S.S. Kresge 5& 10
Springfield Hardware	Colonial Theatre
Zimmerman Bldg	Fashion company
4 tenants	Kinney shoes
New Zimmerman Bldg	Cigar store
17 tenants	Cigar store (at corner)
Alex clothing store	

Streetcars

Supporting the viability of the downtown in the 1920s were the many streetcars that converged on the center city from all outlying directions. After P.P. Mast's private streetcar line of 1871 along High Street 'from downtown to the west end, true public transportation became a reality in 1882, when wealthy Springfield investors led by Benjamin Warder, Asa Bushnell, and Ross Mitchell formed the Citizens Railway Company, capitalized at $ 100,000. The first routes of this mule driven line ran from downtown along east and west Main Street, including Laconda Avenue on the east side. A second line ran along north and south Limestone Street, including Clifton Street on the southeast side to East Street. Other lines soon followed. In 1891, Springfield's streetcar

system, like others across the country, became electrified, the power house being located on Warder Street. From the 1890s through the 1920s, the streetcars were very much part of the city's prosperity and the downtown's viability. The crucial fact to note about the streetcar system was that all routes went through the downtown, which along with the passenger train downtown depots, had the effect of centralizing retail and other businesses, keeping a critical mass of people shopping, banking, and seeking entertainment in the downtown. Contrast this role of the streetcars with that of the private automobile, which later largely decentralized the city.

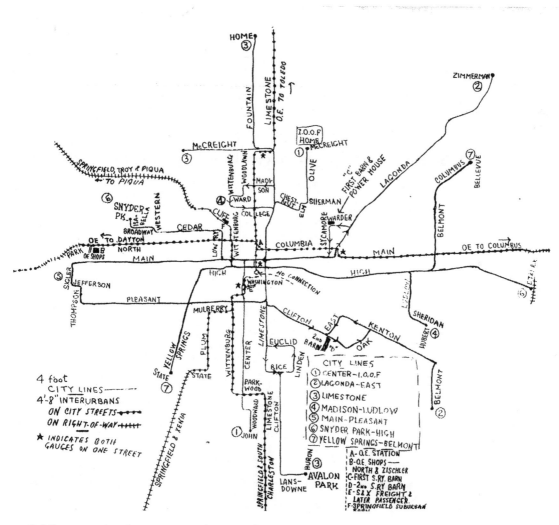

Springfield's network of streetcar and interurban routes. Note that all routes entered the downtown. (Clark County Historical Society map).

Esplanade and City Building: Before leaving the downtown shopping and business area, a couple loose ends need tied up. One was the permanent removal of the 41-foot Kelly Fountain that had highlighted the Esplanade since 1889. A gift of Mayor Oliver Kelly that was praised

at the time, but later apparently poorly maintained, as jets of water sometime in the mid-1910s began to spray beyond the basin onto pedestrians. Consequently it was removed, but the removal date and manner of disposal are unclear. Springfield historian, Orton Rust, left an opinion letter in the files of the Clark County Historical Society, stating his belief that the fountain was dumped in Snyder Park, where the parts were stolen (letter of August 15, 1950). In 1988, a Historical Society board member in a letter stated that the fountain was removed in the late 1910s, part of it taken to the White Hall Farm in Yellow Springs and scrapped, while remaining parts were taken to the O.S. Kelly foundry and melted (letter of July 25, 1988).

A second matter to complete concerns changes to the 1890 City Building and City Market. Beginning in 1919, the interior of the City building was altered, and many would say for the worse. After Springfield's city government in 1914 was changed to a city manager/commission form, the second floor Council chambers were considered too large for the now named Commission of five members. Previously the old Council had ten members. At the same time, the city thought more office space was needed. Consequently the Council chamber and performance hall was chopped into offices and a gymnasium (later the gym was converted into offices). On the first floor, the City Market, which formerly occupied the entire first floor, was reduced to just the eastern half, while the other half became storage space for public properties.[10]

Although the above changes had its critics, another change to the City Building could be supported by all residents. This was the addition of a four-sided clock in the east tower overlooking the Square. Installed by December 1924, it was gift to the city by Howard Diehl in memory of his wife, and unlike Kelly's Fountain, the clock has survived.

Civic Center

Beginning in the 1920s, James Demint's hoped for public square area along Limestone Street was undergoing changes. From the mid 1920s to the late 1930s, four new buildings made their appearance at the intersection of Limestone and North streets, one block north of the Courthouse. As these buildings were completed, Limestone Street took on a new, more attractive look. In the public mind (there was no formal name change) the new buildings at North Street were combined with the nearby adjacent county buildings, and the complex became known as the Civic Center. The new buildings were the Covenant Presbyterian Church, the News and Sun

Building, the U.S. Post Office, and the YMCA Building. That one of the four new buildings was a church did not alter the custom to include it as part of the ensemble.

Covenant Presbyterian Church: This $ 515,000 building was completed in 1924 at the northwest corner of Limestone and North streets. Its late Gothic Revival style was designed by Philadelphia archtect, George Savage, to resemble 14[th] century English cathedrals. The Covenant Church had combined the congregations of both the First and Second Presbyterian churches, which had been located within two blocks of each other and served the same constituency. The name "Covenant" was chosen to reflect the 1638 covenant drawn up in Scotland in order to maintain the purity of the Presbyterian Church.[11]

News and Sun Building: Directly across Limestone Street from the church, the Springfield Daily News and Sun Building was dedicated on October 20, 1929, during the midst of the crushing price declines of the New York Stock Exchange. For many years previously, Springfield readers had enjoyed two daily newspapers—the morning Sun and the afternoon Daily News. The Daily News Building had been located on Washington Place between Spring and Limestone, near the railroad tracks. Today the street has been vacated in favor of a bicycle and walking trail, flanked on each side by parking lots. The Sun had been publishing from its building at 21 N. Limestone. In 1927 both papers had been absorbed into the Cox newspaper chain, based in Dayton, Ohio, an event that led to the combined building. It was designed in the Italian Renaissance style by the New York City firm of Schultze and Weaver, which had previously designed New York's Waldorf-Astoria Hotel and the city's Grand Central Station.

The News and Sun continued as two separate papers until they merged in March 1982, creating the present News-Sun.[12] On Sundays, however, there had been a joint News-Sun for decades.

Post Office: The city's new post office, opening in October 1934, replaced the 1890 Federal Building at Spring and High streets. Built during the early depression years, the post office came in under budget. Congress had appropriated $ 740,000 for the building, but just $ 535,000 was needed. Located directly across North Street from the News and Sun Building, the land on which the Post Office rested had been partly occupied by the Clark County Detention Home, but was abandoned by the county in the early 1930s.

The two-story Post Office of limestone and granite was designed by local architect, W.K. Shilling, who chose to keep it free of ornament, allowing the building's mass and proportion to give the impressive affect. The building fronts on Limestone Street for 199 feet, while its North Street side extends 198 feet. These dimensions and the two floors have given it six times the space of the 1890 federal building, which has allowed for ten offices for use by other governmental agencies. That it is a U.S. government building is symbolized at each top end of the entrance by a large cut stone eagle.[13]

A contemporary photo showing the News and Sun Building from the front yard of the Presbyterian Church.

WMCA Building: The last building to occupy one of the four corners of Limestone and North was the YMCA, completed in 1939 directly across North Street from the Presbyterian Church. It was also on the immediate north side of the Courthouse, fronting Limestone Street. As far back as the 1870s, an upscale private home occupied this site. In the early 1920s, the owner built an apartment building on the same lot, and in 1925, the widow of a wealthy Robbins and Myers executive, donated the apartment building to the "Y," which housed single men in it.

Then in 1929, she gave the house to the "Y," and at her death in 1935, she left $ 300,000 to the YMCA for a new building. The "Y" then demolished both the house and apartment building and completed its 1939 its Italian Renaissance building, designed by Springfield architects, Robert Eastman and Ralph Hartman.[14]

WMCA Building at southwest corner of North and Limestone. Built 1930 and demolished in 1990, becoming then the Courthouse parking lot. The arched entrance faces Limestone Street, looking across to the Post Office Building.

This building served the "Y" until 1990, when it was demolished. (By then changing values made it possible to combine the WMCA and YWCA in a common building). Since 1990, the site has been a county parking lot. The buildings at the other three corners of Limestone and North remain today well used and well maintained.

Other Changes: In the 1920s and thirties' time period, two other changes occurred in the Civic Center area. First the Soldiers Monument that had been directly across from the Courthouse since 1869 was removed in July 1924 and re-dedicated at the Ferncliff Cemetery. The space remained vacant for decades. The Sanborn maps labeled it a "park," but it was not part of the city park system. In 1999, this space across from the Courhouse was named Demint Park, and by 2004, plagues honoring veterans had appeared, placed there by private organizations.

133

The second change was the construction of a new Juvenile Court and Detention Home (recall that the detention home had been located at the site of the new Post Office). The new Detention Home was completed in 1934 on Limestone Street to the immediate south of the old 1868 East County Building, which was still intact and being used as the Municipal Court. The new Detention Home was funded by the county at $ 30,000, of which $ 8,500 was covered by a federal Progress Works Administration grant.

Cultural Patterns

In addition to the new downtown architecture, the 20th century brought changing cultural patterns that affected Springfield city wide. The 1904 sociological study by Edwin Todd referred to earlier called attention to the passing of the 19th century literary societies in which members got together to discuss books and national events, and hear lectures on academic subjects. Now these societies were giving away to the more social and fun loving fraternal organizations. Although the Masons, Odd Fellows, and Knights of Pythias were common in the latter 19th century, the number of their lodges expanded rapidly into the new decades. According to the Todd study, Springfield had a total of ninety-eight fraternal clubs in 1900 having a total membership of over 11,000. These lodges did not admit blacks, but undeterred blacks formed their own parallel clubs and by 1900 had opened nine Masonic lodges with a membership of 430, while the Knights of Pythias had five lodges for blacks. New clubs continued to be formed, the Rotary in 1914 and the Lions in 1920.

Not all was unserious fun, as many of the societies became known for their societal benefit. The Masons, Odd Fellows and Knights of Pythias all chose Springfield as the site for the construction of large state homes for orphans and the elderly. The Masons established their state home in 1897 along the National Road near Route 68. The Odd Fellows built a large, four-story home for their aged members, their wives, widows, as well as for orphans along McCreight Avenue just west of Limestone Street in 1898. The Knights of Pythias completed their Children's Home at McCreight Avenue and Fountain Blvd in 1895.[15]

Culture and the Women's Club

While the mostly male literary societies were declining at the turn of the century, the Springfield Women's Club, founded in 1875, continued in the early 20th century to have a

literary and artistic content, becoming active in promoting and increasing the cultural level of Springfield. One of the Club's first endeavors was the establishment of a successful concert series of classical music. Beginning in the 1915-16 and for the next twelve seasons lasting until the late 1920s, the Club scheduled eight to ten performances per season in the 2,700 seat Memorial Hall, where residents saw and heard concerts by the New York, Cleveland, Minneapolis, and Cincinnati orchestras. In addition, the Club booked appearances by opera companies, and individual voice and instrumental performers. In the late 1920s, the Women's Club turned the sponsorship of the concert series over to the Civic Music Concert Association,

Through the 1920s and into the 1930s, the Club brought national figures to a Memorial Hall lecture series, allowing Clark County residents to hear such luminaries as Amy Lowell, Vachel Lindsay, Edna St Vincent Millay, Thorton Wilder, Norman Cousins, and photographer Margaret Bourke-White.

In 1926, the Women's Club organized Springfield's first legitimate theatre, thereby giving the city a "highbrow" theatre as opposed to Gus Sun's "lowbrow" productions. The new theatre was known as the Folding Theatre Players, and from 1926 to 1928, the Players staged eleven productions. The Folding Theatre actors evolved into the Springfield Civic Theatre, founded in September 1930, and soon after became the city's first permanent theatre with a paid director. The Civic Theatre had enough support and organized strength to endure through the decades, although in the first decades without its own stage. From 1932 to 1951, Keifer Junior High School on South Wittenberg Avenue was its performing venue. Later in the 1950s, the Civic Theatre leased the old vaudeville theatre at Main and Center streets, but it was condemned as unsafe. The Fairbanks Theatre was used for a short time, as was the Memorial Hall. In the late 1950s, the Civic Theatre purchased a house at 1424 W. Main and turned it into a theatre, which provided a somewhat permanent home until the mid 1980s. Some performances were then given at South High School in the late 1980s. Since the opening of the Kuss Auditorium in 1993, the players have had a bona fide theatre stage at the Kuss' Turner Theatre.[16]

The Springfield Symphony

As the 1920s gave birth to the legitimate theatre, the decade was also the advent of Springfield's first symphony orchestra, known from its first year in 1922 as the Civic Orchestra, which consisted of thirty-seven men under the direction of Charles Bauer. Without a permanent performance

hall, the orchestra's first few years were a struggle. In 1927, the orchestra was reorganized as the Springfield Symphony Orchestra, still under the direction of Charles Bauer. The depression years were difficult, leading to the disbanding of the orchestra in 1935. The balance of the 1930s and the war years were not conducive to an attempt a re-organization, but in 1944 Springfield violinist Edwin Juergens and William Fiedler, head of Antioch College's music department in Yellow Springs, issued a call for musicians. William Minnick, who had been training string players in his Evening Fortnighty Musicial Club in Springfield, offered his players as the new orchestra's string section. Interest of local musicians in an orchestra was strong from the start, and after an initial meeting, rehearsals began in the banquet room of the WMCA building on North Limestone Street.

The new orchestra's first concert, featuring fifty players and a chorus of ninety voices was given on March 19, 1944 in the Central Methodist Church at High and Center streets. William Fiedler conducted Brahms' Requiem and Shubert's Unfinished before about 1,500 attendees who packed the Church. After the successful first concert, the symphony secured the Clark County Memorial Hall as its performance stage, which lasted until 1985 when the Memorial Hall was closed.[17]

Decline and Revival Attempts

Throughout the 1930s, forties, and into the fifties, Springfield's downtown remained economically viable—its retail, banks, and movies drawing daily crowds from the city's neighborhoods and other areas of Clark County. The Arcade and the City Market continued as attractive shopping venues, while Fountain Square remained a favorite gathering place. But during the early and mid 1950s, the economic geography of the city began to change in a way unfavorable to the downtown. Historically Springfield had been a centripetal city, that is, the outer areas were drawn to the center. In the early 19th century, roads converged in the downtown. Later the railroads built their passenger depots in the downtown area, culminating in the 1911 Big Four Station at Spring and Washington streets, just two blocks from both the Arcade and the lively downtown intersection of Limestone and High streets. In addition to the trains, the city's streetcar system was an especially centralizing force, as all routes from outer neighborhoods came into the downtown. Unless a passenger made an early departure, all riders became potential downtown shoppers in a system structured to favor downtown merchants. Moreover, the regional interurban rail system brought passengers form outlying villages into Springfield's downtown, discharging most of them at the Esplanade on Fountain Square. Such physical and social forces had made downtown Springfield a commercial entrepot for its first 150 years.

A few years after World War II, the city's centralizing forces began to brake down. Passenger train service was gradually reduced and downtown hotels began to suffer. In 1933 the interurban rail system was disbanded. In the same year, the city's streetcars were phased out, though public transportation continued with buses. The most fundamental change, however, was the resumption of automobile production after the war. The public's fascination with the private auto took passengers from the transit system, and at the same time, the car's greater flexibility meant that drivers were not forced into the downtown. Yet the car craze of the 1950s and beyond was not enough by itself to drain the downtown of its shoppers. After all, Springfield had been inundated with automobile drivers in the 1920s yet the downtown boomed. The automobile was a necessary condition for the weakening of the downtown, but it took the fusion of the car

with the development of shopping areas at the outer edges of the city to begin the movement away from the downtown.

In 1959, the Park Shopping Center on Bechtle Avenue at McCreight on the northwest side became Springfield's first shopping center. This was closely followed by the opening of the Southern Village Shopping Center at Selma Road and Sunset Avenue on the southeast side. Neither shopping center was large by later standards, but each had a mix of retail fronting on a large free parking lot that was attractive to customers. Southern Village opened with a furniture store, a discount general store, a large grocery store, a bank, and several other retail outlets. These two centers were no match for what the downtown could offer, but their openings marked the beginning of the breakup of the downtown's shopping monopoly.

New shopping areas continued to be built in the 1960s. In 1966, Clark County approved the construction of shopping centers just north of the city, one on Derr Road and another on Villa Road. By 1972, a Springfield city planning department paper credited the city with ten shopping centers. Some of these were Northern Plaza on Home Road, Moorfield Square on Deer Road, Circus Shopping Plaza on Leffel Lane, and the giant Upper Valley Mall.

The climate controlled Mall opened in February 1971 just outside the city's northwest boundary, thereby, denying to the city both income tax on employee wages and a share of the property tax collection.

In a News-Sun interview, Harry Strachan, Springfield's Mayor from 1956 to 1960 said. "The city could not have done anything if it had wanted to. If we refused the zoning changes to protect downtown businesses that would not have been fair to the shopping center developers." The downtown merchants, however, attempted by positive means to slow the drain of their customers. The Chamber of Commerce bought land for parking just south of Washington Street, but the expense of the lots led to the self-defeating installation of parking meters. Once the mall opened, it fed on itself, as more retail followed further weakening the downtown. As the president of the Springfield Area Chamber of Commerce said, "Retail goes where the people are, and the people are not downtown anymore." Agreeing with the Chamber, such downtown stalwarts as Wren's, Penney's, Sears, Woolworth's, and the Hub had by the mall's opening signed leases with its owners. (Wren's, however, still kept its downtown store open).[1]

Downtown Supporters

As planning for the Upper Valley Mall was underway, a group of Springfielders nostalgic for the bustling downtown of previous decades got together and formed an organization in March 1969 called the **Committee of 21**. Although the committee's stated objective was to make a study of city and county problems, the focus was soon on Springfield's downtown and the financial problems of the city. Since 1948, the city had levied a one percent income tax on its residents and on those who worked in the city. By 1969 this rate was not paying its way, for by the next year the city would have an operating deficit of over $200,000, and total collections were projected to continue downward. The committee's information showed that from 1967 to 1968, income tax receipts had fallen some $ 90,000, although the collections from employee payrolls had increased in the same period by nearly $ 72,000, as the city's industry continued to do well. The shortfall was entirely attributed to businesses net profits, which had declined by $ 162,500, thereby confirming in dollars and cents the effect of the closing retail, which could not be made up by the Upper Valley Mall retail, since the mall was outside the city. A 1974 study of downtown property tax revenue by a Chamber of Commerce intern supported the findings of the Committee of 21. Beginning in 1960, the downtown property accounted for 21.3 percent of the total city property tax. By 1970 downtown accounted for only 16.9 percent of the city property tax, and in 1974, the downtown property tax contribution had fallen to 10.7 percent of the total. [2]

The tangible result of the committee studies was to urge the City Commission to put a one-half percent income tax increase on the November 1969 ballot. This increase would provide about $ 600,000 for permanent city improvements in addition to allowing a six percent increase in operating expenses. Supported by many organizations including the League of Women Voters and the News-Sun, the increase was approved on November 4, 1969 by a margin of 10,106 to 8,408. The committee further urged that the $600,000 for improvements be directed toward the core block, that is, the downtown's historic shopping area bounded by Main, Limestone, High, and Fountain streets. It was easy for the committee to focus on the core block, for this was the area of many failing businesses that played a role in the falling tax receipts. Specifically, the Committee of 21's proposals in full were.

1.Acquire the core block and raze existing buildings.
2. Build a new city building on the site.

3. Demolish the 1890 City Building and Market.

4. Join the county in a new City-County police and safety building.

5. Acquire land for a sports center.

Blueprint for Progress Committee: Democratic planning can be a messy endeavor, having many points of authority and ineffective lines of communication, resulting in many changes and disagreements. Accordingly, the Committee of 21 would not satisfy all interested parties. There would be three or four additional committees with new members coming aboard. Many individuals not wanting to miss anything were members of multiple committees. But somewhat surprisingly, the planning came together over a five or six year period, and by 1976 all the committees were in common harness.

In the summer and fall of 1969, the Blueprint for Progress Committee was formed. It was not primarily a study committee as was the Committee of 21, but rather a coordinating committee for the development of a downtown master plan. In October 1971, Blueprint committee member, Paul Hellmuth, a native Springfield attorney, but at the time practicing in Boston, addressed a Chamber of Commerce meeting and proposed a $ 50 million downtown revitalization program. His proposals overlapped those of the Committee of 21 of two years earlier, notably the advocacy of a city-county office center (he did not say where), a new downtown hotel, a performing arts center, and a sports center. Topping off the plan was his proposal for 2,000 car parking facility. The entire project would be financed by a bond issue, federal and state aid, bank loans, and local fund raising.

Outside any committee structure, city commissioner, Robert Burton, had two months earlier issued his own plan to the News-Sun. He also wanted a new city-county building, spanning across the Esplanade, which would mean the razing of the Arcade and the 1890 City Building. Agreeing with the Committee of 21, Burton would also demolish all buildings in the core block to allow construction of a multi-story shopping mall.

The centerpiece of all three plans was a new city building. (In the latter part of 1971, the county made it clear that it would not be a part of a new administration building, and after which all spoke of a "city building"). A new city building would be a continuing theme among all interested parties over the next three of four years, the principal disagreement concerned where it would be built.

Two months after Hellmuth's proposal, Blueprint for Progress chairman, Howard Noonan, who was Harry Kissell's son-in-law, addressed the membership and supported Hellmuth's proposals for a new city hall, a high rise motel, a high rise office building, and a performing arts center. Noonan differed from Hellman mainly in wanting his buildings tall. Noonan added that $ 16 million could be raised from non-governmental sources, and that the project could be started within 120 days. This time frame proved to be wildly optimistic.[3]

At this juncture, it appeared that the Arcade and the 1890 City Building may not survive, for Noonan had added his voice to the chorus on record advocating the razing of these buildings that were once considered the pride of the downtown. Those supporting a new city building across Fountain Square were the Committee of 21, the Blueprint for Progress Committee, and the City Commission.

Core Renewal Corporation: In 1973, another committee like the others came into existence in order to revitalize the downtown. This was the Core Renewal Corporation with a membership largely of attorneys and local real estate executives. By its name one could assume that its focus would be on the city's historic downtown shopping block bounded by Main, Limestone, High, and Fountain streets. Its creation was made possible by a 1972 state law allowing the creation of local development corporations that would be private in membership, but permitted to unite with municipalities for the purpose of securing private property and re-developing an area for the public good. The Core Renewal Corporation would fulfill such a role. Paul Hellmuth of the Blueprint committee would serve as chairman and local real estate executive, Martin Levine would fill the president's slot. By virtue of a bond issue, Core Renewal had an $ 11million to manage, broken down as follows:

 a. acquisition of properties on core block—$ 2.5 million
 b. cost of new city building—6.0 million
 c. city share of city-county building—1.2 million
 d. demolition of 1890 city building—700,000
 e. land acquisition for sports center—600,000

Core Renewal was a committee different not only in degree but also in kind from the previously formed citizen committees, whose primary duties involved research, planning, and advocacy. Formed under the sanction of state law and having the authority to act as an agency

of the City Commission, Core Renewal Corporation was a decision making committee with teeth. Acting rapidly on its authority, Core Renewal hired the prestigious Chicago architectural firm of Skidmore, Owings, and Merrill to design a new core block on the assumption that all structures would be purchased and razed. By July 1974, the Chicago architects had completed a core renewal plan.[4]

This is the 1974 plan of the Core Renewal Corporation for the core block. By 1976, the retail did not appear feasible and two commercial/office buildings were substituted in the two vacant corners. Even a crosswalk across Main Street to Wren's was planned. The City Hall and the Credit Life building were completed. But the two corners of Main and Fountain, and High and Limestone have forever remained vacant of buildings. However, the High and Limestone corner was developed into a pleasant green space.

The core plan of Skidmore, Owings, and Merrill received immediate support of downtown bankers and merchants. From the Springfield Bank, its vice-president stated: "To me, it is a genuinely exciting concept, and if this is realized, it could be the beginning of a whole new Springfield." The president of the Springfield Savings and Loan called it "A wonderful idea and it would be a major accomplishment for the city." Springfield Mayor Roger Baker said that he

endorsed the core renewal plan. The enthusiasm carried to the City Commission, and within a week of the plan's presentation, the governing body passed a resolution endorsing the plan.[5]

The approval of the plan led to discussions over its financing. Accordingly, the watchful overseer of the city's finances, the Committee of 21, came forth once again with a proposal for a city income tax increase of one-half percent, which would make the rate two percent on wages and salaries. The campaign led by Citizens for a Better Springfield was successful, as the voters in June 1975 granted the increase by a margin of 7,36 to 7,189. The voters had been promised that twenty percent of the new revenue would be devoted to the core block[6]

Acquisition of Block and Change of Plan

After the approval of the architects' plan, Core Renewal moved rapidly on the acquisitions of the structures in the core block, as well as the buildings on the opposite side of the streets surrounding the core shopping block. By March 1975, the major buildings on the east side of Limestone had been purchased for $ 265,000. These included the large 1882 constructed Mitchell Building, the 1921 Boston Store Building, and around the corner on High Street the 1917 Bancroft Hotel and the Knights of Columbus Building were also purchased. Over the summer of 1975, Core acquired the buildings on the west side of Limestone, the most expensive being the Woolworth Building for $ 350,000. Other purchases included the McCrory Building for $ 85,000, the Majestic Theatre for $ 30,000, the building housing the Ideal Clothing Store for $ 75,000, and the Vlahos property for $ 76,000. By spring 1976, all properties in the core block had been acquired.[7]

Prior to the formation of the Core Renewal Corporation, two financial institutions had already demolished their buildings on the core block. Although not a part of the core planning, the razing of these buildings were fully compatible with the later plan. In 1969, the Springfield Savings and Loan on Main Street had purchased the 1889-91 Zimmerman Building (which housed Penney's) and in November 1971 razed it. The following spring, M&M Savings and Loan demolished its 1892 building, formerly the Gotwald Building with its landmark tower at Main and Limestone streets.[8]

As the clearing of the core block was nearing completion, discussions were continuing about the building plans on the demolished block. Somewhat surprisingly, by March 1976, the

architects' model for the core block that was so highly praised when it was unveiled in July 1974, had nearly two years later been altered. The major change was the cancellation of the department store on the block. Unchanged in the altered plan was the city building, which would still be built facing the High and Fountain intersection. At the other three corners, commercial and/or office buildings were now planned.

Plan Unfulfilled

At bottom the success of the plan of the Core Renewal Corporation rested on hope and hope was not enough. Of the four planned buildings on the core block, the corporation had monetary control over just the city hall, which was completed and dedicated May 29, 1979. The other three structures were to be privately built, yet only one has ever been built to this day. This was the Credit Life Building completed on the northeast corner of the block, facing the intersection of Main and Limestone. Core Renewal played a role in getting the ten-story, eight million dollar structure underway by helping to secure a property tax abatement.[9]

Peripheral Developments: As it was hoped that three buildings would join the city hall in the core block, so it was hoped that private developments would occur elsewhere in the downtown. In unveiling the July 1974 plan, Martin Levine, president of Core Renewal Corporation, addressed what he called "peripheral developments" around the core block. Such developments, he maintained, are "historically associated" with large projects as the core block, and grow from the optimism and confidence engendered by the project. Indeed, Levine could point to surrounding developments already completed or planned.

1. The Security National Bank had purchased the site of the demolished Mitchell Building at the northwest corner of Limestone and High and opened a modern, sleek, horizontal style building in September 1977. This bank had evolved from the Morris Savings Bank established in 1915 on South Limestone Street across from the Regent Theatre. In 1916, it became the Guardian Bank, and in 1969 following a merger with a New Carlisle bank, it became the Security Bank, all the while at 120 South Limestone.

2. Merchants &Mechanics Savings &Loan : At the other end of the same Limestone Street block, we have seen that the M&M Savings had demolished its old building in 1972. By 1978, M&M had opened a three-tier modern building. Thus, these two financial

institutions had nearly completed the renovation of the entire west side of Limestone Street across from the core block.

3. Springfield Savings Society: Although it may have come a little early to be considered a development deriving from the core block, the 1961 opening of the Savings Society was none the less a significant re-development of Fountain Avenue from Main Street to the State Theatre, across from the core block. Soon to become the Springfield Bank, this construction marked one of the city's early bank departures from the brick and stone fortress appearance in favor of glass walls and horizontal lines.[10]

4. Heaume Hotel: In November 1976, a Columbus investor purchased the 1918 Heaume Hotel at the southeast corner of Fountain and Columbia streets, which had been empty for about a year. The new owner, who stated that the planned renewal of the core block influenced him to buy, planned a restaurant on the first floor and an athletic club in the basement A Ruby Tuesday Restaurant did open as planned, and was replaced several years later by a Buffalo Wild Wings.[11]

Although unrelated to the core block planning, two earlier investments in the downtown are worthy of mentioning. In 1956, the Springfield Federal Savings and Loan made a large investment in remodeling its 1914 building on East Main Street between Fountain and Limestone. The old building had the traditional fortress look with a pair of tall columns flanking a recessed entrance. The columns were removed, the entrance brought to the sidewalk, and plate glass was installed as the front wall, making the S&L the city's first financial institution to construct an outside glass wall.[12]

In the previous chapter, it was mentioned that the old Shawnee Hotel had become a senior citizens apartment building. This function continued throughout the core block demolition and the construction of the new city hall. Although the Shawnee still today appears a physical asset to the downtown, Clark County Historical Society president, George Berkhofer, in a 1982 letter to the owner called the building a standard piece of early 20th century commercial architecture of "boring uniformity" except for the limestone panels at the ground floor. Nevertheless, the Shawnee was placed on the National Register of Historic Places in 1985. In 2001, the Model Group of Cincinnati purchased the building for about $ 1.9 million and soon after made renovations to the senior apartments, now called the Shawnee Place Apartments.

The bulk of the downtown re-development was to date provided by financial institutions, hardly a development that would draw crowds into the downtown, as would viable retail. But in May 1977, Core planners and supporters were given a reason to think that crowds may yet be generated.

Wren's: Wren's president announced that a complete facelift of the department store would begin in early 1978 and last about two years. This he said would be" in conjunction with the revitalization with the downtown area." Wren's parent company since 1952, Allied Stores, would provide one million dollars for the changes, which would include all five floors and the basement, where a wine cellar would be opened. The customers would see altered floor arrangements, as well as improved merchandise. Plumbing and heating would also be upgraded.

However, after the renovations ended in 1980, Wren's sales failed to match the hoped for results. In 1985, while still under Allied ownership Wren's merged with the Indianapolis based William Block Company. With this merger, Wren's name passed into history, as the store was renamed Block's. Still unable to generate the needed revenues, Allied closed Block's on September 1, 1987, putting seventy employees out of work. Wren's had had a forty-eight year run in the original Bushnell Building.[13]

While Wren's was sliding toward oblivion, it increasingly appeared by 1983 that new retail was not going to be rejuvenated downtown. A major reason for the failure, according to Mayor Roger Baker, was the inflationary national environment in the early and mid 1980s. During this period, the interest rate on loans hovered in the twenty percent range. He told the Sun-News that "we had some developers very close to agreement, but the interest rate made them drop out."[14]

Other Failures: Northeast corner of Main and Fountain. The long established Laconda National Bank had been at this corner since 1881 when it built a permanent structure, but in July 1966, it abandoned the busy intersection and moved to its recently constructed building at the southwest corner of Columbia and Fountain, just a block away. The new two-story building with eight classical columns facing Columbia Street is still in use, but not as the Laconda Bank. In the late 1970s, the Columbus based Huntington Bank acquired the Laconda, and it passed into history. Yet the original Laconda building still stands at Main and Fountain. For a while in the late 1980s, a restaurant moved in, but it failed. For the past two decades the building

had been empty, devoid of maintenance, and presenting a dismal appearance at one of the downtown's principal intersections.

Northeast corner of Main and Limestone: This key business corner was the site of the five-story New Zimmerman Building for the first half of the 20th century. It was destroyed by fire in 1953, and rebuilt as a smaller, two-store structure, where Lynn's Drug Store was located for about twenty-five years until about 1980, when the business became Brown' Pharmacy lasting until about 1988, when the building was demolished. Since then no interest in development has been shown, and the corner remains a surface parking lot.[15]

Northwest corner of Fountain and High: As we have noted, the Arcue Building was constructed at this corner in 1917. In 1978, the owners anticipating increased downtown business from the Core Block development, invested $500,000 in renovations, but was unable to secure a major tenant on the level of the Hub, which after some fifty years, moved to the Upper Valley Mall. The Arcue was demolished in January 2012.

Fall Back to Arcade and 1890 City Building

As the peripheral developments that Core Renewal had hoped for failed to materialize, it members and the City Commission took a longer look at the Arcade and the old City Building at Fountain Square. Maybe the old structures after all could house the downtown's "missing link," that is, retail growth. By March 1983, city officials and Core had secured a $1.6 million Urban Development Action Grant (UDAG) to get started on an adaptive re-use of the Arcade and City Building. First the travail of the Arcade. We can begin in 1971 when the Board of the Warder Public Library purchased the Arcade for $200,000, the principal sellers being Mrs Stacy Rankin of Yellow Springs and Oliver S. Kelly, son of the builder. The library's plan was to raze the building and use the site for a new library. By 1977 the library's plans had changed, and the board offered to sell the Arcade to Core Renewal for $695,000. Core rejected the offer, and in early 1980, the city bought it for $385,00. Using part of the $1.6 million UDAG grant, the city signed a contact for the re-development of the Arcade for retail use, but because of unmet promises, the City Commission dismissed two developers. While a third developer, the Bernstein Group of Columbus, was working on a plan to secure factory outlet merchants to lease Arcade space, the City Commission decided that the developer's plans were too risky. Not wanting any more retail failures, the Commission voted to demolish the Arcade. Over two years lapsed, as the

city fought off appeals by the Citizens Arcade Alliance to save the building. In the end, the city prevailed, and in March 1988 demolition of the Arcade began.[16]

Marketplace: As the attempted Arcade renovation failed, more progress was being made with the 1890 City Building, as it was reborn first as the Marketplace, then as the Clark County Heritage Center. Using the UDAG grant and the developer's $2.7 million that was borrowed from a bank, the Bernstein Group began work in April 1984 and completed renovations in February 1985, on time for the city to celebrate the 95th anniversary of the City Building. The Marketplace was essentially an updated version of the city market that had been failing since the 1960s as the rest of the downtown was economically slipping. Various vendors occupied the first floor and a restaurant was planned for the second floor. In the next few years the vendors did well enough, but in 1989, the developer, Bernstein Group, defaulted on its loan from Fifth Third Bank, which began foreclosure proceedings. Foreclosure, however, was averted in the fall 1991, when Robert Tormey of Roscommon Properties in Dayton purchased the building from Fifth Third Bank for $675,000, the City Commission helping out with a $300,000 loan to Tormey. The Marketplace operations continued through the debt problems, the vendors being satisfied with the new owner.

Clark County Heritage Center: By the mid 1990s, interest had grown that favored the City Building as an ideal site for the historical society's collections and substantial artifacts. The society had not found a permanent location since the Memorial Hall closed in 1985. Tormey, the building's owner, agreed that the large building was more suitable for a museum than as a commercial building. He offered to donate the building to the county and the historical society, if the city would forgive his $300,000 debt. The federal Small Business Administration also would have to agree to the debt write-off, since the city funds for the loan came from the federal agency.

Interest in allowing the historical society to take over most of the building was high. William Kinnison, former president of Wittenberg and a previous president of the historical society, headed a fund drive to raise about $3.5 million for a historical society endowment. Major renovations of the building were not needed, since the crucial repairs had been made by the Bernstein Group in 1984. Still internal alterations were needed for the historical society to operate a museum, a book and gift shop, and a research library. For these expenses, the County Commission was asked to increase the county sales tax by one-half percent for one year. This would raise about $5.5 million. The commissioners also wanting space for the county artifacts agreed to the request, and in November 1996 voted 3 to 0 to supplement the sales tax for a year,

beginning February 1997. (No public vote on the increase was required). The commissioners decision was made easier by the success of the Kinnison fund drive, which by the end of 1996 totaled about three million dollars, thus indicating to the county the amount of public support for a new historical society home.

In March 1998 a firm agreement on the future of the 1890 City Building had been reached. The Small Business Administration supported the city in forgiving Tormey's debt on the building. The County Commissioners would take over control of the building from the city and lease it to the historical society for ten dollars per year for twenty-five years.[17]

In the historical society's planning for its move into the City Building, its board had always wanted to keep the first floor vendors in the eastern half of the building, and re-design the market's appearance to resemble an early 20th century market. This living museum would complement the museum of artifacts and other historical displays that would be displayed in the west end of the first and second floors of the building. However, the historical market plan had to be cancelled when the market's principal vendor, McFarland Brothers Meats, announced in January 1999 that it would close the business after 115 years in Springfield. Since the customer base of the market would be weakened by the loss of McFarland's, the society decided that the cost of funding the maintenance and utilities would be prohibitive with only a few tenants remaining. By April 1999, all vendors had moved out. In the place of market vendors, an espresso coffee shop was secured. The current shop, called the Un Mundo, has developed an ample customer base serving breakfast and lunch items throughout its twelve-hour per day operation.

A New Complex

When the Clark County Heritage Center opened in September 2000, one could look back over the previous decade and see the formation of a building ensemble that encompassed Fountain Square and the area to its immediate south just past Washington Street. Here the Clark County Public Library had completed a large new facility in 1989 and by 1993, the impressive Clark State for the Performing Arts building had opened.

We have seen that the city's grand plan for the downtown as it progressed through the Committee of 21, the Blueprint for Progress, and finally the Core Renewal Corporation had largely failed, as the core block did not fill up. Moreover, the hoped for peripheral developments,

which to the planners meant retail, failed to arrive. Yet without any plan that attempted to tie the buildings together, the four structures, all with different but compatible functions developed organically into a unified whole. When the Arcade on Fountain Square could not be made to work, the city cut its sizable losses and demolished the building in 1988. But rather quickly, local investors used the historic site (recall that for about thirty years in the 19th century, the site was the centerpiece of Whiteley's Champion empire) for the development of the Springfield Inn, which opened in April 1990. The 124 room hotel with an upscale restaurant was partly funded by a group of fifty-three local investors who raised about $500,000. The lion's share of the funding, however, came from the Cincinnati based Brilyn, Inc, which obtained a bank loan of five million dollars. The five-story hotel is enhanced by meeting rooms, and an attractive bar and lounge area open to the public. The completion of the Inn and the previously completed Marketplace meant that Fountain Square was once again bookended by viable buildings, as it was initially in 1890.

During the 1980s, the trustees of the Warder Public Library were moving ahead on its own independent track. Crowded conditions at the Warder dated from mid-century, and in 1961 the library announced that it could no longer serve the public adequately unless overcrowding was alleviated. Yet a bond issue for a new building failed in 1968. Fund raising for a new building continued, and as we have seen, the Warder Library purchased the Arcade in 1971, hoping to use the site for a new building. Changing its mind on that location, the library trustees sold the Arcade and settled on the Fountain Avenue and Washington Street location. A library bond issue of $4.3 million for a new building passed in November 1985. Ground breaking began in June 1987 along Fountain Avenue, and the new Clark County Public Library opened in January 1989. Having about 50,000 square feet, of which 30,000 was for public use, the new library nearly tripled the space of the Warder building. With ample parking, spacious reading and computer areas, the new library has drawn a high number of users who both walk and drive to the facility.

The final piece of the ensemble to join the Heritage Center, the Inn, and the public library was the Clark State Center for the Performing Arts. This endeavor germinated under the auspices of Clark State Community College during the late 1980s. The new arts center would be built across Fountain Avenue from the library and directly south of the Springfield Inn on land donated by the city, which it had purchased in the 1970s for a sports center or a multi-purpose building. This was part of the 1970s planning that never materialized. Now some twenty years later, the land area was being put to use. Like the Springfield Inn, the push for a performing arts center

began with a local fund raising drive, headed by retired Bond Oil Company president, Richard Kuss. Under Kuss, the campaign netted nearly six million dollars. Another six million dollars came from a state grant.

A packed gala on November 6, 1993 formally opened the Center. Designed by Columbus architect, James Schirtzinger of the NBBJ firm, he gave the building a rounded form, which historically represents urban gathering. The 1,515 seat Kuss Auditorium, named in honor of fund raisers, Richard and Barbara Kuss, was the heart of the building's interior. This would become the performance stage of the Springfield Symphony Orchestra, which like the historical society, had not had any permanency since the closing of Memorial Hall in 1985. For smaller live stage productions, the Turner Studio Theatre, seating 250, is available. This, as noted earlier, became the stage for the Civic Theatre.

This complex of brick structures has given the south edge of the city's downtown an attractive appearance, while the functions they serve have drawn thousands of city and county residents to the area. But the downtown's historic shopping area still has a way to go. Prominent downtown corners still remain unused. These are the northeast corner of Main and Fountain, the northwest corner of Main and Limestone, and the southwest corner of High and Limestone. Sadly, the Laconda Building at Spring and High streets remains looking abandoned and needing care. Yet some downtown building owners are hard at work. Today the most impressive work at downtown restoration is being led by the Bushnell Building owners, James H. and Nike D. Lagos. While Wren's owned and occupied the building for nearly fifty years, many alterations were made for its department store purposes. These included painting and sealing windows, and adding wall partitions for various reasons. Under Lagos, new windows have been added and partitions removed so that each floor is flooded with light, as the original builder intended. Modern amenities have been installed, including new sprinkler and ventilation systems, as well as heat pumps and cooling towers on the roof. On the exterior, all brick and decorative work has been cleaned by hand, without chemicals or power washing. The cornice, which was growing weaker with age, has been strengthen and cleaned. Not the least of the restoration is the return of the arched entrance that previous owners had eliminated. All the restoration work is being done to the standards of the Ohio Historical Preservation Office.

The restoration of the Bushnell has resulted in new tenants, including Yoga Springs Studio, Oasis at Center City Salon and Medi-Spa, Gary Geis School of Dance, Real Estate II, Dollar Days

Tom Dunham

General Store, and Springfield Health and Fitness Center. On the ground floor with a window onto Main Street is the popular 50s style soda shop, which stays busy serving lunch, as well as old fashion milk shakes and sodas. The largest tenant is HGS Code Blue, a claims management outsourcing company that handles a high volume of various claims that reduce company cost and time. Currently, Code Blue occupies the fourth floor with about 175 employees, and is planning expansion to another floor and employing additional workers.[18]

Endnotes

Chapter 1

1. See Oscar Martin, History of Clark County, Beers, Chicago, 1881, pp. 430-445. Also William Rockel, 20th Century History of Springfield and Clark County, Chicago, 1908, pp. 371-75. Also Benjamin Prince, A Standard History of Springfield and Clark County, Chicago, 1922, pp.47-65.

2. Op. Cit. Prince, p. 78 and Martin, p.425.

3. Ohio Writers Project of WPA, Springfield and Clark County, 1941. Martin, ibid, p. 462.

4. WPA, ibid, p.29 and Rockel, ibid, pp. 390-92.

5. Springfield City Directory, 1852, p. 113. Also Sketches of Springfield, 1856, pp. 35-45.

6. Martin, ibid, p. 591.

7. See legislative act and Springfield history in 1852 City Directory.

8. Rockel. Ibid, p.37

9. Yesteryear in Clark County Vol. 3, 1949. Whiteley quote in Yesteryear, Vol, p. 2

10. Springfield News-Sun, 2-11-1940, p.6. Also Martin, ibid, p. 461.

11. Centennial of High Street Methodist Church, 1849-1949.

12. Baptist Church Directory, 1978 and News-Sun, 5-24-1936.

13. National Register Nomination Form for First Lutheran Church.

14. James Frankart, A History of Springfield, 1799-1875, unpublished 1960, Clark County Public Library. Also see City Directory, 1852, history summary and Prince, ibid, p. 176

15. Martin, ibid, pp. 466-69.

16. William Kinnison, Wittenberg: An American College, 1842-1920, Xlibris Corp, 2008, pp. 68-9.

Chapter 2

1. Prince, ibid, p.212.

2. WPA, ibid, p. 31

3. W.F Austin, Histories of Manufactures of Springfield, Ohio, Austin, Publisher, 1884, p.9

4. Prince, ibid, p. 249.

5. Glessner WEB site.

6. Frankart, ibid, p. 81

7 Barbara Marsh, A Corporate Tragedy: the Agony of International Harvester Company, Doubleday, New York, 1985, p. 22.

8 Marsh, op. Cit, p.27.

9 See the lengthy student paper by John Alberti, William Whiteley, Champion of Springfield, Antioch College, 1974. Also Herbert Casson, Romance of the Reaper, New York, 1908.

10. Quote from Prince, ibid, p. 447 and Casson, ibid, p 68.

11. Austin, ibid, p. 9.

12. Alberti, ibid, pp. 75-6 and News-Sun, 12-7-1999.

13. Casson, ibid, p. 69.

14. News-Sun, 11-14-1937.

15. Biographical Record of Clark County, Ohio, 1904. Centennial Celebration of Springfield, Ohio, Prince, ed. Springfield Publishing Co, 1901.Also Austin, ibid in biography section.

16. Austin, ibid (useful throughout the 40 pages). City Directories. Also Weekley Republic, 2-14-1884.

17. Calvin Roberts, 150 Years from Buckets to Diesels, Miller Printing, Springfield, 1978, p.86.

18. The Sun, 8-18-1935, 2-5-1967, 10-6-1985.

19. Daily News, 10-3-1927 and The Sun, 2-6-1967.

20. Sun, 3-8-1969 and 12-27-1970.

21. News-Sun, 3-22-1931.

22. New Concept Magazine, June 1978. Kinnison, ibid, pp, 130-31. Also City Directories. Also R&M file Clark County Historical Society.

23. Industries of Springfield, 1893. Also Sun 3-3-1937 and 11-14-1937.

24. Roberts, 150 Years . . . ibid, p.76. Also News-Sun 11-14-1937.

Chapter 3

1. Rockel, ibid, p.363.

2. Martin, ibid, p.430.

3. Prince, ibid, p. 54.

4. Martin, ibid, p. 260.

5. Plat Book at historical society and Rockel, ibid, p.363.

6. Kinnison, ibid, p.122-23.

7. City Directory, 1870 and Harry Laybourne, Images of America, Springfield, 1998, p. 15. Martin, p.482.

8. Rockel, ibid, p.394. Also Roberts, ibid, pp.89-91.

9. Martin, ibid, p. 262

10. George Berkhofer letter in CCHS files.

11. Three Quarters of a Century of Banking (brochure of Laconda National Bank, 1873-1958). Also Daily News, 12-16-1928, 11-14-1937, 2-25-1964.

12. Daily News, 3-12-1950 and The Sun, 8-6-1961.

13. Traced in City Directories.

14. Leading Manufacturers and Merchants of Ohio, Inter. Publishing, NY 1886.

15. Both the historical society and public library have thick files on the Arcade and the City Building and Market. For overview of the City Building see News-Sun, 2-11-1940.

16. Weekly Republic, 12-22-1881 and Martin, ibid, p. 481.

17. News-Sun, 2-11-1940.

18. Codified ordinances of Springfield, 1907.

19. Rockel, ibid, p. 397. Also Zimmerman biography in Rockel's history.

20. Daily News, 1-15-1928. Also News-Sun 7-4-1976. Also M&M brochure in public library files.

21. Springfield Daily Republic, 7-6, 1893. News-Sun 3-29-1992.Rockel, ibid, p.398 for quote. Also Nomination Form for National Register.

22. The Sun, 8-5-1956 and News-Sun, 9-1-1991. Nomination Form for National Register.

Chapter 4

1. Nomination Form, East High Historic District. The Sun, 11-5-1972 and 1-9-1972. News-Sun, 1-18-1993

2. Nomination Form Bushnell House. Ruth Blumenberg, Houses and Homes in the Springfield Area. (Student paper, Wittenberg Univ, 1971.) Also News-Sun, 8-29-1988.

3. See public library file for Greek Orthdox Church.

4. Benston quote, p.1. Kinnison, ibid, p.37.

5. Rockel, ibid, p.361. Also 1875 Clark County map.

6. Rockel, ibid, p.361.

7. Ida Williams, 175 Years of Struggle, 1976, p.6. Also City Directories.

8. Rockel, ibid, p.361.

9. City Directories and Brochure of St Joseph's Church.

Chapter 5

1. News-Sun, 11-14-1937; 8-9-1992. Also George Kessler, Report on the proposed City Park System, 1908. (commissioned by Commercial Club). Also City Parks brochure.

2. Roberts, ibid, pp. 80-86. Quote on p. 85.

3. Mahavira Shreevastava, Industrial Development of Springfield, Ohio, Ph.D dissertation, Ohio State Univeersity, 1956, pp. 228-235.

4. Stacy Pavlatos, The Sewage System of Springfield, Ohio (student political science paper, Wittenberg Univ, 1971). Also Daily News, 12-22-1967 and 1-23-1967 and 11-23-1976.

5. Williams, 175 Years . . . Ibid, pp 15-70.

6. City Planning Associates, Inc,Community Renewal Program City of Soringfield,1961, pp.57 &90.

7. Patricia Ann Cooper, Philanthropy in Springfield in the Gilded Age, (student paper, Wittenberg University, 1971.

8. Shreevastava, Industrial Development . . . ibid, pp. 161-65.

9. American Antiques Journal, January 1994 and April 1995. Also Daily News, 1-10-1926. Also Stephen Siek, notes in public library by a Wittenberg professor.

10. Marsh, ibid, pp. 30-42.

11. Company printed history of International Harvester on file in public library. Appears to have been written by public relations department about 1980.

12. News-Sun, 1-5-1953. Also company history (note 11).

13. Special edition of the News, November 1937, p. 3.

14. News-Sun, 8-10-1947, 3-22-1931. Also company brochure at Historical Society.

15. News-Sun, 12-28-1992 and 3-22-1931.

16. News-Sun, 11-16-1987 (part of a five part series).

17. News-Sun, 9-29-1972. Quote from 11-7-1972.

18. Edwin Todd, A Sociological Study of Clark County, Ohio, Ph.D dissertation, Columbia University, 1904, pp. 94-98. Also Daily News, 12-31-1905.

19. George Beerkhofer, No Place Like Home: A History of Domestic Architecture in Springfield and Clark County, 2007, pp. 145-47.

20. Daily News,11-12-1916.

21. Both Elmwood Place and Warder Park are discussed by Dallenbeck in her Ridgewood book, pp.139-142. See note 23.

22. Daily News, 10-14-1913

23. The material relating to Ridgewood was taken from Tamara Dallenbach, Ridgewood in the Country Club District, 2011.

24. Daily News, 6-23-1923.

25. T.C> Holy, Survey of the Schools of Springfield, Ohio, 1931.

Chapter 6

1. Unsigned paper summarizing the history of the 1904 hospital (hospital file at public library. Also News-Sun, 8-8-1971.

2. Daily News, 11-14-1937. Also Memorial Hall file at public library.

3. Daily News, 12-31-1905. The Springfield Paper, 1-11-2012. Also City Directories.

4. Daily News Special, 1928, article by C.A. Radford, publicity director of Big Four Railroad.

5. Daily News, 4-17-1963, 1-30-1975, and News-Sun, 4-1-1965.

6. City Directories.

7. City Directories. Also Prince, ibid, p.435.

8. Springfield Weekly Republic, 3-9-1893

9. Nomination Form for National Register.

10. Springfield City Building (a consultant's study of the 1890 city building)

11. Covenant Church brochure. Also News-Sun, 1-5, 1986.

12. News-Sun, 1-5-1986 and City Directory.

13. The Sun, 10-17-1934.

14. T.C. McMillen, Springfield, Ohio WMCA, 1854-1954. Also News-Sun, 1-5-1986.

15. Todd, ibid, p. 82. Also WPA, ibid, p. 109.

16. News-Sun, 11-14-1937. New Concept Magazine, Sept, 1978. Also Women's Club brochure at public library.

17. Sherwood and Frances Moran, Springfield Symphony Orchestra, 25th Anniversary, 1969. See orchestra file at public library.

Chapter 7

1. News-Sun, November 15-20, 1987. Also City Directories. Historical Society file on city renewal.

2. Tom Wing, Impact of Real Property Tax on Springfield's Central Business District, 1975. (Paper by Chamber of Commerce intern from Wittenberg University).

3. News-Sun,12-3-1971.

4. News-Sun, 7-21-1974. Budget breakdown from Daily News, 6-5-1975

5. Daily News, 7-24-1974.

6. Daily News, 6-5-1975.

7. News-Sun, 12-28-1975.

8. Daily News, 3-29-1972.

9. News-Sun, 8-13-1975 and company brochure.

10. The Sun, 8-6-1961, News-Sun, 7-21-1974, and New Concept Magazine, October 1977.

11. The Sun, 11-6-1976.

12. The Sun, 12-11-1969.

13. News-Sun, 5-15-1977, 11-27-1980, and 2-29-1992.

14. News-Sun, 11-18-1987.

15. The Sun, 12-16-1978 and 12-11-1969.

16. The Sun, 9-26-1971 and 3-26-1977. Also Daily News, 1-17-1978 and 3-13-1979. Also News-Sun, 9-14-1985, 8-3-1988, and 3-18-1988. Also Dayton Journal Herald, 3-31-1983.

17. News-Sun, 3-11-1998.

18. News-Sun, 11-1-1991, 10-28-1993, 12-31-2001. Both the public library and the historical society have files on all four buildings.

Bibliography

Maps

1. Atlas of Clark County, Ohio. C.O. Titus, Philadelphia, 1870.
2. Atlas of City of Springfield, Ohio. Robinson, N.Y. 1982.
3. Combination Atlas Map of Clark County, Ohio.L.H. Everts, 1875.
4. Original Plats of the City of Springfield, Ohio. Clark County Historical Society.

Articles

1. Berkhofer, George. "The Courthouses of Clark County," On file at Clark County Historical Society (CCHS).
2. Cooper, Patrician Ann. "Philanthrophy in Springfield in the Gilded Age," 1971. Student paper, Wittenberg Univ, 1971.
3. Lagos, James H. "History of the Bushnell Building," Bushnell Investment Co, Springfield, 2011.
4. Pavlatos, Stacey. "The Sewage System of Spingfield, Ohio," Student paper, Wittenberg, Univ, 1971.
5. Wing, Tom. "Impact of Real Tax on the Springfield Central Business District," Student paper, Wittenberg Univ, 1975.
6. Muirford, Russell. "Civic Theatre: First 50 Years," New Concept Magazine, September 1978.
7. Meier, August and Elliott Rudwick. "Early Boycotts of Segregated Schools: The Case of Springfield, Ohio, 1922-23." American Quarterly, Winter 1968.
8. American Antiques Journal, "The Westcott Motor Car," January 1994.

Books

1. Alberti, John. William N. Whiteley, The Champion of Springfield, Ohio. Antioch College Senior History Project, 1974.

2. Armstrong, Ann. City Hall Project. Office of City Manager, Springfield, 1981.

3. Austin, W.F. Histories of Manufactures of Springfield, Ohio. Austin Publisher, 1884.

4. Banner, Warren. A Review of the Economic and Cultural Problems of Springfield Ohio. National Urban League, 1961.

5. Barth, Allen. Looking Back, Looking Forward: the Story of a Neighborhood Repurposed for the Springfield Regional Medical Center, Springfield, 2010.

6. Benston,Anne and Gerhardt, Joyce. Cemetaries of Springfield Township and the City of Springfield, Clark County, Ohio, 2000.

7. Berkhofer, George H. No Place Like Home: A History of Domestic Architecture in Springfield and Clark County, Ohio. Orange Frazer Press, Wilmington, Ohio, 2007.

8. Biographical Record of Clark County, Ohio, 1902.

9. Blumenberg, Ruth. Houses and Histories in the Springfield Area. Student project, Wittenberg Univ 1971.

10. Casson, Herbert N. Romance of the Reaper. Doubleday, N.Y., 1908.

11. Centennial Celebration of Springfield, Ohio. B. Prince, ed., 1901.

12. City Planning Associates, Inc. Community Renewal Program for the City of Springfield, 1961.

13. Clark County and Springfield Regional Planning Commission. Revised Land Use Plan, June 1960.

14. Commercial Club. Springfield: the Great Manufacturing City. 1905. (all photographs)

15. This is Crowell-Collier. Self published by company, 1947.

16. Dallenbach, Tamara K. Ridgewood in the Country Club District. Orange Frazer Press, Wilminton, Ohio, 2011.

17. Frankart, James. A History of Springfield, 1799-1875. Wittenberg Univ history project, 1960.

18. Frantz Scrapbook. Springfield History, 1900-1920. (collection of newspaper articles).

19. The Greek Orthodox Church, Assumption of the Blessed Virgin Mary, 2001.(Printed by the church).

20. Holy, T.C. Survey of the Schools of Springfield, Ohio. Board of Education, Springfield, 1931.

21. The Industries and Wealth of Ohio: Columbus, Dayton, Springfield, and Zanesville. American Publishing Company, 1891.

22. Kinnison, William A. Wittenberg: An American College, 1842-1920. Xlibris Corp, 2008.

23. Kummerow, Burton K. Heartland. Springfield, Ohio, 2001.

24. Laybourne, Harry. Images of America, Springfield. Arcadia Publishing Co, Chicago, 1998.

25. Leading Manufacturers and Merchants of Ohio: Dayton, Springfield, etal. International Publishing Company, N.Y., 1886.

26. Marsh, Barbara. A Corporate Tragedy: The Agony of International Harvester Company, Doubleday, N.Y.,1985.

27. Martin, Oscar T. History of Clark County. W.H. Beers Cc, Chicago, 1881.

28. Moran, Sherwood and Frances. Springfield Symphony Orchestra, 1969. (self published).

29. McMillen, T.C. Springfield, Ohio YMCA, 1854-1954. Sringfield Tribune Co, 1954.

30. Ohio Writers Project of WPA: Springfield and Clark County. Springfield Tribune Printing Co, 1941.

31. Policemen's Mutual Benefit Assn. History of the Police Department of Springfield, Ohio, 1909.

32. Prince, Benjamin F. A Standard History of Springfield and Clark County, Ohio, Vol I. American Historical Society, Chicago, 1922.

33. Rickey, Benjamin D. Minority History—Architectural Survey. National Park Service grant, 1986

34. Roberts, Calvin. 150 Years from Buckets to Diesels. Miller Printing company, 1978.

35. Rockel, William M. 20th History of Springfield and Clark County, Ohio. Biographical Publishing Co, Chicago, 1908.

36. Rust, Orton. Fifty—Five Years of Service, 1873-1928: The Laconda-Citizens National Bank. (self published.

37. —.History of West-Central Ohio, three volumes, Historical Publishing Company, Indianapolis, 1934.

38. —. 63 Years of Banking: the first National Bank, Springfield, Ohio, 1927 (self published).

39. St. Joseph's Church Centennial, 1882-1983. (self published).

40. Shreevastara, Mahavira. The industrial Development of Springfield, Ohio. Ph.D dissertation, Ohio State University, 1956.

41. Sketches of Springfield in 1856. (printed by Daily Nonpareil Office, Springfield.

42. Skinner, Herbert K. Scrapbook of Newspaper Articles on Springfield History, 1907. Published by Springfield History Committee, 1971,1972, 1973.

43. Springfield City Directory. Williams & Co. Annual series begins in 1852 and to continues to current year.

44. Springfield Chamber of Commerce. Springfield, Ohio: In the Heart of the Mad River Valley, 1924.

45. Three Quarters of a Century of Banking: Seventy-Five Years of Progress, 1873-1948. (brochure of the Laconda National Bank).

46. Todd, Edwin S. A Sociological Study of Clark County. Ph.D dissertation, Columbia University. Published by Springfield Publishing Company, 1904.

47. Williams, Ida. 175 Years of Struggle: History of Black People in Springfield, Ohio. Springfield Program in Inter-Cultural Education, 1976.

48. Yester Year in Clark County, Vols 1-6, 1947 to 1972. Clark County Historical Society, Bauer Press, 1972.

Organizations

The Clark County Historical Society has a wealth of material on Springfield history. The maps shown in the text are possessed by the historical society. To summarize its holdings would be daunting. Much of it has to be retrieved from a climate controlled room. Fortunately the curator, Natalie Fritz, is very helpful and generous with her time.

The Clark County Public Library has over the years maintained a clipping file on a long list of Springfield topics. It is kept on open stacks, making the material convenient for the browser.

The Springfield Preservation Alliance does something different than the library and the historical society. For a number of years, it has conducted historical walking tours through many Springfield neighborhoods, as well as the downtown. The well researched tours provide the participants with a working knowledge of the area and allows one to grasp the geography of the neighborhood. The tours are principally put together by former board member, Kevin Rose, who also conducts many of the tours.

Appendix

Population

	Springfield	Clark County
1830	1,080	13,114
1840	2,062	16,882
1850	5,108	22,178
1860	7,002	25,300
1870	12,652	32,070
1880	20,730	41,948
1890	31,895	52,277
1900	38,253	58,939
1910	46,921	66,435
1920	60,840	80,728
1930	68,743	90,936
1940	70,662	95,647
1950	78,508	111,661
1960	82,723	131,440
1970	81,926	157,115
1980	72,563	150,236
1990	71,006	147,538
2000	65,958	144,741